exploring

3D MODELING
with MAYA 7

exploring

3D MODELING
with MAYA 7

Patricia Beckmann
Scott Wells

EXPLORING 3D MODELING with MAYA 7
Patricia Beckmann and Scott Wells

Vice President, Technology and Trades SBU:
David Garza

Director of Learning Solutions:
Sandy Clark

Managing Editor:
Larry Main

Acquisitions Editor:
James Gish

Production Manager:
Jaimie Weiss

Marketing Director:
Deborah Yamell

Marketing Manager:
Penelope Crosby

Director of Production:
Patty Stephan

Production Manager:
Andrew Crouth

Content Project Manager:
Nicole Stagg

Technology Project Manager:
Kevin Smith

Editorial Assistant:
Niamh Matthews

Library of Congress Cataloging-in-Publication Data:
Beckmann, Patricia.
 Exploring 3D modeling with Maya 7.
 p. cm
Authors, Beckmann, Patricia, Wells, Scott.
 ISBN 1-4180-1612-8
1. Computer Graphics. 2. Three-dimensional display systems. 3. Maya (Computer file)
1. Wells, Scott. II. Title.

NOTICE TO THE READER

contents

CONTENTS

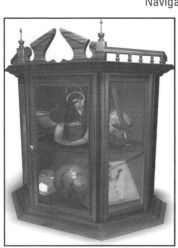

| preface |

INTENDED AUDIENCE

This book concentrates on the concepts and tools required by the novice artist using three-dimensional (3D) art concepts. Our goal is to provide graphic tutorials targeted at the creative artist. We also hope to expand the definition of 3D art.

On completion of this book, you will be ready to understand even more sophisticated tools and procedures available in Maya.

Students of all art media, creative arts educators, and professionals looking to increase their skill sets will find this book's content appropriate. The tutorials invite creativity, and the straightforward text is amply illustrated.

EMERGING TRENDS

Computer art is stepping away from the technical and toward the organic. Artists are now finding the medium to be easier to understand. Digital art should not be identifiable by its software program; rather, it should serve to achieve the artist's vision using a new pencil. This book strives to bring the technology to the artist in a nonthreatening and visual manner.

BACKGROUND OF THIS TEXT

I wrote this book because, as a professor and feature animation trainer, I found the standard textbooks in use were not addressing the creative interests of my students. Scott and I wanted to create something that inspired students to work beyond the tutorials and develop their own vision. Our ultimate goal is to create the text that would have best taught me as a beginner artist.

Students and creative professionals need a resource that can be easily digested. When I worked in the film industry, my work week already

contained overtime. During my free time I attended classes and read books to train myself: however, the process was arduous. During training, every tool available was explained and speedily demonstrated instead of just the tools I needed. I began to have less and less time to relax. This text is meant to isolate a mainframe of tools needed to complete basic tasks as quickly as possible. The learning process will then lead you to advanced tools. You will eventually learn what tools are useful daily and which are useful in specialty situations.

For effective usage of this text, you should have a basic understanding of how to save and retrieve files on a computer. You should also have a three-button mouse connected to your computer.

TEXTBOOK ORGANIZATION

Exploring 3D Modeling with Maya 7 is structured by asking an essential chapter question and then answering it with clearly thought-out goals and tutorials. Tools presented in each chapter are clearly identified preceding the text. A mini-tutorial is presented for most tools. Each chapter is organized in this manner to clearly identify what you are learning and why.

The topics covered are as follows:

- Chapter 1 introduces you to the interface and explains how to save projects and files.

- Chapter 2 introduces basic concepts and universal tools in modeling with Maya.

- Chapter 3 concentrates on polygons and some tools specific to this method of modeling.

- Chapter 4 is about modeling with nonuniform rational B-splines (NURBS). You will use tools and techniques specific to NURBS.

- Chapter 5 is about subdivisional modeling methods and tools used to create subdivisional models.

- Chapter 6 explores colors and textures. Here you learn how to use Maya to apply colors and texture through shaders.

- Chapter 7 introduces lighting as a way to paint color, add texture, or create a mood. Here you tweak attributes available in lights.

- Chapter 8 is about cinematography and how to use the camera in Maya to achieve the shot you want. You also experiment with the settings for cameras.

- Chapter 9 covers rendering and how you can use a shading network to create a believable image.

- Chapter 10 supplies an introduction to animation. Here you cover how to create animation using an effective production method that can be edited and easily understood by your supervisor.

FEATURES

The following list provides some of the salient features of the text:

- Learning goals are clearly stated at the beginning of each chapter.

- The text is written to meet the needs of design students and professionals for a visually oriented introduction to basic design principles and the functions and tools of Maya.

- Client projects involve tools and techniques that a designer might encounter on the job to complete a project.

- The full-color section provides stunning examples of design results that can be achieved using Maya.

- The "Exploring on Your Own" sections offer suggestions and sample lessons for further study of the content covered in each chapter.

- Review Questions are provided at the end of each chapter to quiz your understanding and retention of the material covered.

- A CD at the back of the book contains tutorials and exercises.

HOW TO USE THIS TEXT

The following features can be found throughout the book:

▲ Charting Your Course and Goals

The introduction and chapter objectives start off each chapter. They describe the competencies that you should achieve upon understanding the chapter.

▲ Don't Go There

These boxes appear throughout the text, highlighting common pitfalls and explaining ways to avoid them.

▲ Review Questions and Exploring on Your Own

Review Questions are located at the end of each chapter and allow you to access your understanding of the chapter. The "Exploring on Your Own" sections contain exercises that reinforce chapter material through practical application.

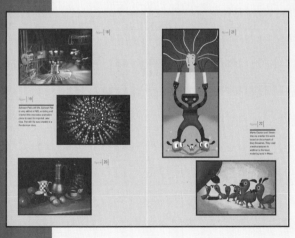

Adventures in Design

These spreads contain client assignments, showing readers how to approach a design project using the tools and design concepts taught in the book.

▲ Color Insert

The color insert demonstrates work that can be achieved when working with Alias/Wavefront Maya.

E.RESOURCE

This electronic guide was developed to assist instructors in planning and implementing their instructional programs. It includes sample syllabi for using this book in either an 11- or 15-week semester. It also provides answers to the end-of-chapter review questions, PowerPoint slides highlighting the main topics, and additional instructor resources.

ABOUT THE AUTHORS

▶ Patricia Beckmann-Wells

Patricia Beckmann-Wells earned her M.F.A. in cinema and animation from the University of Southern California while

 working as a traditional animator with Phillips Media and holding a fellowship at Silicon Studios in Los Angeles. As a computer graphics artist for Warner Brothers, she created computer graphics effects and animation for the films *Batman* and *Mars Attacks* using high-end software such as Maya. For Film Roman

(producers of *The Simpsons* and *King of the Hill*), she managed the computer graphics development department. She was art director on interactive cartoon projects for DreamWorks (*Chicken Run*), ABC (*Norm*), Newline Cinema, E!Online, and Coca-Cola. Her short *Matilda* won the Playboy Animation Fest and led to a television pilot for Oxygen Media entitled *Gertrudah and Her Grandmothers*. Patricia spent two years founding the animation program of a large college in the Southeast as chair and professor of a 1,200-student department.

Patricia has received a number of awards, including the Emerging Artist Award at the Rico Gallery Fine Arts Competition in 1999 and was chosen as one of the Top 25 Women of the Web in 2001 by the San Francisco Women of the Web. She was selected to serve as the Educators Program Chair of the 2005 SIGGRAPH to be held in Los Angeles and continues with SIGGRAPH in the role of Foundation Chair for 2007.

She presently serves as Manager of Artistic and Professional Development at Disney Feature Animation. There she manages training in the arts and computer graphic programs for all artists on production of feature animated films. She is also creating short films for festivals.

▶ Scott Wells

Scott Wells is an animator and designer who has worked in broadcast and interactive multimedia for nearly 15 years. He has broad experience in a variety of areas, including character animation, broadcast motion graphics, virtual environments/blue screen production, and interactive media design,

from his work with broadcast, corporate, educational, entertainment, and museum clients. Some of the noteworthy clients he has worked with include PBS, The Discovery Channel, Nickelodeon, Ford, Volkswagen, Apple Computer, and Capital Records.

He has received several honors for his work, including two Emmy nominations for *Where in Time Is Carmen San Diego?*, a Telly for a project for Royal Caribbean Cruise Line, and an MIMC award for the Design Your Own Car exhibit at Ford's Spirit of Ford Museum. Scott holds a B.F.A. in illustration/design from the University of Massachusetts at Dartmouth and an M.F.A. in animation from the Savannah College of Art and Design, where he held the Artistic Excellence Fellowship.

Scott is presently working as a Modeler for Rhythm and Hues, a top production studio in Los Angeles, creating creatures for feature films.

ACKNOWLEDGMENTS

The authors would like to thank the following people for their contribution to the book: Jonathon Shaw, Dong Sool Shin, Suwhan Pak, Marty Clayton, Edward Kinney, Cui Jian, Eric Evans, Ryan Yokley, Istvan "Steve" Stecina, Xin (Alex) Wang, David Boxser, Kyle Winkelman, Brian Ellis, Danny Ramirez, Emily Meger, Joshua Reynolds, Krista Grecco, Yuri Johnson, and Woong-pyo Hong.

Thanks also go to the Thomson Delmar Learning staff: Jim Gish, Senior Acquisitions Editor; Jaimie Weiss, Product Manager; Niamh Matthews, Editorial Assistant; and Tom Stover, Production Editor.

Thomson Delmar Learning and the authors would also like to thank the following reviewers for their valuable suggestions and expertise:

Tom Bledsaw
Graphics Department
ITT Educational Services
Carmel, IN

Karen Sanok
Graphic Design Department
The Art Institute of Fort Lauderdale
Fort Lauderdale, FL

Matt Kriftcher
Graphic Arts, Web Design,
Animation, & Multimedia
Production Departments
New Mexico Junior College
Hobbs, NM

Peter Weishar
Animation/New Media Department
Dean of Film and Digital Media
Savannah College of Art & Design
(SCAD)
Savannah, GA

A very special thank you also goes to David Dawson and Stephen Steinbach who also assisted in Maya's update to version 7.

Patricia Beckmann-Wells &
Scott Wells
2004

QUESTIONS AND FEEDBACK

Thomson Delmar Learning and the authors welcome your questions and feedback. If you have suggestions that you think others would benefit from, please let us know and we will try to include them in the next edition.

To send us your questions and/or feedback, you can contact the publisher at:

Thomson Delmar Learning
Executive Woods
5 Maxwell Dr.
Clifton Park, NY 12065
Attn: Media Arts and Design Team
800-998-7498

Or the authors at:

bunsellapb@yahoo.com

a discovery tour

 charting your course

The computer is just another pencil; don't let the initial complexity overwhelm you.

Three-dimensional (3D) software can help you build anything you can imagine. Everyone learns the same buttons, but your own individual imagination will create the art.

This chapter will introduce you to the different places wherein you will find your tools. First, you must understand the interface. Once you become comfortable with it, learning will get easier.

 goals

- To discover the four main modules in Maya Complete and where they lead you.

- To learn the basics of the interface and mouse interaction.

- To set up a file directory to save your work.

- To get comfortable with navigating in Maya Complete.

NAVIGATION

Consider the interface to be a giant file cabinet with four main drawers. Inside these drawers are files. These files contain envelopes. The envelopes contain tools. The secret to getting the tool you need is to know which drawer, file, and envelope to look in. This becomes second nature after a bit of practice. Then you will be prepared to look deeper into the cabinet for the smaller folders containing the more complex tools. In this book, we will concentrate on practicing the tools found in the Maya Complete program.

Before we move ahead, make sure your interface looks like that shown in Figure 1–1.

figure | 1-1 |

The Maya interface.

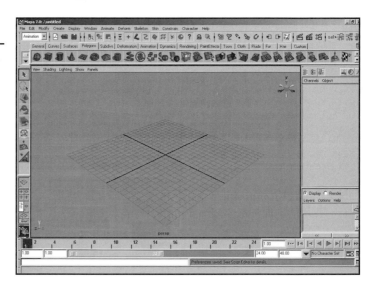

Select the following:

Display > UI Elements

Make sure there is a check mark next to each interface item (Figure 1–2).

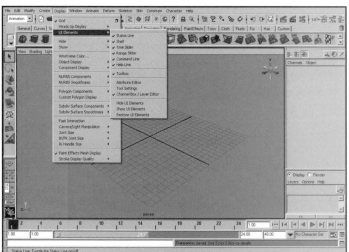

figure | 1-2 |

Display interface items using the Display > UI Elements command.

In a school, many people will have access to the same software and computer you are working on. Each user will change the interface and customize it to his or her own individual work habits. Someone may turn off all interface menus. The next person who logs on will just see the perspective view and nothing else. You can get all of your navigation windows back by using:

Display > UI Elements

Just check or uncheck your desired options.

THE DRAWERS

Maya Complete consists of four base modules. Consider these as your drawers to the cabinet. These four modules organize the thousands of tools available in Maya as they pertain to animation, modeling, dynamics, and rendering. When you are in the Animation module, you will find the tools you need for setting up a skeleton and key-framing movement. In the Modeling module, you will find the tools you need to model a ship. The Dynamics module allows you to program physics into your models. The Rendering module gives you access to tools to process the scene for viewing.

You will find these modules in the upper-left corner of the interface. Click on the pull-down menu to reveal all of the four modules for Maya Complete (Figure 1–3).

figure | 1-3 |

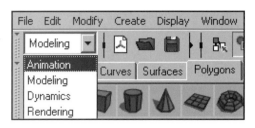

The four basic
modules in Maya
Complete are
Animation,
Modeling, Dynamics,
and Rendering.

Select each module in turn. Nothing really changes on the interface
except for the pull-down menus at the top.

THE MAIN FILE FOLDERS

The area at the top of the application window is called the menu bar
(Figure 1–4). The menu bar changes depending on which module
you are in. Consider these titles to be the names of folders in the
drawers of your file cabinet. Make sure you are in the Animation
module, and then examine the menu bar titles.

| File Edit Modify Create Display Window Animate Deform Skeleton Skin Constrain Character Help |

figure | 1-4 |

The menu bar. Can
you determine which
mode this is?

Each module has the same six folders beginning the menu. These are
File, Edit, Modify, Create, Display, and Window. These menus drive
preference features you can access in any module of the interface.

To follow our file cabinet analogy, consider the choices available
in these submenus to be the "envelopes" inside your "folders"
(Figure 1–5).

figure | 1-5 |

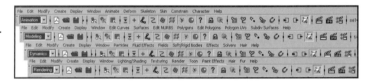

Each module has the
same six folders
beginning the menu.

**MAYA'S
HOTBOX**

You can also access the modules and subfolders by holding down
the space bar. When you hold down the space bar, Maya's Hotbox
will appear. The Hotbox contains the main folders and subfolders
plus the modules, as well as recent commands and the Hotbox
display options. The Hotbox is a quick and easy way to access tools
in Maya that can be customized to help speed up the workflow
(Figure 1–6).

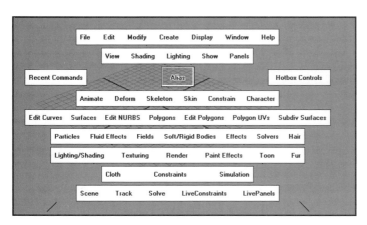

figure | 1-6 |

Hold down the space bar to access the Hotbox.

THE TOOLS

Pull down a menu bar and tear off a dialog box.

To do this, highlight a menu item and look for the dou-

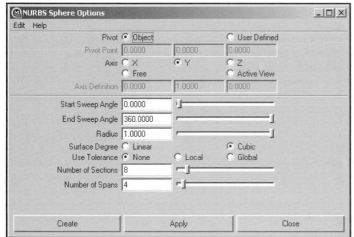

figure | 1-7 |

The double blue line is at the top of the drop-down box.

ble blue line. Left mouse click on the lines, and the menu will float in the interface (Figure 1–7).

Left mouse click on one of the directories. These are your tools.

Do you notice the little boxes to the right of the tools? Left mouse click on one of them. A new box opens as shown in Figure 1–8. These are called options boxes. They allow you to modify the creation settings for that command. You do not always need to modify these settings. Most of the time, it is fine to use the default. If you are a student sharing a machine with many others, make sure you reset

figure | 1-8 |

The options box allows you to modify the settings of your tools.

these settings by using > **reset settings.** Then close the options dialog box. When you have done so, you are ready to use your tool.

THE STATUS LINE

The Status line (Figure 1–9) contains tools to edit your scene as a whole, by object, or by detail. The mode selector is at the far left. Look to the right of it, and you will see the Collapser icon. Left mouse click on it. The menu collapses or expands, depending on its initial setting.

The Status line.

This is used to hide a section of the Status line and eliminate clutter. When the Collapser shows an arrow, something is hidden. When it shows a box, you have the ability to hide the items on the right. These icons are shown in Figure 1–10.

figure | 1-10 |

The Collapser with an arrow and a box.

The next important area to discover is the Hierarchy/ Object/Component mode (Figure 1–11). This very important group determines how you select objects in the scene for editing. Hierarchy selects an entire grouped object, such as a model of a car, and all the elements. Object will pick a piece of the car, such as a tire, for example. Component will allow you to select a piece of the car, such as a tire, and then select the points in space that make up the tire.

figure | 1-11 |

Hierarchy mode, Object mode (selected), and Component mode icons.

As you click on each of these, you will notice that the section to the right on the Status line changes. These icons represent what can be edited while in that mode. Hierarchy icons manipulate the grouped objects as a whole. Object mode icons affect base objects, such as primitives. Component mode icons affect smaller components of the model, such as lines, hulls, and vertices.

figure | 1-12 |

Snap to Grids, Snap to Points, and Snap to Planes icons.

The next section is Snap modes (Figure 1–12). When you snap to something, it is as if the object has a magnet luring your object to the selected Snap mode. We will explore these later.

figure | 1-13 |

Construction history icon.

Construction history (Figure 1–13) is the next important button. It looks like a scroll and feather.

Construction history records all of the commands used to create an object. The construction history is used as a reference so that when

you edit an object, all related information gets updated with it. Do not continually leave this feature on. You should only use it when you need to because it uses considerable random access memory (RAM).

The Scene icons (Figure 1–14) represent the different rendering modes in Maya. A render is the final graphic output of the scene showing model, lighting, texture, and possibly animation. It is as if you are shooting a reel of film with your camera as you model, light, texture, and animate, and then you take the reel of film to the one-hour-photo shop for developing.

On the left side of the interface is the Toolbox (Figure 1–15). These tools are the most often used, and they relate to positioning objects in the scene.

The first tool in the Toolbox is the Select tool. This allows you to select an object by left mouse clicking on it. Next, the Lasso tool allows you to draw a shape around an object to select it. The third tool is the Move tool, which allows you to translate an object through x, y, and z space. The Rotate tool allows you to rotate an object in x, y, and z space. The Scale tool is fifth, and it allows you to scale in x, y, and z space. The sixth tool in the Toolbox is the Universal Manipulator. This is new to Maya 7. This tool combines the functions of the Move, Rotate, and Scale tools into a single manipulator. The seventh tool in the Toolbox is the Soft Modification tool. This tool allows you to push and pull on geometry as if you were a sculptor working with clay. The eighth tool in the Toolbox is the Show Manipulator tool. This tool displays a manipulator that is modified to fit the specific node that is selected and the particular task at hand. It is used frequently when modeling with the polygons as well as creating and adjusting lights and cameras.

The Quick Layout buttons (Figure 1–16) are below the Toolbox. These allow you to pick different views of your model. Click through them to get comfortable with finding your Four-Panel view, Perspective view, and others. You can enlarge any of the individual layout windows to Full-Screen view by first selecting the viewport and then tapping the space bar. Tap the space bar a second time to return to Layout mode.

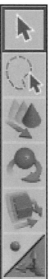

figure | 1-14 |

Scene icons.

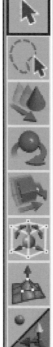

figure | 1-15 |

Toolbox.

figure │ 1-16 │

Quick Layout
buttons.

The largest portion of real estate on our interface is the View Panel (Figure 1–17). This is the stage that is used to construct your artwork.

Go to the Quick Layout buttons and select the Four-Panel view, it is the second button from the top of the list. This configuration of views offers the artist one of the most advantageous ways to view the scene file. The reason the Four-Panel view is so advantageous is because it incorporates the use of both orthographic and perspective view ports.

The Perspective view is a true 3D view. The other kind of view offered in Maya is Orthographic, which includes views such as Front, Left, Back, Top, Bottom, and Side views. Lines do not converge at a distance in Orthographic view, but they do in Perspective view, which is how the two views differ.

figure │ 1-17 │

The View Panel, in
the Four-Panel view.

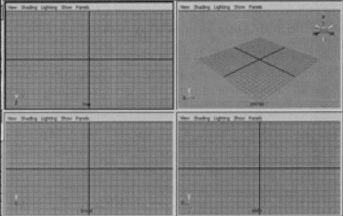

VIEW COMPASS

New to Maya 7 is the View Compass button (Figure 1–18) located in the Perspective viewport. The View Compass button is a quick and easy way to move from the Perspective view to any one of the six Orthographic views. The Orthographic views include Front, Left, Back, Right, Top, and Bottom (Figure 1–19). To move from the

Perspective view to an Orthographic view, simply click any of the arrows on the View Compass. To return to the Perspective viewport, simply click the blue box in the center of the View Compass.

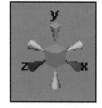

You should be using a three-button mouse with this software. Avoid two-button mice with

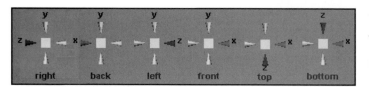

right back left front top bottom

figure | 1-19 |

Orthographic views in View Compass.

scrollwheels, though they can be used. The three buttons each have a unique purpose in Maya. Try the following combinations of buttons and keyboard controls for navigating the View window (Figure 1–20):

- Put your mouse icon in the Perspective view. Press the left mouse button (LMB) and the Alt key at the same time and hold them down. By moving your mouse, you rotate around the window. This method only works in the Perspective view.

- Press and hold down the middle mouse button (MMB) and the Alt key at the same time. By moving the mouse, you pan around the window. This method works in all window views.

- Hold down the left and middle mouse buttons (LMMB) and the Alt key. By moving your mouse, you dolly in and out of the window. This method works in all window views.

On the right of the interface, you should have your Channel Box (Figure 1–21). This window allows you to put in mathematical values for Translate, Rotate, and Scale. You may also make adjustments to newly created objects. You can also change this window to the

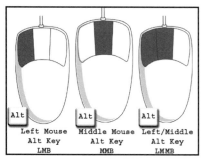

Left Mouse Middle Mouse Left/Middle
Alt Key Alt Key Alt Key
LMB MMB LMMB

figure | 1-20 |

LMB (rotate), MMB (pan), and LMMB (dolly).

Attribute Editor or Tool Settings window by selecting one of the icons in the upper-right corner of the interface (Figure 1–22). We will use this area quite often.

figure | **1-21**

Channel Box with a sphere selected.

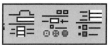

At the bottom of your interface, you will find the Time slider, Playback controls, and Range slider (Figure 1–23). When you animate, these controls will identify at what point in time you are adding information.

Below the Range slider is a blank rectangular field known as the Command line.

figure | **1-22**

Attribute Editor, Channel Box, and Tool Settings icons.

The Command line (Figure 1–24) allows you to type MEL commands directly into Maya. (MEL is the programming language used in Maya.) Maya operates through script commands. Every icon on the interface merely represents a script command. If you wish,

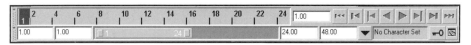

figure | **1-23**

Time slider, Playback controls, and Range slider.

you can bypass the icons and directly type in the commands to create artwork in Maya.

If you are uncertain of what an icon represents, move your mouse over it and look at the Help line (Figure 1–25). This will give you a written definition.

figure | **1-24**

Command line.

figure | **1-25**

Help line.

SETTING UP YOUR ACCOUNT

Correctly saving files will keep you from losing or misplacing scene files containing many hours of work. Always remember to do a double backup of your files. Countless artists have lost beautiful work because of misplaced disks, corrupted media, and computer crashes. No teacher, production manager, or client will accept the

excuse that you lost your file when the project is due. It is recommended that you back up your files on a daily basis.

TUTORIAL:
SETTING UP YOUR FIRST PROJECT

To set up your project directory, follow the steps outlined here.

As shown in Figure 1–26, select the following:

File > Project > New

figure | 1-26 |

Creating a new project.

The New Project window opens (Figure 1–27). This window shows a directory holding all the folders for this project. In this directory, you will store your textures, scene file, rendered pictures, and all other data. This is where you will look for information pertaining to your project. Make sure this directory is backed up onto your personal backup media when you are done.

In the Name box, put your name or the word "Tutorials." For the Location box, click on Browse. This opens your computer, and you can locate an area on your computer disk where you can store this directory. You may also store directly to your personal media. Choose the location you want, and click OK. The location you have chosen will show up in the Location path. The location may be a drive other than C, a recordable CD, DVD, or flash card.

figure | 1-27 |

New Project
window.

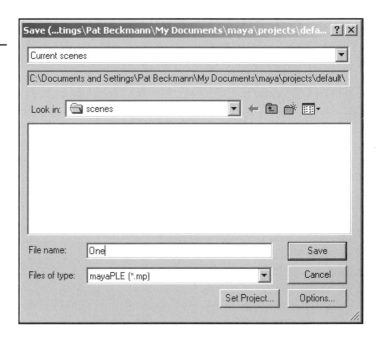

At the bottom of the box, click Use Defaults. Folders will be named with default directory names. Click Accept. You now have a directory in the location specified. Search for the directory you have created to make sure you know where it is.

Now save your first file. Go to the main pull-down menu, and select the following:

File > Save Scene As...

A new window pops up. These are your save settings. Look in the window under Current scenes. This is the directory path leading to where your file will be saved. You can navigate away from this directory in special circumstances, but for now leave it here. Name the file "One," and select Save (Figure 1–28).

Look at the top of the Maya interface. The directory path to your file is presented here. If you need to access files from your directory, you can find them using this path. All data created in your scene will be found in the folders in this directory.

When you back up this directory, don't forget to include such things as your textures and scripts. They will be linked from different folders contained in the directory. If you are missing any information, you will have to reconstruct it the next time you consult your project.

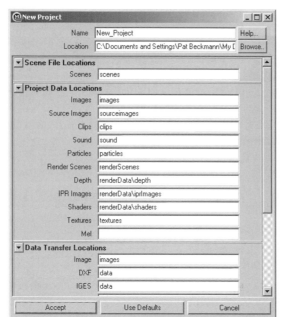

figure | 1-28 |

Saving the new project.

Don't make the biggest mistake that digital artists make. Don't forget to double back up your work!

Make two backups of your work at the very least. Keep a backup in a box in a safe, dry place. Keep one with you. You *will* lose your files. Your disk *will* eventually corrupt. Disks are easy to abuse—and they exact revenge. Once that happens, your competition three states away will be that much closer to getting your dream job. Protect yourself with double backups.

SUMMARY

Congratulations on making it through the introduction. You have absorbed some very important basic material. The interface is your map. If you don't know where you are going, you will get lost. You should also now understand how to pack your treasures away and take them with you.

Now close the book, and think about what you have learned. Play with the software, and do the tutorial again without referring to the book. Then answer the review questions and perform the homework exercises in this chapter.

in review

1. What are the four main modules in Maya Complete?

2. What keyboard entry is required with the left mouse button that allows you to rotate around in the Perspective view?

3. How do you turn on the display of different user interface elements?

4. What are the differences among Hierarchy, Object, and Component modes?

5. How do Orthographic and Perspective views differ?

6. How do you set up a project directory?

7. How often should you back up your work?

➤ EXPLORING ON YOUR OWN

1. Access the Help menu option to view introductory learning materials that are provided with Maya. Here you will find tutorials, a method of looking up unfamiliar terms, and learning movies.

2. View the Essential Skills Movies under Help/Learning Movies. They will help you learn the interface.

3. Work on the tutorials in addition to what you will do in this book. These tutorials can be found under the Help button.

4. Examine the Help file information pertaining to system and document preferences.

notes

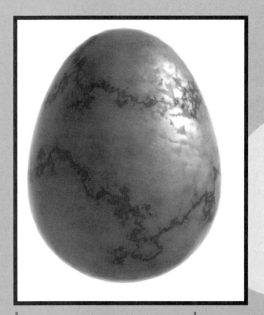

basic modeling overview

2

 charting your course

Now we begin our exploration of 3D space. You are about to learn how to sculpt objects by connecting points in space.

There are three different surfaces in Maya that you can use when you are modeling. (NURBS), polygons, and subdivisional surfaces. The three different surfaces each have a distinctly different method that is used when modeling with it. Traditionally each one was used for a different end product, but today the lines are blurring.

In the following chapters we will present an introduction to each method. You can then make your own choice as to which method is appropriate for your particular need. For now, learn a few basics that are used in all three modeling methods.

 goals

- To discover what 3D modeling is.
- To introduce you to the three surface modeling methods: NURBS, polygons, and subdivisional surfaces.
- To understand Hierarchy, Object, and Component modes.
- To learn the basics of creating and modifying primitives.

NAVIGATION

All of our tools for this chapter reside in the Modeling module (Figure 2–1).

figure

The Modeling module.

Before we move ahead, make sure your interface looks like that shown in Figure 2–2.

figure | 2-2 |

Display interface items.

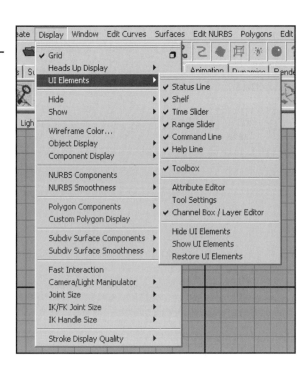

Go to:

Display > UI Elements

Make sure there is a check mark next to the features indicated in the figure.

THE BASICS OF MODELING IN 3D

Modeling in 3D can be a lot like modeling in clay.

Grab a ball of clay and roll it into a sphere (Figure 2–3). Pinch out a head with a neck, and pinch out arms and legs (Figure 2–4).

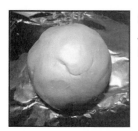

figure | 2-3 |

Ball of clay.

figure | 2-4 |

Clay as it is sculpted into form.

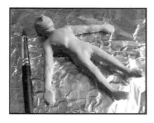

figure | 2-5 |

The clay figure emerges.

figure | 2-6 |

Details tell the story. (Sculpture by Patricia Beckmann.)

Now add details. Add arms and legs molded to identify a few muscle groups. For the head, smooth out the facial area and identify a chin and nose bridge. Smooth out the form of the main body. Your model should look like that in Figure 2–5.

Now add finer and finer details. Add eyes, fingers, and toes. Give your figure clothing. Add a briefcase, a pair of boots, or other accoutrements. Be creative with your details. Figure 2–6 gives an example.

Did you notice the process of construction? You began with a basic shape and pulled out the details from your clay. This is also one of many ways you may construct an object in 3D.

As a beginner in 3D modeling, you will most likely begin with a very simple shape. You will extrude the larger areas and then work on details.

WHY ARE THERE THREE WAYS TO MODEL IN MAYA?

(NURBS) stands for Nonuniform Rational B-splines and they have been used in high-end print and film work because of the smooth surfaces they generate when rendered. NURBS take considerable time to render but are very detailed. A particular type of modeling method that is often used when generating a NURBS surface is Patch modeling. This process involves stitching together square "patches" of NURBS surfaces into what looks like one solid surface.

Polygons are used in gaming because the number of polygons can be adjusted to the strength of the real-time game engine. The fewer polygons an object contains, the faster it renders into a visible object for a game. However, when modeling an object for a real-time engine using fewer polygons means less detail.

Subdivisional surfaces are a hybrid of both polygons and NURBS. The tools used when modeling a subdivisional surface are much like those of a polygonal surface. While the subdivisional surface is modeled similar to a polygonal surface it renders with the smoothness of

DON'T GO THERE

It is always a good idea to build a pre-visual of your project before opening up your 3D package. Drawings and sculpture allow you a hard reference, and they are faster to generate than those constructed with 3D modeling software.

On the job, you will need mock-ups and layout designs approved before you begin 3D production, so you had best get used to the process now. If you don't, you will lose many production hours, slowing down progress to the deadline and thus potentially losing you future work. Pre-visualization is the best communications tool available between the artist and client. It is a life preserver for avoiding costly errors.

Your art director or client will feel it necessary to give input no matter how perfect you feel your designs may be.

a NURBS surface. The subdivisional surface is very popular and has become useful in the same arenas as NURBS and polygon models. However, a subdivisional surface can make an animated character heavy and hard to move. Figure 2–7 shows examples of NURBS, polygons, and subdivision spheres.

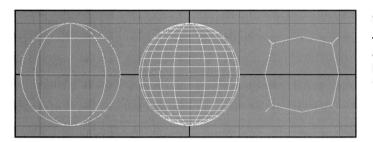

figure | 2-7 |

A NURBS sphere, a polygon sphere, and a subdivision sphere.

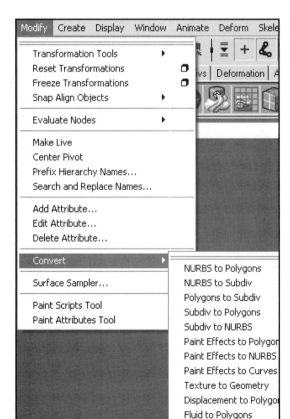

figure | 2-8 |

Convert box.

Any 3D object can be exported into any surface. I do not advise re-lying on this technique. The transfer creates problems. However, this ease of export allows you to use all of your favorite tools from each system and to export the object to suit your end purpose. Figure 2–8 displays the following conversion options:

- NURBS can be converted to polygons.

- NURBS can be converted to subdivisions.

- Polygons can be converted to subdivisions.

- Subdivisions can be converted to polygons.

- Subdivisions can be converted to NURBS.

Please note that polygons cannot be converted to NURBS.

We will experiment building with all three surfaces in this book.

THE CARTESIAN PLANE

The difference between two-dimensional (2-D) and three-dimen-sional (3D) objects is volume (also known as depth). Three-dimen-sional objects have width, height, and depth. This depth is

figure │ 2-9 │

Cartesian plane.

represented in space using the x, y, and z values defined in the Cartesian coordi-nate system (see Figure 2–9).

Imagine that as you sit in front of your computer you are actually sitting in a Cartesian coordinate system. You sit at the origin, where x, y, and z meet. This is also known as point (0, 0, 0). Your computer is one foot in front of you and three feet off the ground. Presuming that $x =$ the floor to your left and right, $y =$ up, and $z =$ the area in front and in back of you, your computer would be at (0, 3, 1) for (x, y, z).

In the past, you would have to know programming to create these points in space, but this is no longer 3D. A smart programmer created an interface called a graphical user interface (GUI) that allows non-programmers to create 3D models using icons instead of scripting. If you turn on the Curve tool and click within the Perspective view, you will be assigning points in space to mathematical values on the Cartesian plane. Before the advent of the GUI, you would need to

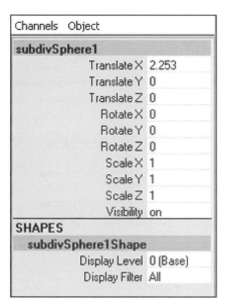

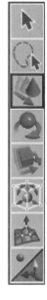

figure | 2-10 |

The Channel box and
the Tool box.

know a programming language. The programming language for
Maya is MEL.

The Channel Box (Figure 2–10) on the right of the GUI contains
the (*x, y, z*) values of your object. Using the Channel Box, you are
able to refine the volume and placement of your points in space.
You are also able to interactively do this using the tools in your
Tool Box.

HIERARCHY, OBJECT, AND COMPONENT MODE

These modes help you to edit your object. Depending on which
mode you are in, different editing tools are available to you. As an ex-
ample, consider that you have a bag of cookies. You pull one cookie
out of the bag. You bite off a chunk, and a crumb falls on the ground.
Hierarchy, Object, and Component modes operate much like this
bag of cookies.

In Hierarchy mode (the whole bag of cookies), you can take the en-
tire model and change its values as a whole. In Hierarchy mode, you
can scale the bag into a tall bag of cookies, a short one, or a very large

bag of cookies. The scale affects the bag, the individual cookies, and the ingredients all in the same way.

In Object mode (the cookie), you can take a part of the whole object and change its values without affecting the entire grouped model. You could pick one cookie from the bag and alter its placement, scale, or rotation without affecting the rest of the cookies in the bag or the bag itself.

In Component mode (the crumbs), you are affecting the values of ingredients of the object.

Click on each mode— Hierarchy, Object, and Component— and take note of how the icons change to the right of the mode.

Hierarchy Mode

Hierarchy is an organization of objects, a method of grouping. You will find yourself grouping objects into hierarchies to make assets more easily identifiable. These hierarchies can be seen in the Outliner window (Figure 2–11). When the hierarchy name is selected, everything grouped under it is selected.

figure | 2-11 |

Hierarchy mode.

Object Mode

An object is a single piece of geometry. A light, camera, or primitive sphere is an object (Figure 2–12).

figure | 2-12 |

In Object mode, you can affect single assets.

Component Mode

In Component mode (Figure 2–13), you can modify the parts that make up the object.

figure | 2-13 |

Component mode.

TOOLS

In this section, we will practice our new understanding of modes. We will pick an entire hierarchy, object, and component of an object. Once you understand modes, you can already model thousands of basic objects.

Open Maya. Make sure you are in the Modeling module and that you have turned on Four view, which allows you to see out of all four cameras at once.

Select the following:

Create > NURBS Primitive > Sphere

A NURBS sphere will appear at the origin. Whenever a new primitive is created, it appears at (0, 0, 0). If the object is selected, it turns green by default. When it is not selected, it is blue. These colors are by default.

Go to the Tool Box, and make sure the Move tool is selected. The object should still be green but now have arrows shooting in different directions (Figure 2–14). You can pull on the arrows with your left mouse button (LMB) held down to move the sphere. These arrows help you modify the of the selected objects or components. Select an arrow with your LMB. The arrow turns yellow. Hold down your LMB, and move the mouse right or left. The selected sphere follows.

Now, select the following:

Edit > Duplicate

This function makes a duplicate of your object by default. The new object is created exactly over the old one and is indiscernible as a

figure | 2-14 |

Sphere at origin and
its Transform
manipulator.

separate object. If you get confused, you can always look in the Out-
liner window and select your object. We will use the Transform tool
to move the copy off of original.

Select the red arrow, and move the duplicate copy off of the origi-
nal. You should now have two spheres in two separate locations,
as shown in Figure 2–15. If you are having trouble selecting one
sphere, select a sphere from the Outliner window and then move it
off of the original.

figure | 2-15 |

Duplicate spheres.

From one of the four panes, select the following:

View > Frame All

This will allow you to see your objects closer and use all of the real
estate on your desktop (Figure 2–16).

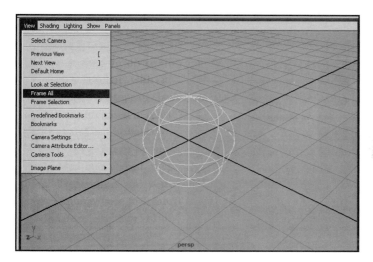

figure | 2-16 |

A framed object.

Open the Outliner window as follows:

Window > Outliner

Look in the Outliner window, and you will notice two NURBS objects named "nurbsSphere1" and "nurbsSphere2" (Figure 2–17).

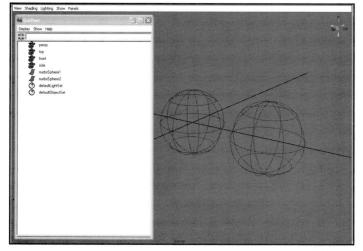

figure | 2-17 |

The two NURBS spheres in the Outliner window.

We will now group these objects into a hierarchy. Use the shift key and the LMB to select both spheres. Then, select the following:

Edit > Group

Look in your Outliner window. The Outliner should display "group1" with a plus sign next to it. Move your LMB over the plus

sign and left mouse click the plus sign. Underneath "group1" are the objects "nurbsSphere1" and "nurbsSphere2." The object "group1" is the parent of child "Sphere1" and child "Sphere2" (Figure 2–18).

figure | 2-18 |

Parent–child
relationship.

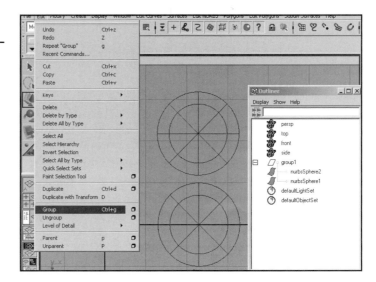

Rename "group1" to "bag." Do this by moving your cursor over the name "group1" in the Channel Box and left mouse click on the name to highlight it. Type over "group1" with "bag." Press Enter. You will see the new name in the Outliner box. You may also rename the "group1" object in the Outliner box using the same method. You will need to double click on the name in the Outliner box.

Give new names to the spheres. Call them "peanut" and "chocolate" (Figure 2–19).

Now, look at the top of the GUI and identify the hierarchy, object, and component selection tools. Select Hierarchy mode, and select the Select tool from the Tool Box.

Left mouse click on the "chocolate" sphere in the Front view window. What happens? Both spheres are selected, even though you only clicked on one. Next, left mouse click on the "peanut" sphere. The same thing, happens.

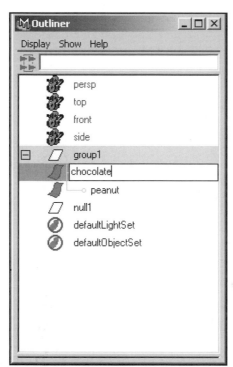

figure | 2-19 |

Renamed NURBS
primitives.

Now select Object mode, and left mouse click on the "chocolate" sphere in the Front view window. What happens? Only the "chocolate" sphere is selected. Click somewhere else onscreen to deselect before clicking "peanut." Select only the "peanut" sphere.

Now, select Component mode. Left mouse click on the "chocolate" sphere. What happens? The "chocolate" sphere is selected, but it looks different. It is light blue. And, depending on which tools in the row next to the Component button are selected, it could

figure | 2-20 |

Hierarchy, Object,
and Component
icons.

have purple *x*'s, squares, or lines all around it. These are the ingredients of your sphere.

We will now explore modifying the sphere.

First select Hierarchy, then select the Scale tool, and finally select both spheres. The Scale manipulator icon appears over the original sphere (Figure 2–21). It has four colored boxes: red, blue, green, and yellow. These reflect the *x, y,* and *z* coordinates of the object space. Look how these colors coincide with the Cartesian icon in the lower left corner of the camera window. Red is *x,* green is *y,* blue is *z,* and the yellow box represents all three coordinates.

This manipulator represents the position of the pivot. The pivot is like a thumbtack in the center of a piece of paper. When you spin the paper around the pushpin, it spins about the axis generated by the pushpin. Move the pushpin to a different area of the paper, and the paper spins about a different axis. The same thing happens with the pivot. Left mouse click on the red square, representing the scale value of *x,* and drag left. Notice how both spheres scale around the pivot.

We will now move the pivot.

With the spheres selected, press the Insert key on your keyboard. Notice how the manipulator changes to a small yellow box surrounding a circle. You may now select the pivot with your LMB and

move it over to the center of the other sphere. When you are done, press Insert again to regain your Manipulator tool (Figure 2–22).

The pivot in the center of the primitive sphere.

Now, select the Scale tool, and drag the red square again using your LMB. See how the spheres react differently? Move the pivot again. Select the *y* and *z* scale values and change them. Observe what happens when you move the pivot and use the Rotate tool.

Deselect by clicking anywhere on the screen. Select the Object mode. Left click on one of the spheres. Scale the object, move the pivot, and rescale the object.

The same thing can be done in Component mode. Make sure "select by Component type: points" is depressed while in Component mode (the square box), and use your LMB to select a group of the purple squares (Figure 2–23) by holding down the LMB and dragging over the group.

The pivot will be in the middle of the selected components. Any change to the pivot at the component level is not permanent. The pivot of selected components can also be adjusted by clicking in the viewport in the desired location with the middle mouse button. You first need to set up pivot settings in the preferences. At the top of the GUI, go to Preferences and then Setting Preferences (Figure 2–24). When the Preferences dialogue box opens, go to Manipulators, and,

under Component Manipulators, engage the Reposition Using
Middle Mouse Button field (Figure 2–25). Now you will be able to
move the pivot of the selected components by simply clicking with

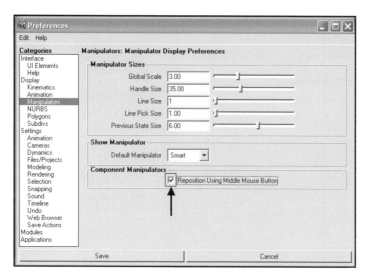

figure | 2-25 |

Preferences for manipulators.

the MMB in the viewport. With the LMB you can manipulate the control vertices by using the Translate, Rotate, and Scale tools.

A great deal of sculpting can be done with the Soft Modification tool (Figure 2–26), which is the sixth tool in the Tool Box.

Delete your sphere, and create a new one. It can be a NURBS, polygon, or subdivision sphere. The Soft Modification tool works on any surface type. Make sure the sphere is selected, and then click your LMB on the Soft Modification tool in the Tool Box. You can also select this option with the command (Figure 2–27):

Deform > Soft Modification

An S appears within a blue circle, with scale options. This symbol represents the new cluster you made on the object. This cluster is like a rubber band on a ponytail. The hair remains long, brown, and straight; however, the ponytail holder gathers it together in an organized fashion. A cluster does this to the points on a surface.

Now you can use your LMB to select the arrows pointing away from the S and sculpt the surface of the sphere (Figure 2–28).

figure

| 2-26 |

The Tool Box.

figure | 2-27 |

The pull-down menu
for Deform > Soft
Modification.

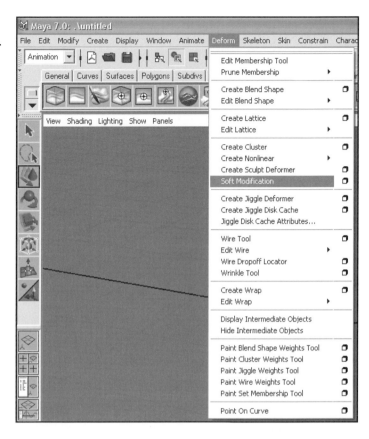

figure | 2-28 |

What soft
modification looks
like when applied.

By double-clicking on the Soft Modification Tool you can see the settings for it (Figure 2–29; pick up from 2–28)

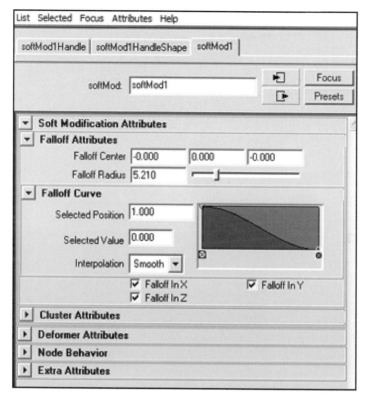

figure | 2-29 |

Attribute editor for the Soft Modification tool.

You can change the amount of falloff in the Fall Off curve box by clicking your LMB on the curve and moving your mouse. This affects how much of the object will be affected by the Soft Modification settings (Figure 2–30).

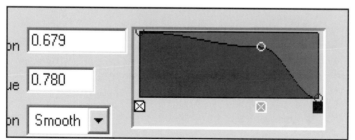

figure | 2-30 |

Curve editor for the Soft Modification tool.

An excellent way to organize your work in Maya is with layers. Layers work much like the layers in Photoshop. Objects organized into layers can be made invisible, grayed out, and used as a template while editing other objects, or rendered separately. You will find the Layers dialogue box at the bottom right-hand side of the GUI under the Channel Box.

Select all the geometry you have made, and press Delete on your keyboard.

We will now practice using layers. Create a group of spheres, and place them on separate layers:

Create > NURBS Primitives > Sphere

Edit > Duplicate > Options Box

Open the Duplicate Options box by clicking on the box next to Duplicate (Figure 2–31). Under Translate, change the *x* to 2 and change the Number of Copies to 3. Click "Duplicate."

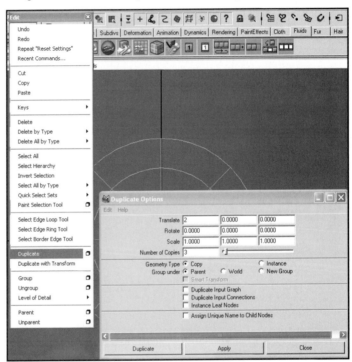

Look in the Outliner window (Window > Outliner). You will see four spheres listed (Figure 2–32).

Up until now, we have been looking at our model in Wireframe view. If we want an approximation of how the model will look rendered, we need a Shaded view.

In the Perspective window, go to the Shading pull-down menu (Figure 2–33) and select the following:

Shading > Smooth Shade All

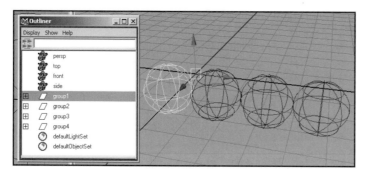

figure | 2-32 |

Original sphere and three duplicates.

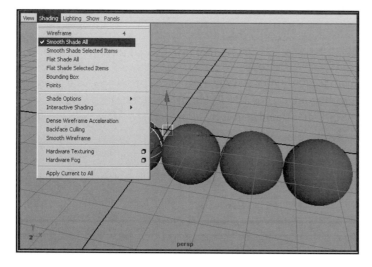

figure | 2-33 |

Shaded view.

Any object in the window will now have a gray surface, allowing you to see the modeling detail of the surface. When you want to go back to Wireframe view, go to the Shading pull-down menu and select Wireframe. You may also use a shortcut. Press the number 4 on your keyboard, and you will be in Wireframe mode.

MODELING FROM REFERENCE

Professional modelers start with concept sketches of the item they are responsible for creating. It is helpful to have these drawings scanned and brought into Maya for reference.

You will need a Side view of your model, a Front view, and a Top view (Figure 2–34). You will find images for the exercise on the enclosed CD. They are called model_front, model_side, and model_top.

figure | 2-34 |

Model Top, Front, and Side views. (Sculpture by Patricia Beckmann.)

Once you have identified your images, import them into Maya. We will do so by attaching an image plane to the camera. The camera controls the window you model in, so we are basically attaching an image-like wallpaper to the camera. Go to the View drop-down menu in the Front camera window (Figure 2–35).

View > Image Plane > Import Image

figure | 2-35 |

Import an image to the camera.

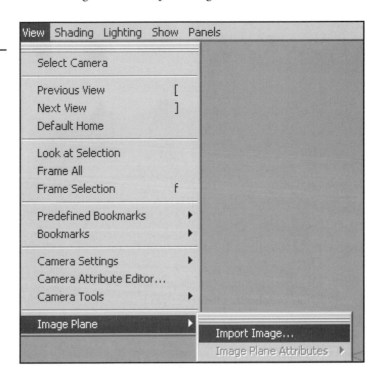

Locate your image in the locator box. Select the image, and press Open. You will find these images on the CD under Chapter 2.

The image will appear in the back of your window. You can now match the model against the measurements of the image. Side and Top views can be obtained similarly (Figure 2–36).

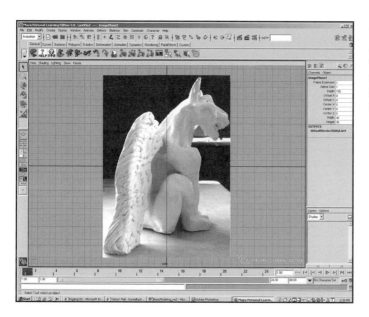

MODELING WITH PRIMITIVES

You created your first NURBS primitive when you created the NURBS
sphere. Check out what other primitives exist. There are primitives
available for each surface type (Figures 2–37, 2–38, and 2–39).

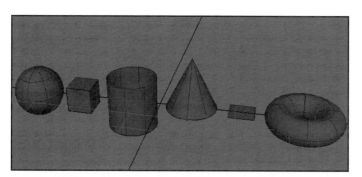

figure | 2-37|

NURBS primitives.

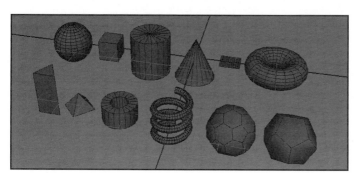

figure | 2-38|

Polygon primitives.

figure | 2-39 |

Subdivision
primitives.

!DON'T GO THERE

When you model, remember to save multiple versions of your file. Save them by giving a basic name to the file like "Ball." When you make significant changes to the file, denote a version. Follow this naming convention with a date or time:

Ball_v1_0204.ma (file: Ball, version 1 created on February 4, 2004)

Ball_v2_0210.ma (file: Ball, version 2 created on February 10, 2004)

You will find that mistakes happen, and if you do not have a previous version of the file to revert to, you may need to start over.

TUTORIAL:
MODELING AN AGATE GRIFFIN EGG

In our exploration tutorials, we will be creating a curiosity box. Curiosity boxes were made in the early nineteenth century to contain traveling museums of uncommon objects. They were boxes with many compartments. Each compartment would contain an element that told details about a larger subject.

Look up curiosity boxes on the Internet. You will find boxes on the subject of foreign animals, unusual plants, or freaks of nature. Say you had a box on elephants. Sample compartments would hold a picture of an elephant, a piece of tusk, an ivory carving, a piece of bone, a piece of elephant skin or hair, and possibly a copy of an elephant footprint. Each element proves the existence of the elephant and gives hard evidence of its size and texture to people who have never seen an elephant.

In our exercises, we will prove the existence of griffins. The griffin is a monster with the body of a lion, the head and wings of an eagle, a back covered with feathers, and a snake tail. People used to make drinking cups out of its huge claws. It builds a nest out of gold and lays an agate egg. Griffins love and collect jewels and shiny objects, amassing large treasure troves that they guard fiercely. In classic mythology, griffins were guardians of Scythian gold treasures, and, in Greece, they were the guardians of godly treasures. The Arimaspians were a one-eyed people of Scythia who hunted the griffin and tried to steal its treasure. Much more information is available on the griffin; research it to find more details and ideas.

The following objects for the curiosity box will be created in the exercises:

- a curiosity cabinet to hold items

- an agate egg

- a talon cup

- a one-eyed helmet

- jewels

- a plaster footprint

- an old picture of a griffin

- objects that you dream up and model using the tools you have learned in this text

We will texture and light these objects for a professional presentation.

For your own portfolios, choose your own subject. Be exotic—in 3D you can make anything you want.

In your portfolio, never include exercises you did from a book. Anybody can follow an exercise, and doing so will not impress a future employer. You need to follow the tutorials to learn tools, but then you need to access your own creativity and use the tools to produce something you yourself have inspired.

DON'T GO THERE !

figure | 2-40 |

Agate egg.

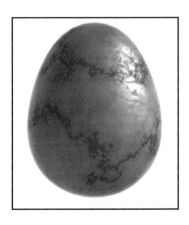

Our first project will be to model an agate griffin egg (Figure 2–40). Select the following (Figure 2–41):

Create > NURBS Primitives > Sphere

A sphere will appear at $(0, 0, 0)$ — this is the origin. Now, select the following:

View > Frame All

Frame the entire sphere in your window. Look in the Outliner window for the new object you created, and rename it "Egg" (Figure 2–42).

Switch to Component mode. Your sphere will turn blue. Now that you are in Component mode, you have access to the tools to the right of the Component mode. These are the different ingredients you may alter. Select the first tool, the square icon. Depressing this icon will allow you to work on several component-level attributes. You can see what these are by right-clicking on the square icon (Figure 2–43).

Purple squares now cover the sphere. These are control vertices. These can all be moved using the Move tool. Moving these will reshape the surface of the object.

figure | 2-41 |

NURBS sphere.

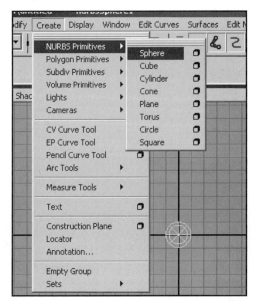

figure | 2-42 |

Rename "Egg."

figure | 2-43 |

How to reach the
NURBS control
vertices.

With your LMB, select the top four rows of control vertices, as
shown in (Figure 2–44). LMB hold and drag to select. Use the Front
window view. If you use Perspective view, you may select the wrong
control vertices.

figure | 2-44 |

Select four rows of
control vertices.

figure | 2-45 |

Scale manipulator
and box handles.

Now, select the Scale tool. Your manipulator is now made of three boxes, which represent the *x, y,* and *z* scale of the control vertex group (Figure 2–45). Push and pull on these boxes to see what they do. When you are done, press down and hold Ctrl on the keyboard, and push the Z key. This undoes your last command.

Keep pressing Ctrl + Z to undo all the commands until you are back to the original selection.

Select the red box on the scale manipulator with the LMB, which represents the *x* scale value, and move the box to the left. The top part of the sphere should be getting smaller. Look in the other windows. The egg appears to be forming in the Front window, but it appears lopsided in the other windows. The situation is depicted in (Figure 2–46). The lopsidedness occurs because you are only squashing the object in one scale value. In the Top window, select the blue square, and move it down toward the center of the sphere. This squashes the sphere control vertices in the *z* scale. You now have the basic shape of an egg (Figure 2–47).

Notice that you need to use all your windows when you model in 3D. What looks correct in a Front view may not be correct in the Perspective view. You may have selected too many objects in one view and not know it until you checked your work in the Top view, only to discover that you now have a lopsided object.

We will now use another Component mode tool: Select Hull (Figure 2–48).

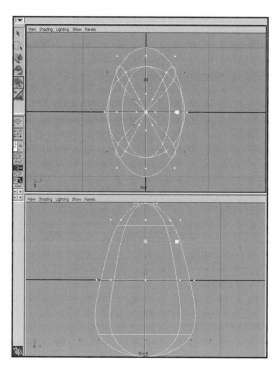

figure | 2-46 |

With the *x* value of control vertices (CVs) moved inward, the Front view is fine, but the Top view is lopsided.

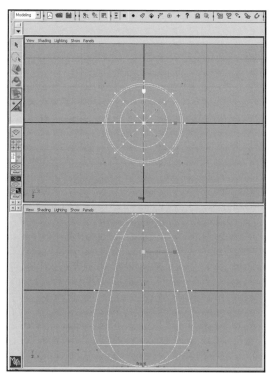

figure | 2-47 |

With the *z* value of CVs moved inward, the sphere is now an egg in all views.

figure | 2-48 |

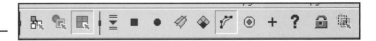

Component level:
the Select Hull tool.

Hulls are groups of control vertices that lie on the same line. Now, instead of picking a purple square (control vertex), select one of the lines. All of the control vertices that make up that line will be selected. When you use the Scale tool, it affects all of these vertices as a unit. Select the center square of the Scale tool and all of the CVs uniformly move in. Select the hull near the bottom of the egg. Scale it in a little bit (Figure 2–49).

figure | 2-49 |

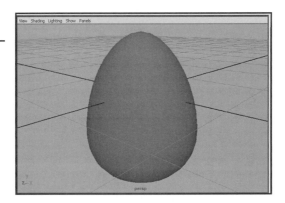

Hull selected and
scaled in a little bit,
in Shaded mode.

Turn off the Hull tool, and turn on the CV tool in the Component mode.

Select and pull the top four rows of CVs down a little by selecting them and moving them down toward the bottom of the egg using the Translate tool (Figure 2–50).

figure | 2-50 |

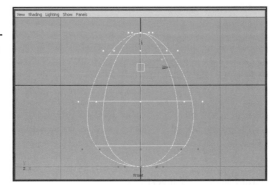

Top four rows of CVs
selected and
translated.

The model gets more precise depending on how many control vertices add information to the surface. Having too many control vertices

makes an object heavy and requires a great deal of time and processing to render. With too few control vertices, the object lacks detail.

You now have an egg shape.

If you would like to add more vertices to an object so that you can create more detail, you will need one more tool.

In Component mode, select by component type "lines" (Figure 2–51). With this preference, you can now select the lines that make up an object. By selecting a line and duplicating it, you are actually creating new control vertices, which then create that line. These CVs can then be modified.

In Component mode, select by component type "lines."

Select a line of the egg, and a red line will appear. With the LMB held down, reposition the line. Once you release the left mouse button the line will become a broken yellow line (Figure 2–52).

figure | 2-52 |

Selected line turns yellow.

Now, select the following (Figure 2–53) and press Enter:

Edit NURBS > Insert Isoparms

This creates a new line on the surface. Look at it in component level, and you will see several move control vertices.

Save this object in your Scenes folder. We will add texture and color to it at a later time.

figure | 2-53 |

Edit NURBS > Insert
Isoparms.

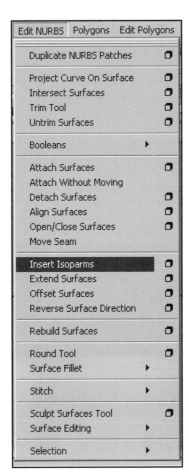

THE CREATIVE PROFESSIONAL

Your demo reel shows not only your command of the tool set but your creativity. Anybody can learn Maya, but not everyone can think creatively. The difference between a demo artist and an animator, lighting director, cinematographer, or texture artist lies in artistic method. A demo artist is highly skilled with the tool set: He or she is a problem solver aware of each tool and its application. The others are highly skilled in artistic theory and application. Demo artists do not need to know how to draw; the others do. Think about who you want to be, and pursue your training accordingly. Each position is necessary and respected, but you have to be the best to get somewhere. This book is geared for the creative professional who can draw and wants to use Maya as another "pencil" to make that drawing.

Although this was a simple project, its intent was to introduce you to some necessary tools in a low-stress exercise. With the tools you have just learned, you can already model anything you want in NURBS—from a room to an organic character. However, it will take you a long time. The more tools you learn, the quicker you will become. The tools you learned in this chapter—Scale, Translate, Import Image, the various modes—will pertain to every surface. Tools beyond these specialize to which surface you are working on. Try all three, and choose your favorite.

SUMMARY

All of these objects are like the balls of clay we worked with at the beginning of the chapter. You may begin a model with a primitive and then sculpt the model by modifying, inserting, and deleting components. When you are done modifying the parts, you then group them into the desired object. When you want to go back and edit, it is useful to have items on separate layers so that you can turn items on and off when they are in your way.

in review

1. What is the Cartesian plane?

2. What are the three modeling surfaces available in Maya?

3. What kinds of primitives are available for each modeling surface?

4. What are the three modes mentioned in this chapter, and why are they necessary?

5. How does the manipulator change when you switch from the Translate tool to the Scale tool?

6. How do you import an image?

7. When you duplicate an object, where does the duplicate object appear?

8. What is the Outliner window?

9. What can you select in Component mode?

10. How do you add more control vertices to a surface?

▶ EXPLORING ON YOUR OWN

1. Bring in a primitive, and make objects to fill a simple room. Make a couch, a chair, and a table. You should be able to do everything with the tools you learned in this chapter provided that you are using NURBS.

2. Bring in a torus, and build a simple chain.

3. Draw a picture, scan it, and save it on your hard drive. Bring it in as a camera background and try to model against it.

notes

ADVENTURES IN DESIGN

ACHIEVING A FRESH LOOK

The art world is an untapped resource for some digital artists. The current trend is reality modeling and animation. The next trend may be a style like anime.

Digital art requires taking control of the software and pushing it to do what you want it to do instead of letting the default controls rule you. It is no longer sufficient to know every button in the software; you must be able to understand how to create a style using the tools available. You must learn to adapt different styles to your work if you want to be considered for the high-level jobs.

Go to art galleries and find an artist you like. It is a tough assignment to re-create someone else's style—but a daily requirement for employed artists. Try comic book art, cartoons, museum paintings and sculptures, or cool furniture. Try your hand at emulating the texture, lighting, color palette, and mood.

Artist Gary Baseman gave my students the generous offer to digitally re-create his artwork. Gary is the creator of *Teachers Pet*, a Saturday morning cartoon created by Disney. He is also a very well-regarded illustrator and painter. Students chose paintings from Gary's Web site and created 30-second animations based on their interpretation of the painting.

Istvan "Steve" Stecina chose the painting shown in Figure A–1. He then used

A-1 Gary Baseman painting of dogs.

this image as a reference for the image shown in Figure A–2. Steve's animation is included on the book's CD.

A-2 Steve Stecina interpreting Gary Baseman in 3D.

Eric Evans and Ryan Yokley used the painting shown in Figure A–3. They also have an animation on the enclosed CD. An image from it is shown in Figure A–4.

A-3 Gary Baseman painting of a cat.

A-4 Eric Evans and Ryan Yokley interpreting Gary Baseman in 3D.

Jonathon Shaw chose to emulate the way Baseman does ducks. Baseman's ducks look like the one shown in Figure A–5. John created an animation in this style (Figure A–6).

Marty Clayton chose images from the *Modulus Popularis* series (Figure A–7).

He ended up creating a three-faced image dancing to the tune of "A Lion Sleeps Tonight." Figure A–8 shows a sample image.

Here Kwame Hawkins created an experimental animation using 'Nippleman' (Figure A–9).

Everyone who completed a project ended up with something fun and gorgeous to watch.

A-5 Gary Baseman painting of a duck.

A-6 Jonathon Shaw interpreting Baseman ducks in 3D.

A-7 Gary Baseman created *Modulus Popularis* with artist Mark Ryden. It is a series of interchangeable character parts.

A-8 Marty Clayton image from a digital *Modulus Popularis*.

A-9 Kwame Hawkins re-creates nippleman.

Project Guidelines

1. Search the Internet for a favorite artist or go to libraries, galleries, and museums. Obviously, don't plan on reprinting or using any artwork for profit unless you have the original artist's permission.

2. Scan the artwork so that you have a digital reference.

3. Create textures in your favorite painting program similar to the textures found in the art reference. Create separate textures for each prop. Or, create the texture by painting or sculpting and then scan that surface into a 640 × 480 image. The size of this image you create for a texture depends on the size of your output image and the amount of detail you want to see.

4. Sketch your objects and characters from the front, left side, and top— and attach these images to your cameras (see the discussions in Chapters 2–5).

5. Model the objects using a modeling method of your choice.

6. Pose the models and light them (see Chapter 7).

7. Assign the textures to materials in Maya (see Chapter 8).

8. Move the camera to create a nice composition (see Chapter 6).

9. Render an image (see Chapter 9).

Things to Consider

This project is just to introduce you to the wild world of alternatives to realism that you have out there. With enough of these types of projects under your belt, you will be able to create an arsenal of artistic tools to create unique 3D designs and characters.

- Copyright issues forbid you from re-creating another artist's work and profiting from it without his or her permission.

- Look at textures and backgrounds in art. Bring in painterly patterns or sculpted textures to add depth to your work. Don't rely on default textures supplied in Maya.

- Create a few artist-inspired images for your portfolio to show how you will treat designs given to you by a prospective employer.

| polygon modeling |

3

 charting your course

Polygons have been traditionally used in game graphics because they render quickly. We will explore polygons and their components in this chapter. Then we will do several small exercises using the different tools available. We will create a helmet for our one-eyed warrior using these tools at the end of the chapter.

 goals

- To understand the components of a polygonal object.
- To practice polygonal editing tools on the primitive object.
- To create and edit polygonal surfaces.

NAVIGATION

All of our tools for this chapter reside in the Modeling module (Figure 3–1).

figure | 3-1 |

The Modeling module.

WHAT ARE POLYGONS, AND HOW DO I USE THEM?

Polygons are also known as faces. They are typically three- or four-sided planes. These small shapes make up a surface like tiles in a mosaic. Like a mosaic, the larger the tiles are, the less detail is in the painting. Using smaller tiles gives more detail, but this also creates more work for the person creating the mosaic! You have a choice as to how many polygons to use in an image. Using more polygons means it takes more time to render.

As game engines get stronger, different mathematical calculations are used to decide the number of polygons to use per object. If you use many objects in a scene, fewer details per object are available, whereas the opposite is true for scenes requiring fewer objects.

Maya converts NURBS to polygonal objects before rendering, but these are tens of thousands of polygons. To see your poly counts, use the following:

Attribute Editor > **Tessellation** > **Advanced Tessellation**

You have no real control over the number of polygons generated by NURBS modeling. Polygon modeling allows you to decide the "heaviness" of your model before sending it to render. By using the Heads Up display in Maya's main GUI, you can keep track of how many polygons your model has at all times. Simply go to Display > Heads Up Display > Poly Count. You will notice that a readout of the number of vertices, edges, faces, tris, and UVs that are contained

in your scene file will display in the top left-hand side of the active viewport (Figure 3–2).

Polygons are made up of vertices, edges, and faces (Figure 3–3).

figure | 3-2 |

Heads Up Display.

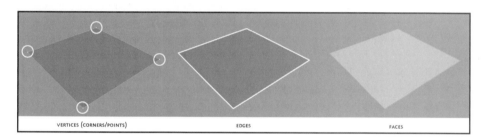

| VERTICES (CORNERS/POINTS) | EDGES | FACES |

figure | 3-3 |

Polygon attributes.

Each of these components can be manipulated just like its NURBS counterparts. Select an edge, face, or vertex by clicking your right mouse button (RMB) over the surface of the polygonal object. A marking menu appears (Figure 3–4). This marking menu is a menu of additional tools available. From this menu, choose Vertex, Edge, or Face. These components can then be manipulated using any of the tools.

figure | 3-4 |

Polygon marking
menu.

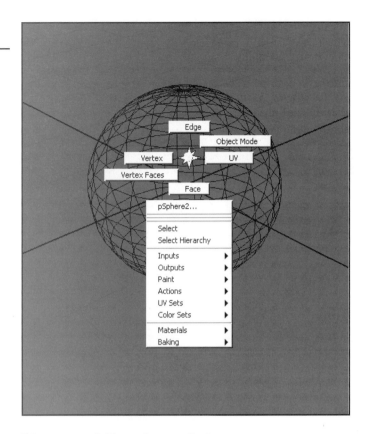

Planar and Nonplanar Polygons

Planar means that all the points lie on one plane. A triangle polygon is always planar because three points define a plane. Planar polygons are preferable to nonplanar polygons because nonplanar polygons can create shading errors.

A polygon is nonplanar if it has more than three vertices and if any one of those vertices is not in the same plane (Figure 3–5).

Drawing a Polygon

With NURBS, you draw a curve to create a NURBS surface. Since you are trying to create a polygon, you need to learn how to draw a face. You cannot use a curve tool to draw a polygon.

To draw a face, use the following:

Polygons > Create Polygon Tool

Make sure your options in the Polygon Tool Options box look like those in Figure 3–6; pick up from 3–5.

figure | 3-5 |

Nonplanar polygons.

figure | 3-6 |

Create Polygon Tool
Options box.

Click your left mouse button (LMB) somewhere in your Front view
window, and place a point. Place another point nearby and then a
third in a counterclockwise fashion. Press Enter, and you have a tri-
angular surface. Most polygons will have three or four edges, though
you can build them with as many sides as you want. From this sur-
face you can extrude edges or faces, split the face for finer detail, or
delete a surface and make holes. From this small three-sided surface,
you can build any object you want using the tools described in the
next section.

By consistently drawing your polygons in a counterclockwise fashion, you will ensure that they all point in the same direction and that their normals face in the direction of the view you are working in.

TOOLS

We will be learning an array of tools for the following tutorial. There are many more tools available; these you can explore when you become more proficient.

Here are the main tools we will use:

● Edit Polygons > Extrude Face, Extrude Edge

This set of tools pulls out new polygons from existing faces or edges.

● Edit Polygons > Duplicate Edge Loop Tool

This tool lets you cut in edge loops around a selected edge within your model's geometry.

● Edit Polygons > Split Edge Ring Tool

This tool lets you select and cut a semi or complete edge ring within your model's geometry.

● Edit Polygons > Split Polygon Tool

This tool splits a face into multiple faces by drawing boundaries across the face.

● Edit Polygons > Cut Faces

This splits all faces along a cut line.

● Edit Polygons > Merge Vertices

This tool is used to merge vertices that are within the tolerance distance of each other.

● Edit Polygons > Merge Edge Tool

This tool lets you merge edges by clicking them.

● Display > Custom Polygon Display

Use this tool to control the display of polygons and polygon components in the view panels.

- Polygons > Average Vertices

This tool smoothes the polygon mesh by moving vertices.

- Edit Polygons > Fill Hole

Use this tool to create a face to fill a closed border edge.

Edit Polygons > Extrude Face, Extrude Edge

By extruding faces or edges, you can pull new polygons out from existing faces or edges (Figure 3–7).

figure | 3-7 |

Extruded edges from a polygonal plane.

First, create a polygon cube as follows:

Create > Polygon Primitives > Cube

In the Camera view, select the following:

View > Frame All

In Perspective view, click your RMB on an edge of the cube to reveal the pull-down menu, and select Face (Figure 3–8). Blue squares appear in the center of each face. These can be selected and pulled, much like what you did with the control vertices when working with NURBS.

Click your LMB on one of the small blue squares in the center of the face. The face will be outlined in orange if selected. Choose your Move tool and the move manipulator will appear. Pull one of the arrows, and see what happens to the cube (Figure 3–9). The box

figure |3-8|

RMB pull-down
menu.

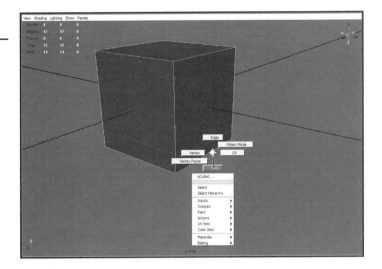

figure |3-9|

Changing the shape
of the box.

changes shape. If you prefer, you can select a polygonal face by click-
ing anywhere on it versus clicking on the blue dot in the center of
the face. First, you must adjust your preferences in the GUI. Go to
Window > Settings/Preferences, and in the Preferences dialogue
box under Selection, Polygonal Selection, engage the Whole Face
option (Figure 3–11). Now you will be able to select a polygonal face
by LMB clicking anywhere on it.

To select an edge, click your RMB on one of the edges of the cube
and select Edge from the pull-down menu (Figure 3–10). Left mouse

clicking on an edge will select it. Once your edge is selected, go to the following:

Edit Polygons > Extrude Edge

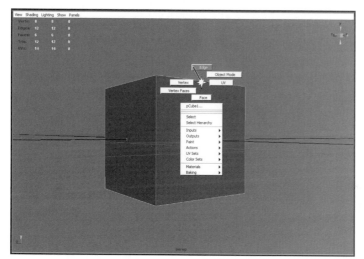

figure | 3-10 |

Settings/Preferences.

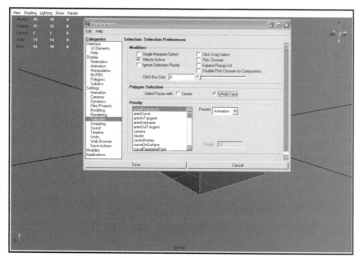

figure | 3-11 |

Pull-down menu.

A manipulator appears. Notice that all of the tools–Translate, Scale, Rotate–are represented on this manipulator. Notice also the small blue bull's-eye on the edge of your manipulator. This *magic circle* (Figure 3–12) allows you to change from local to world axes.

figure | 3-12 |

The magic circle.

What is the difference between world, object, and local space?

Objects in 3D exist with *x,y,z* coordinate systems called spaces.

World space is the coordinate system for every object in the scene. It is one universal reference point at the center of the scene—also known as (0, 0, 0). Think of how planets (objects) revolve around the sun (0, 0, 0).

Object space is the *x,y,z* coordinate system from an object's point of view, the object as it rotates around its own pivot. It is like the earth in the aforementioned universe swirling on its own center of gravity.

Local space uses the origin and axes of the object's parent node in the hierarchy of objects. This is useful when the object is part of a group that is transformed.

Both extrude operations allow you to "pull" geometry out of the primitive object, much like you would pull arms and legs out of a clay ball when making a figurine. Once you extrude, this new edge can be lengthened by using the Move tool.

Edit Polygons > Duplicate Edge Loop Tool

This tool will allow you to duplicate existing edge loops within your model's geometry.

In the Perspective window, create a sphere by going to Create > Polygon Primitives > Sphere. Next, in the Perspective window go to

View > Frame All, and finally hit the 5 key to Smooth Shade the Sphere (Figure 3–13).

figure | 3-13 |

Smooth shaded sphere.

Select the following:

Edit Polygons > Duplicate Edge Loop Tool

Make sure the option box for the Duplicate Edge Loop tool looks like Figure 3–14.

figure | 3-14 |

Options box for Duplicate edge Loop Tool.

Once you have activated the tool, simply LMB click and drag on an edge within the sphere. You will notice that the edge turns an orange color and two dotted green lines immediately appear around it.

By clicking and dragging with the LMB, you can adjust the position of the two new edge loops which surround the previously selected edge (Figure 3–15).

figure | **3-15** |

New edge loops.

Once you release the LMB, the edge loops are cut into the sphere's geometry as shown in Figure 3–16.

figure | **3-16** |

Edge loops cut into the surface.

Edit Polygons > Split Edge Ring Tool

This tool allows you to cut a series of connected faces that make up an edge ring within your object's geometry.

In the Perspective window, create a sphere by going to Create > Polygon Primitives > Sphere. Next, go to View > Frame All in the

Perspective window, and finally hit the 5 key to Smooth Shade the Sphere (Figure 3–17).

figure | 3-17 |

Smooth shaded sphere.

Select the following:

Edit Polygons > Split Edge Ring Tool

Make sure the options box for the Split Edge Ring tool looks like Figure 3–18.

figure | 3-18 |

Option box for the Split Edge Ring Tool.

Once you have activated the tool, simply LMB click and drag on an edge within the geometry of the sphere. You will notice that the selected edge turns an orange color and a dotted green line appears within the faces that make up the edge ring (Figure 3–19).

New edge ring.

Once you release the LMB, the dotted green line is cut into the faces of the sphere's geometry creating a new edge ring as shown in Figure 3–20.

New edge ring cut
into the surface.

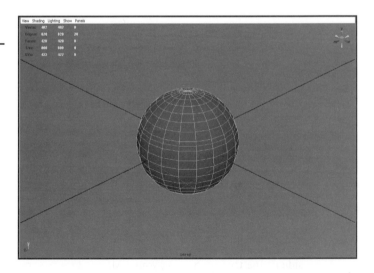

Edit Polygons > Split Polygon Tool

This tool allows you to split a face into multiple faces, done by drawing boundaries.

The following presentation shows you how to you create details. A sample screen shot is shown in Figure 3–21.

figure | 3-21 |

Split Polygon tool used on a flat plane.

Let's create a cube. Create > Polygon Primitive > Cube. Select the following:

Edit Polygons > Split Polygon Tool

Make sure your options box looks like that shown in Figure 3–22.

figure | 3-22 |

Split Polygon Tool Options box.

Select one side of the face by clicking your LMB. A green square appears on the edge. Select the opposite side of the face with your LMB. A green square surrounded by a yellow box appears. Press the RMB to complete the operation. Your face has split in two, as shown in Figure 3–23.

figure | 3-23 |

These faces can now be extruded using the previous Extrude Face and Extrude Edge tools.

Edit Polygons > Cut Faces

The Cut Faces tool splits all faces along a cut line. This allows you to cut objects in half, no matter how many faces are on the surface.

You must first have part (Component mode) or all (Object mode) of an object selected to use this tool. Create a Polygonal Cube, and select it while in Object or Component mode. Select the following:

Edit Polygons > Cut Faces

Make sure your options box looks like that shown in Figure 3–24.

figure | 3-24 |

Select an edge of the object with your LMB. While holding down your mouse button, pull away from the object. A thick black line appears. This thick line will act as a knife along the object. When the thick line is in an acceptable position, let go of the mouse button. Notice all of the new faces cut into your object (Figure 3–25).

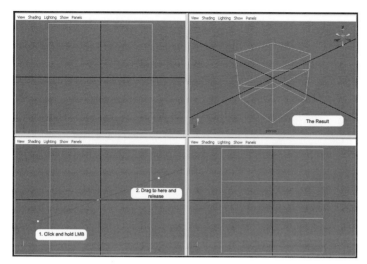

figure |3-25|

Cut Faces tool in action.

Edit Polygons > Merge Vertices

This tool merges vertices that are within the tolerance distance of each other. Use this tool to close holes in a surface or to bind a surface together.

Create a polygonal plane. In Component mode, click your RMB and select a face. Delete one face using your Delete button. You should end up with a hole as shown in Figure 3–26.

figure |3-26|

A hole in the surface.

Now switch to vertex (in Object mode, RMB to bring up the menu and select Vertex) (Figure 3–27). Make sure you are in Shaded view.

figure | 3-27 |

Component type:
Points tool.

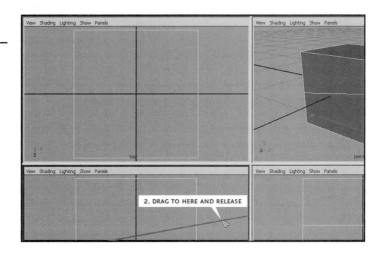

Select the four vertices surrounding the hole (Figure 3–28). LMB drag or use Shift + select. Select the following:

Edit Polygons > Merge Vertices

figure | 3-28 |

Four vertices
surrounding the
hole.

In the Merge Vertex Options box (Figure 3–29), the Distance value should be set to a value greater than 0. (Initially, try small values such as 0.25.) Click the Apply button. If the vertices do not merge, increase the Distance value by 0.25–0.50. Click the Apply button again. If the vertices still do not join together, increase the distance in the options box until they do.

figure | 3-29 |

Merge Vertex
Options box.

You should always take care not to set the Distance value any higher than it needs to be to merge your target vertices; otherwise, you risk merging points you might not intend. For example, if you model half of a character's head and then want to mirror and merge the halves, you could use the Combine tool to make the two halves one object, then select all the vertices making up the edge between the two halves, and then use the Merge Vertex tool to weld them together. In this case, you want to merge corresponding points on each half; if you set the Distance value too high, you may collapse the geometry around the edge by merging points with their neighboring vertices in addition to the corresponding ones you intended. Work with small decimal increments when using this tool.

Your polygons should end up looking like those shown in Figure 3–30.

figure | 3-30 |

Closed surface.

Edit Polygons > Merge Edge Tool

The Merge Edge tool lets you merge edges by clicking them. These edges must be on the same polygonal object.

If you wish to combine the edges of two separate surfaces, you must first combine the objects. To do this, select both surfaces and then use the following tool:

Polygons > Combine

Both surfaces will act as if they are one object.

Create a polygonal plane (make sure the subdivisions are set to 1×1 in your options box), and duplicate it. Place the duplicate next to the original (Figure 3–31).

figure | 3-31 |

Duplicate surface planes.

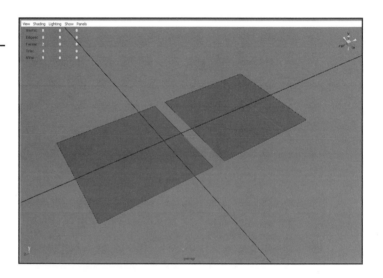

Combine the two objects.

Now let's try out the tool. Right mouse click on the surface and select Edge from the pull-down menu (Figure 3–32). Go to the following:

Edit Polygons > Merge Edge Tool

Make sure your options box looks like that shown in Figure 3–33. Your cursor turns into a hollow arrow. Pick two edges that are close to each other. Press Enter. The merged edges should end up looking like those in Figure 3–34.

figure | 3-32 |

Edge in pull-down menu.

figure | 3-33 |

Merge Edge Tool Options box.

figure | 3-34 |

Merged edges.

Display > Custom Polygon Display

This tool is very useful for getting important information about your models. It allows you to tell Maya how to display polygon objects so that you can easily identify the underlying structure and

figure | 3-35 |

Custom Polygon
Display tool options.

problem areas in a polygon object (Figure 3–35). Important features you should be aware of are:

● Objects Affected: Either Selected or All can be picked. This will determine whether the changes you make in this tool are applied only to the objects selected or to all the polygon objects in the scene.

● Highlight > Border Edges: When checked, a thicker line will appear in areas where there is an open hole or edge on the mesh. Often, if a tool like Append Polygon or Smoothing doesn't function the way you might expect, there may be holes in the mesh you are not aware of. Turning on this feature will quickly show you if such a problem area exists.

● Face > Normals: When checked, you will see the normals (indicated by a dotted line sticking out from the center of each face) for a polygon object. In general, you want all the normals in an object pointing in the same direction (outward). Sometimes, either in the process of modeling or when importing objects from other programs, you can have all the normals reversed (pointing inward) or nonuniform normals where some point inward and some point outward. The latter can cause some modeling tools to fail or appear to perform incorrectly. Turning on this option will give you a quick visual way of determining if there are any issues with the normals of an object.

● Backface Culling: When on, this causes polygons whose normals are pointing away from the camera to be not visible. This can help keep your view of a model cleared because it will hide polygons on the backside of objects.

You can access much of the same information that the Custom Polygon Display gives you by using the Attribute Editor function. Simply select the object, and hit ctrl + A. This will display the Attribute Editor. At the top of the Attribute Editor, you will notice a series of tabs. Left mouse click on the second tab, which is the shape node of the object. Once you have selected shape node, you will see a list of attributes with arrows to the left of them. Left mouse click on the arrow next to the set of attributes labeled Mesh Component Display. This will display much of the same information for the selected object that was just covered in the Custom Polygon Display (Figure 3–36).

figure | 3-36 |

Attribute Editor.

Polygons > Average Vertices

The Average Vertices tool allows you to smooth the polygon mesh without adding additional geometry. It is an advanced smoothing tool that will average the position of the vertices in the mesh by an amount determined by the Iterations value in the Average Vertices Options box (Figure 3–37).

figure | 3-37

Average Vertices
Options box.

Basically, if you have a surface with oddly placed vertices and you want to "soften" or "relax" the surface, this is one tool you could use.

Edit Polygons > Fill Hole

Use the Fill Hole tool to fill a closed border edge.

Create a sphere, and delete a couple of faces. Now, select the border edge you want to fill (Figure 3–38). Shift + select each edge of the border until the entire rectangle is highlighted. Select the following:

Edit Polygons > Fill Hole

figure | 3-38

Sphere with border
edge selected.

figure | 3-39 |

Sphere with hole filled.

The result should look like Figure 3–39.

Be careful when choosing this method. This creates a multifaceted poly that will not save rendering time and could cause some texturing issues.

SMOOTHING

When modeling with polygons, the general practice is to work on a low-resolution version (i.e., one with fewer faces or vertices than the final model will have) and use some method of smoothing to increase resolution for the end product. This can be achieved by a number of methods in Maya, namely the Smooth tool, Smooth Proxy, and Subdivision Surfaces. The procedure is similar for each. The following will briefly discuss the Smooth tool and Smooth Proxy. Subdivisions will be handled in a later chapter.

Polygons are geometrical shapes made up of vertices (corners), faces (shaded area inside the vertices), and edges (lines between the vertices). When modeling, you will switch among Vertex, Face, and Edge component modes (accessed by right-clicking on the model and selecting the desired mode on the marking menu) with the various polygon modeling tools.

You should approach your modeling by first blocking out rough shapes with exaggerated features, much as you might in sculpture or drawing. You should gradually model in detail as you go, but leave the features exaggerated because whatever method you use to

smooth the final model, the details will be reduced. To understand this, it is useful to think of the CV Curve tool and how it works. When you draw a curve with the CV Curve tool, two things happen: First, the curve does not flow through the CV points you create; rather, it averages them and creates a curve that flows inside the points. The second thing you will notice is that the closer together the points are in the curve, the closer the curve gets to those points and the shape they create. The various polygon smoothing methods work in a similar fashion, although in three dimensions. In essence, the polygon becomes a "cage" for the smoothed geometry in the same way NURBS objects have a cage associated with them. (To see this, create a NURBS sphere and switch to Hull component mode.)

Therefore, when building your low-resolution polygon model, keep the detail in smooth areas low and increase it where you want edges or finer detail in the geometry. Figure 3–40 shows some examples.

figure | 3-40 |

Edge placement
effect on smoothing.

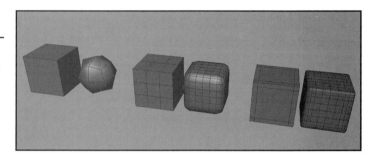

In general, it is a good procedure to use only four-sided polygons (quads). Quads will smooth the most evenly and predictably. Three-sided polygons (triangles) and N-sided (with $N > 4$) should be used sparingly. Triangles can be used in some circumstances to create detail; you will need to experiment and look at other artists' work to get the hang of when to use them.

In addition, you should attempt to have the form of your polygons follow the form of the surface you are attempting to create. What does that mean? In the case of anatomy, the polygons should logically follow the underlying musculature and bone structure. For example, the muscles in the face are formed in loops around the eyes

and mouth; your polygons should mimic those loops (Figure 3–41) both because it will be easier to get a believable form and because it will deform better when animated.

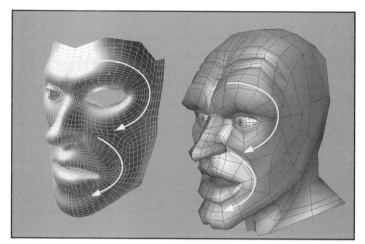

figure | 3-41 |

Edge loops.

The Smooth tool has a couple of important attributes:

- Continuity: This setting controls how much the Smooth tool will average out the geometry (with 1.0 equating to completely smooth and 0 equating to no smoothing). Figure 3–42 gives an example.

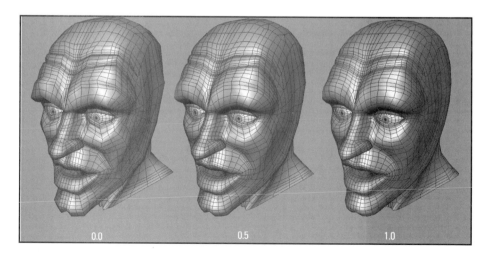

figure | 3-42 |

Effects of continuity setting.

● Keep Border Edges: This can be useful if you need to have openings on your model that retain their initial shape (or not). An example might be a car window—you would want to retain the shape and corners for the opening but smooth the rest of the geometry. This setting is either on or off.

The Smooth Proxy tool is basically an automated script that will duplicate your model, put the two copies on separate layers, and smooth one. The meshes will be linked so that anything you do to the low-resolution model will update in the high-resolution one, including modifying and adding new geometry. Maya will also make the lower-resolution version slightly transparent to make seeing the effects on the smoothed mesh easier. The smoothed mesh has all the same settings available in the Channel Box as if you had directly applied the Smooth tool. This can be useful to see the immediate results of your actions rather than having to smooth and undo each time you want to see the effect.

One final technique worth mentioning is a way to maintain symmetry in your model as you modify it (i.e., editing the vertices on the right side of a head model and having the matching vertices on the left side mirror the change). Using a character head as an example, you would look at the model from the Front view, switch to Face component mode, select all the faces to the right of the center axis, and delete them.

Switch back to Object mode, open the Duplicate tool's options panel, and reset the tool's settings. In the case of a head, set the geometry type to Instance and the x scale to -1.0. Click Duplicate, and you have what appears to be a full head again (although you actually have one model that is referenced by two transform nodes). As you modify and add geometry to one-half, the other will reflect the change.

Two other aspects are worth noting in regards to this method of symmetrical modeling. First, the two halves are not joined, so smoothing will show a crease on the center axis. Second, it is possible to build unwanted geometry inside the model at the shared edge when using the Extrude tools. Experiment, and be aware of these things so you can pick a workflow that works best for you. When you finish your model, delete one-half and then use the Mirror Geometry tool to mirror and merge the model.

TUTORIAL: MODELING A HELMET

Using the tools found in the Polygons and Edit Polygons menus, you will model the helmet pictured in Figure 3–43.

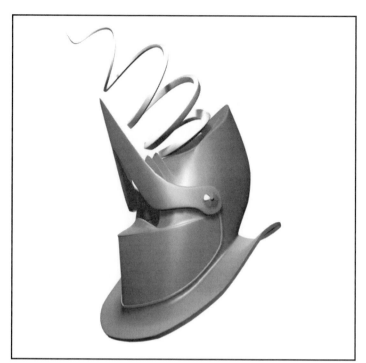

figure | 3-43 |

Finished helmet
model.

For many people, polygons allow for a slightly looser, more intuitive
mode of working than NURBS do. This tutorial will rely on only a few
of the Polygon tools (Extrude Edge, Extrude Face, Duplicate Edge
Loop, Split Edge Ring, Split and Merge Vertex, Append Polygon,
Smooth, Split Polygon, and Cut Faces) along with the standard Move,
Rotate, and Scale transform tools to achieve the desired end product.

First, make a polygon cube at the default settings (Figure 3–44).

figure | 3-44 |

Basic cube.

Switch to Vertex component mode, and, using the Move and Scale tools, modify the shape of the cube as shown in Figure 3–45.

figure | **3-45**

Reshaped cube.

Switch to Face component mode, and select all the faces that make up the cube by clicking and dragging a selection box around the faces. With the faces selected, use the Cut Faces tool to cut two lines through the sides of the cube as shown in Figure 3–46.

figure | **3-46**

New faces cut into cube.

With the faces still selected, vertically cut in additional lines in the Front and Side views through the center of the cube as shown in Figure 3–47.

Detail added with Cut Faces tool.

Go to the following:

Polygons > Tool Options

Make sure Keep Faces Together is checked (Figure 3–48). Keeping this setting checked ensures that when you extrude a group of adjoining faces, they will form a single unified surface rather than a separate extrusion for each face.

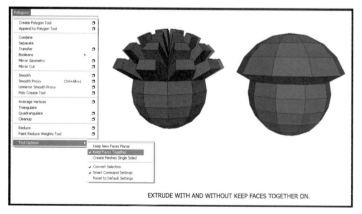

Keep Faces Together effects.

Select the faces on the bottom of the object, and use Edit Polygons > Extrude Face three times. As you extrude each new set of faces, switch modes in the Extrude tool and use the Scale option so that, when completed, your shape looks like the one in Figure 3–49.

figure | 3-49 |

Three extrusions.

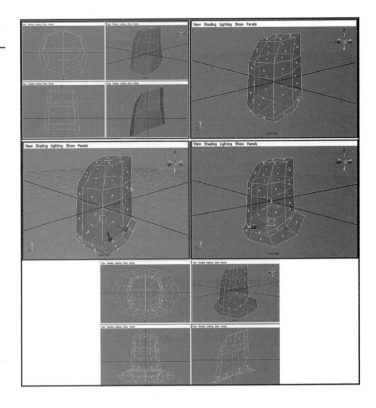

Extrude the bottom faces three more times to make a rim for the shoulder area. Delete the bottom faces. Then, switch to Vertex component mode to tweak the points so that your object looks like that shown in Figure 3–50. Notice that the shoulder area now has a curve so that it looks like it would more snugly sit on someone's shoulders.

Selecting the faces in the eye area, activate the Extrude Face tool. Instead of moving the new faces, use the Scale option to scale the new faces inward and downward. Then use the Move option to move them slightly forward. Figure 3–51 shows the result.

Switching again to Vertex component mode, drag the vertex on the front centerline below the eye area outward as indicated in Figure 3–52. Now, select the faces that are on the front lower half of the model (except the shoulder area). This may be easier if your display mode is wireframe or shaded with the X-ray option turned on. Using the Cut Faces tool in the Side view, cut a new row of polygons by dragging the tools cut line parallel to the existing polygon edges at the top of your selection (Figure 3–53).

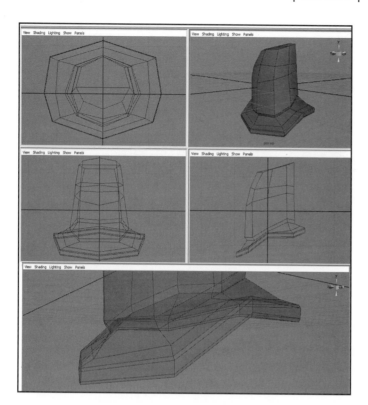

figure | 3-50 |

More extrusions.

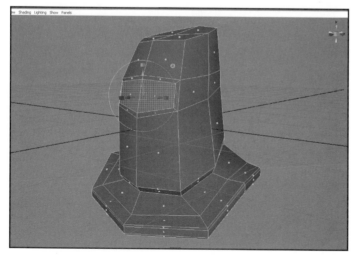

figure | 3-51 |

Roughing out the eye area.

Next, select the vertices on both sides of the model that are at the back end of the line you just created as well as the ones immediately above them. Select the following:

Edit Polygons > Merge Vertices (dialogue)

figure | 3-52 |

Reshaping the
helmet.

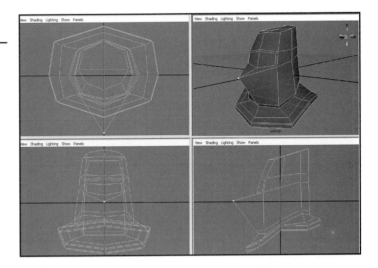

figure | 3-53 |

Adding geometry.

Set the tool's Distance value to 0.14, and click Merge Vertex. You
should now see one vertex where there were previously two (on each
side; see Figure 3–54).

Next, you are going to use the Split Edge Ring tool to cut in an
additional row of polygons through the entire model just slightly
below the last ones you cut. Go to Edit Polygons > Split Edge Ring
Tool. With the tool engaged, select an edge below the faces that you
just cut on the front lower half of the model. A ring of edges will
highlight orange, and a green dotted line will appear indicating
where the new edge will be cut. By holding down the LMB and sliding

figure | 3-54 |

Merging vertices.

your cursor up and down the selected edge, you can adjust where the new edge will be cut in (see Figure 3–55).

figure | 3-55 |

Cutting additional polygons.

From the Side view and using the Cut Faces tool, cut a vertical line between what would be the ear area and the eye area. When complete, tweak the new vertices from the Front and Side views so that the mesh continues to develop the proper curvature. The results should look like those in Figure 3–56.

Continuing in Vertex component mode and using the Move and Scale tools, tweak the points in the eye area to match the image shown in Figure 3–57.

figure | 3-56 |

Refining the shape.

figure | 3-57 |

Refining the eye
area.

Select the two faces that make up the eye area. Using the Extrude Polygons tool, extrude the faces inward three times (the first and third time moving only slightly inward to maintain a sharper edge around the opening. Delete the selected faces to create an opening (see Figure 3–58). When repeatedly using the same tool in Maya, you can speed your workflow by either pressing the "g" key or using the Hotbox > Recent Commands to reselect the tool. When complete, hit the Delete key to remove the faces blocking the hole.

figure | 3-58 |

Extrude three times to build opening.

Now that most of the basic geometry for the helmet is in place, you will use a new technique for manipulating the shape of the helmet. With this new technique, you do not have to worry about selecting matching vertices on both sides of the model, nor will you have to be as careful with the Move and Scale tools so as not to throw the model out of symmetry.

Switch to the Front view and activate the Face component mode. Select all the faces on the left side of the face by click dragging with the Select tool from the upper left to the centerline of the helmet. Press the Delete key to delete the faces.

You should now have half of the helmet. If there are any faces remaining on the left side, select and delete them. To ensure that the vertices at the center edge fall at 0 on the X axis, turn on the grid snap, select the center vertices from the Front view, and move them

slightly using the X manipulator (red arrow). All the points will snap to zero.

In Object mode, open the options panel for the Duplicate tool. Reset the tool, set the *x* scale value to −1.0, and set the Geometry Type to Instance. Click Duplicate. You should now have an entire helmet again.

Now, select a vertex on one side of the model, and move it around. The matching point on the other side should move in a mirror fashion. We did not do this earlier because of the Extrude Polygon tool. Because your helmet is in fact two halves that are separate entities in Maya (although they are linked by the instancing), the Extrude tool would have created additional geometry inside at the centerline.

From now on when you move vertices or cut or split polygons, the other half will get updated, reflecting the changes.

Set your active view to Side view. Cut in lines from the rear vertical edge of the side polygon indicated in Figure 3–58 to the center of the eye area (including the inner edges of the eye hole) by selecting the polygons and using the Cut Faces tool. Tweak the vertices with the Move and Scale tools so that they look similar to Figure 3–59. Be sure to turn off Snap to Grid.

figure 3-59

Refining detail.

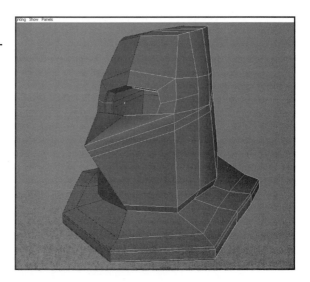

Notice that the helmet pictured at the beginning of the tutorial (Figure 3–43) is stylized in a worried expression. You will now begin the process of adding geometry and tweaking the vertices to make that happen.

Using the Cut Faces tool, cut a line as in Figure 3–60. Using the Move tool, move the vertices above the eye to look like Figure 3–61.

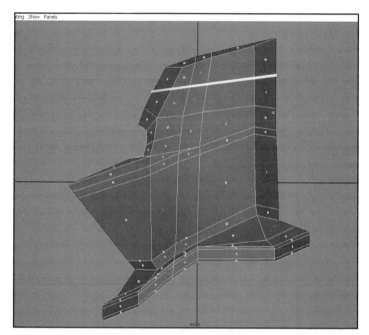

figure | 3-60 |

Cutting another row of polygons.

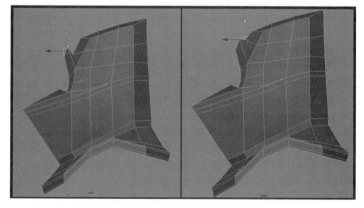

figure | 3-61 |

Reshaping the eye area.

Open the options panel of the Split Polygon tool, and then reset the tool. Set the Snap To Magnets to 10 and the Magnet Tolerance to 100. The snap magnet value divides the edge of the polygon you are cutting into equally spaced points that the tool will snap to, the number of which is determined by the value you set (with a minimum of

0 and a maximum of 10). The Snapping Tolerance controls how strongly the tool will try to snap to those points, with 0 being not at all and 100 being unable to do anything but snap to those points. Getting your cut lines to go where you want them, especially if you are working in Perspective view, is a nice feature.

Cut an additional line like that shown in Figure 3–62. If you make a mistake, use the Delete key to back up and redo your cut.

figure | 3-62 |

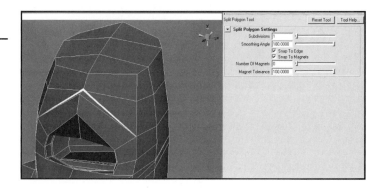

Splitting polygons.

The next few steps show an example of how you can rework the topology of the geometry to better suit your needs.

Looking at the forehead area of the model, you see that you have a few triangles (Figure 3–63). Triangles are acceptable in your particular geometry, but, in general, you want to work with quads whenever possible. Triangles can cause creases or pinching in the

figure | 3-63 |

Triangles in forehead area.

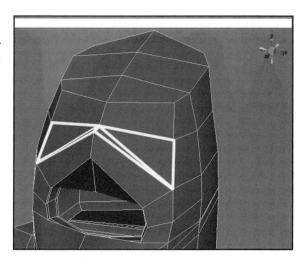

geometry when smoothed, which is fine if that is the desired effect. In this case, one set of the triangles is fine, but the other set would better suit your needs if they were quads, as shown in Figure 3–64.

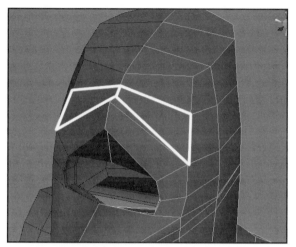

figure | 3-64 |

A better
configuration.

Switch to Vertex component mode. Select the point at the centerline of the model where the two upper triangles meet (Figure 3–65). Select the following:

Edit Polygons > Split Vertex

figure | 3-65 |

Selected vertex.

Switch to Edge component mode. Now click on the center edge of the quads directly above where you split the vertex (Figure 3–66). Make sure you have not accidentally selected any edges on the back side of the model by rotating your view.

Selected edge.

Use the Move tool to move the edge slightly upward and backward (Figure 3–67). Select the deviant triangle, and delete it by pressing the Delete key (Figure 3–68).

Moved edge.

figure | 3-68 |

Deleted triangle.

Next, select the following:

Polygons > Append to Polygon Tool (dialogue)

Reset the tool, and then unclick Ensure Planarity. Now click on the lower and upper edges of one side of the hole, as shown in Figure 3–69.

figure | 3-69 |

Appended polygon.

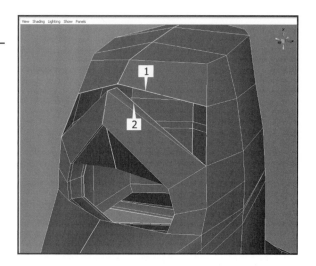

Now, select the vertices at the center edge of the new polygons by click dragging them (again, being careful not to accidentally select any vertices behind the model; see Figure 3–70).

figure | 3-70 |

Selected and merged vertices.

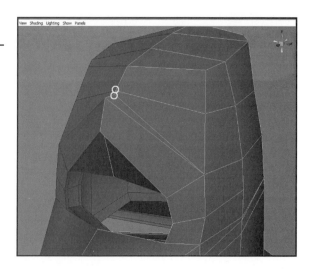

Select the following:

Edit Polygons > Merge Vertices (dialogue)

Make sure the Distance setting is 0.010. You generally require some distance in this setting to make sure the vertices merge, but too much may cause unintended vertices to merge. Hit Apply.

Select the following:

Display > Custom Polygon Display (dialogue)

Set Objects affected to All, and, in the Edges section, check Highlight Border Edges. Click Apply and Close. If your vertices did not merge, you will see highlighted edges similar to those in Figure 3–71.

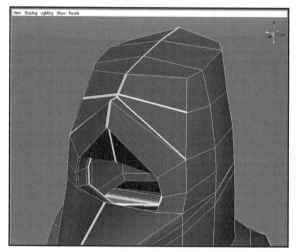

figure | 3-71 |

Border edge highlighted.

Remember, the two halves are not merged, so there should be a highlighted edge running through the center where the two halves meet. However, there should not be any horizontal edges highlighted. If this occurs, reselect the vertices, increase the Distance value in the Merge Vertices tool in tiny increments (values below 1), and reapply the tool until the thick border lines disappear. Once the vertices are all merged, you may wish to reset the Merge Vertices tool.

Using the Split Polygon tool, cut in edges as shown in Figure 3–72. Now move the center vertex of the upper edge upward (Figure 3–73). Next, select the polygons, and use the Cut Faces tool as shown in Figure 3–74. Select the vertices shown in Figure 3–75. Open the Merge Vertices tool's options panel, and increase the Distance value to 0.10. Click Apply. Your model should look like the one shown in Figure 3–76. If it does not, try increasing the Distance setting by 0.05, and try again.

figure | 3-72 |

Creating additional
detail.

figure | 3-73 |

Tweak the point
upward.

The upper geometry you just created will ensure a sharper edge in that area when smoothing. The geometry you removed by merging the vertices in the middle-rear area of the model eliminated the excess, unnecessary geometry that might create creases or bumps in the model later. Remember, edges that are close together help to retain edges and detail in the geometry when smoothed. In the middle of a large, smooth area like the back of the helmet, that is not necessary. Close edges are retained in the front to help maintain the edge you have created.

figure |3-74|

Cut faces.

figure |3-75|

Selected vertices.

Reopen the Custom Polygon Display options panel, uncheck Highlight Border Edge, and click Apply.

Since all the geometry is now in place, you can tweak the vertices with the Move tool to more closely resemble the final shape (Figure 3–77).

Create two new display layers. Name one "base" and the other "mask." Select both halves of the helmet, and add them to the base layer. Select the faces shown in Figure 3–78.

figure | 3-76 |

Model with vertices
merged.

Select the following:

Edit Polygons > Duplicate Face

You should now have a duplicate copy of the faces you selected as a separate model. Move the new geometry to the mask layer (Figure 3–79).

Shut off the base layer. Extrude the faces on the mask layer and then reshape them as in Figure 3–80. Once you have done that, extrude the faces again to create an edge for the front part of the mask.

Move the points on the centerline of the mask slightly outward on the X axis, and then delete the faces that were created on the centerline when you used the Extrude tool. Switch to Object mode, and duplicate the geometry with the Geometry Type set to Copy and the X value set to −1. Once complete, select both halves and use Polygon > Combine to make them into one object. Use the Append Polygon tool to close the gap between the two halves (front, top, and bottom). The appended polygons are shown in Figure 3–81.

Next, you will make a hinge object for the mask. Make a new layer, call it "hinge," and make it the active layer. Select the following:

Create > Polygon Primitives > Cylinder (dialogue)

Create a cylinder with the following settings:

● Radius: 0.05

● Height: 0.125

figure | 3-77 |

Reshaped model.

- Subdivisions Around Axis: 12
- Subdivisions Along Height: 3
- Subdivisions on Caps: 0
- Axis: X

Click Create.

figure | 3-78 |

Selected faces.

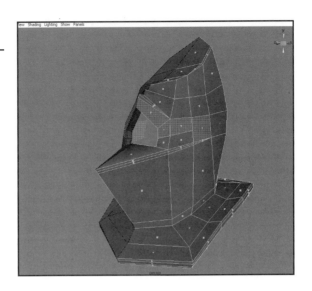

figure | 3-79 |

New mask geometry.

A note about the Subdivision on Caps value: Setting this number to zero creates one face for each of the top and bottom caps of the cylinder. A value of 1 would divide the caps up into triangles that

figure | 3-80 |

Reshaping mask and
extruding faces.

figure | 3-81 |

Appended polygons.

would match the Subdivisions Around Axis value. Try it to see the
difference.

Tweak the vertices with the Move tool to look like Figure 3–82. Then
use the Extrude Face tool to create a new end cap, slightly moving it

figure | 3-82 |

Making the hinge.

out and uniformly scaling it in a bit. Finally, delete the opposite end cap (negative X side).

Next, using a polygon cube primitive as a starting point, use the Extrude Face tool and the Move tool in Vertex component mode to create the shape shown in Figure 3–83. Position it relative to the cylinder object as shown. Make sure you do not actually move the cube or cylinder in object mode, just reshape them by moving the vertices and faces in component mode. You want the pivot points for each to remain at 0, 0, 0. If this is a problem, you can turn on grid snap, select the Move tool, press the Insert key, and move the object's pivot point to the grid origin (0,0,0).

Parent the new object to the cylinder object by selecting Edit > Parent. Name the object you just created "leaf1" by double-clicking on it in the outliner and entering a new name. Rename the cylinder "hinge 1."

figure | 3-83 |

Creating additional geometry.

Select the leaf object you just created and open the Duplicate options panel. Reset the tool, and then use the following settings:

- Translate: 0, 0, 0

- Rotate: 72, 0, 0

- Scale: 1.0, 1.0, 1.0

- Number of copies: 4

- Geometry Type: Instance

- Group Under: Parent

Click Duplicate.

You now have copies of the original, but these are linked so that Maya does not have to keep several copies in memory and so that whatever changes you make to one of the copies will be applied to all of them. Select one of the leaf models. Open the Smooth Tool Options box, and reset the tool. Set the Subdivision Levels to 2, and click Smooth. You should have results similar to Figure 3–84.

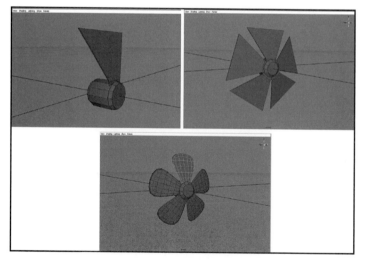

figure | 3-84 |

Creating hinge detail.

Select the hinge, move it up to the positive X side of the mask, and rotate it so that it appropriately sits on the geometry. When you are satisfied with the position, group the hinge assembly to itself to create a new pivot point at 0, 0, 0. Open the Duplicate Tool Options panel, and reset the tool. Set the x scale value to minus 1.00 and the Geometry to Instance. Click Duplicate, and you should have a copy of the hinge on the other side of the mask (Figure 3–85).

figure | 3-85 |

Duplicate hinge.

We will create a horn for the helmet. To prepare the drawing for the horn, you need to model a place for the horn to sit on the helmet. Following the series of images in Figure 3–86, you will create the area for the horn.

First, select the two faces shown, and delete them. Select all the edges around the hole except the front ones. Use the Extrude Edge tool and the Move and Scale options to bring the edge in as shown. (Click on the bull's-eye icon on the upper right of the tool widget, switching it to Local space to get more predictable results.) Extrude a second time and move the edge downward. Select the edges shown, and use the Collapse tool to remove the edges. Select the vertices shown, and use the Move and Scale tools to reposition the vertices back where they were originally. Finally, use the Append Polygon tool to fill the hole.

The last major item on the "to build" list is the horn. You will recall that the horn shown in the image at the beginning of the chapter is a sort of bent-corkscrew type of object. There are several ways to approach this. The easiest way is to use the Extrude tool in the NURBS tool set. This is, however, the polygon modeling chapter, so you will take a slightly different route. You will still need to create some "guide" geometry using the NURBS tool set after which you will use Maya 7's Extrude Face on Path option.

Before you get started, make sure History is turned on.

Switch to the four-view layout, and create a new display layer called "base_curves." Make it the current layer.

You may wish to create a template or reference to the other layers so that you do not accidentally select or modify them during this part of the tutorial.

First, you will need to draw a CV curve that will act as the basic vertical shape for the horn (think of it as a backbone). Make sure the

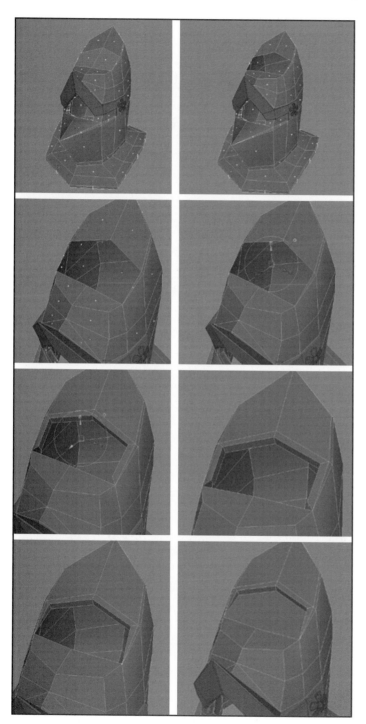

Steps to make base
of horn.

CV Curve tool's Curve Degree is set to 3 Cubic. Draw a curve in the side view similar to Figure 3–87.

figure | **3-87**

Create backbone curve.

Next, set the CV Curve tool to Linear, and draw a second curve as shown in Figure 3–88.

figure | **3-88**

Create section curve.

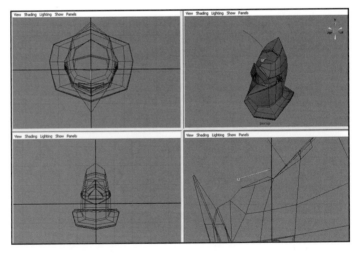

Select the short curve first, then the longer curve, and then open the following:

Surfaces > Extrude (dialogue)

Set the tool up as follows (Figure 3–89):

- Style: Tube
- Result Position: At Profile
- Pivot: Closest End Point

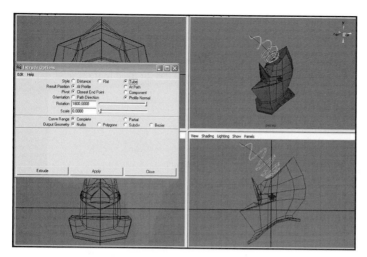

figure | 3-89 |

Extruded curve.

- Orientation: Profile Normal

- Rotation: 1800.00

- Scale: 0.00

- Curve Range: Complete

- Output Geometry: NURBS

Click Extrude.

Your shape may vary slightly because it depends on the way you created the first "backbone" curve. Experiment until you get a result you like.

Create a new display called "guide_curves," and make it the current layer. Switch to Isoparm component mode, and select the outside edge of the spiral (Figure 3–90).

Use the following:

Edit Curves > Duplicate Surface Curve

Create a new duplicate curve. Shut off the base_curves layer. You should now just have the spiral curve, as shown in Figure 3–91.

Create a new display layer called "profile_polygons," and make it active. Create a polygon plane with the following settings (Figure 3–92):

- Width: 0.2

- Height: 0.2

figure | 3-90 |

Selected isoparm.

figure | 3-91 |

Spiral curve.

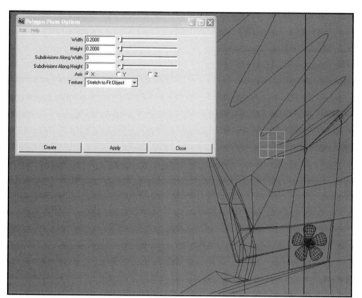

figure |3-92|

Polygon plane.

- Subdivisions Along Width: 3

- Subdivisions Along Height: 3

- Axis: X

Move it to the base of the spiral curve in the Side view.

Reshape and then rotate the vertices to get the profile shape of Figure 3–93.

figure |3-93|

Reshaped polygon plane.

Switch back to Object mode and, with the polygon plane you just created selected, select Modify > Center Pivot to make sure the pivot is positioned properly.

Create one last display layer called "horn_geometry," and make it current. Select the profile polygon geometry you just made and the spiral curve. Open the Extrude Face tool's options panel (Figure 3–94). Make sure all settings are reset. Then, in the Other Values Section, make sure Use Selected Curve for Extrusion is checked, Taper is set to 0, and Divisions is 90. Click Extrude Face. You should now have a horn similar to the one in of Figure 3–94.

figure | 3-94 |

Extruded polygon on curve.

You created a dependency between your current shape and the geometry you created by turning on History before starting this part of the tutorial, which is one interesting byproduct of turning on this feature. Try reshaping the backbone curve, the original profile curve, or the spiral curve to see what happens. This is a handy option to think about before you start modeling if you want maximum flexibility to tweak your model's shape later. This type of model would be impossible to tweak easily in the ways you currently can if the dependency between the current geometry and the original curves is not maintained.

You should also do any additional tweaking of the geometry that you feel will help convey the character of the helmet. Remember, you need to exaggerate the low-resolution version of the model since the Smooth tool will average out the mesh. If you place your vertices where you want the final geometry to fall, you will be disappointed as your features will be less pronounced when you smooth.

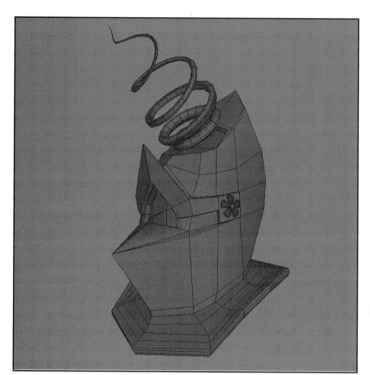

figure | 3-95 |

Final model.

Figure 3–95 presents the final version of the low-resolution geometry.

You will notice some additional trim geometry the author created by using the Duplicate Edge Loop tool and then separating the resultant geometry. (You have to separate it; otherwise, it will not smooth properly.) Some unique materials have been applied to the geometry to distinguish one part from another.

Finally, once your helmet is complete, you should smooth your geometry. Using the Smooth tool, smooth the following objects with the following settings.

For the base (helmet) and any trim you create:

- Subdivision Method: Exponential

- Subdivision Levels: 2

- Continuity: 0.65 (to maintain a bit more of the character of the low-resolution model)

- Smooth UV'S: On

- Keep Geometry Borders: Off

- Keep Selection Borders: On

- Keep Hard Edges: Off

- Keep Tessellation: On

For the mask, all the settings are the same except Continuity, which is set to 1.0.

You could smooth the horn with one subdivision if you like (or you could have created it with more divisions in the Extrude Face tool when you created it).

Do not apply any additional smoothing to the hinges.

The final smoothed helmet is shown in Figure 3–96.

Of course, you are free to experiment with your own settings. If History is on, you can change the tool settings any time you want in the Channel Box by selecting the PolySmoothFace input and scrolling down to the tool settings (which only appear when you select the input) at the bottom of the Channel Box.

SUMMARY

You now have had a chance to use much of the Polygon tool set in a practical exercise. You have also seen how NURBS tools and objects can be used in some situations to construct polygon objects when they offer a better method for getting the job done. Remember that we started with a basic cube, which we gradually refined and added detail to until we had our final model. You should now have the basic skills and understanding to begin modeling more complex objects on your own. Good luck!

in review

1. How do you pinch out extra geometry from a primitive?

2. How do you create a detail in a primitive?

3. How do you fill a hole in a primitive?

4. What is the difference between modeling in NURBS and modeling in polygons?

▶ EXPLORING ON YOUR OWN

1. Use Extrude Edge to build a 3D box from a plane.

2. Build a hammer using the Maya tutorial under the Help menu in Maya. You will learn a few additional tools.

3. Import an image, and model against it. Try creating a simple object like a coffee cup.

4. Model a simple wooden chair with a seat cushion.

5. Model a dinner set (fork, spoon, knife, and plate).

6. Model a teddy bear.

7. Model a spiral-corkscrew-wine-bottle opener.

notes

ADVENTURES IN DESIGN

MAKING A MAQUETTE FOR 3D MODELING

When building a 3D model in Maya, knowing as much about your subject as possible is required to create an accurate likeness. Photos and sketches are often used as reference in modeling. Another method used by many is building a *maquette*—a real-world 3D model from clay or some other substance—prior to starting a model in Maya. This is particularly useful if you are building a character or object that doesn't exist in the real world. The advantage of having an object you can hold in your hand and examine cannot be understated. You will have an understanding of your surface from creating it in three dimensions that you won't ever quite achieve in sketches. Further, you can photograph your maquette from the top, front, and side views and use them as image planes in Maya for reference as you model. (This helps prevent inconsistencies among views that might arise with hand-drawn images.)

Recently, when I was investigating character designs for a project, I decided to develop one of the characters with Sculpey (a kind of polymer clay) in addition to drawing sketches. I had tried modeling the character in question from an early sketch (Figure B–1) but was unsatisfied with the results.

B–1 Original character sketch.

I realized I needed to investigate the form more and thought that working with some clay in my hands might be

the best method to do so. If you aren't familiar with it, Super Sculpey is a type of clay that can be purchased in most art stores and can be baked in a regular oven. It can be further sanded and etched after firing. Depending on your needs, you may have to create an armature skeleton from wire to support your model.

After playing around a bit, I came up with a more exaggerated version of my character that I found to be much more satisfying (Figure B–2).

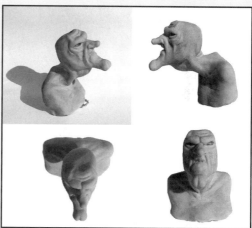

B-2 Sculpey model.

Having the form clear in my mind from just having physically built it, I was amazed at both how quickly and how much better the new model came together when I sat down in front of Maya with the sculpture in hand. I not only had a model in my hand that I could rotate to compare to my perspective view in Maya, but I had a much more intuitive sense for where and how to lay out my geometry. Views of the model in progress are

shown in Figure B–3. Figure B–4 shows the final version.

Since then, this method of modeling has become a part of my process whenever it is applicable. This is also another good way to present ideas to clients prior to the time investment of modeling and, it may save time and money if you are or become proficient at building models this way. Finally, for me, it brought back some of my traditional art training in the process and has led to a more rewarding way of working. It may not be a technique that everyone will enjoy, but you should give it a try and see if it works for you.

B-3 Model in-progress screen shot.

B-4 Detail of final character model.

Project Guidelines

1. Get yourself some Sculpey or other material to work with. (A substance that can be baked or air-hardened is better than one that stays pliable.) Using aluminum foil as a core will help save material.

2. When you have created something you are happy with, photograph it from the top, side, and front views. Import these photos into Photoshop and be sure their scale and orientation align with each other.

3. Import the images as underlay graphics in Maya in your orthographic views and start modeling.

4. Keep the maquette at your workstation and compare your Maya model with the clay model in perspective views.

5. Evaluate how you modeled and posed your maquette as a resource for modeling in Maya. Modify your approach and try another model.

Things to Consider

The idea with this project is to develop alternate techniques for translating your ideas into Maya models. Different people think in different ways, so trying several approaches will help you develop a process that best suits your individual style.

● Posing a full-body maquette or torso in the da Vinci pose (with arms out 90 degrees to the side and legs spread) lends itself better to modeling in Maya than a relaxed or action pose.

● Sometimes drawing a wireframe on half of the maquette with a fine-tip felt pen is helpful for modeling.

● Taking sculpture, painting, and figure-drawing classes can only help you as a 3D computer graphics artist. Consider adding them to your development as an artist if you haven't already.

modeling in NURBS

4

 charting your course

Nonuniform rational B-splines (NURBS) are surfaces that have been tradi-
tionally used in high-end graphics because they lend themselves to smooth
detail. Film studios still use NURBS modeling for high-detailed imagery.
DreamWorks is one such studio. In this chapter, we will explore using some
NURBS creation and editing tools. There are many more, but these will give
you a good start.

 goals

- To understand the components of a NURBS object.
- To discover a few NURBS modeling tools.
- To create and edit NURBS surfaces.

NAVIGATION

All of our tools for this chapter reside in the Modeling module (Figure 4–1).

figure | **4-1** |

The Modeling module.

WHAT ARE NURBS, AND HOW DO I USE THEM?

NURBS stands for nonuniform rational B-splines. Editable knots control the Bezier curve shape. A typical NURBS object is made up of control vertices, edit points, isoparms, and patches.

NURBS modeling is generally based around the construction of curves, the subsequent creation of surfaces from those curves, and the modification of those surfaces through various methods of trimming, stitching, and sculpting. They require a bit of forethought as to how to approach your object (as does any method of modeling) and how to choose the tools that will best achieve your goals. For instance, similar shapes can be achieved with the Loft and Revolve tools, but each may provide advantages of simplicity or flexibility in specific modeling situations. As you learn and experiment, this will become clearer to you.

figure | **4-2** |

Creating a curve with the EP Curve tool.

Draw a NURBS curve using the following tool (Figure 4–2):

Create > EP Curve Tool

Make sure your options box looks like that shown in Figure 4–3.

Always reset all options before using a tool. Look in the upper left-hand portion of the options box. Select Edit > Reset settings. This brings your tool back to the default state.

figure | 4-3 |

Tool Settings option box.

Click your left mouse button (LMB) on several points in space. Wherever you click, an edit point is placed. A curve appears with the second edit point (Figure 4–4).

figure | 4-4 |

Edit point curves appear after two points are placed.

Try the same thing with the CV Curve tool (Figure 4–5):

figure |4-5|

CV Curve tool.

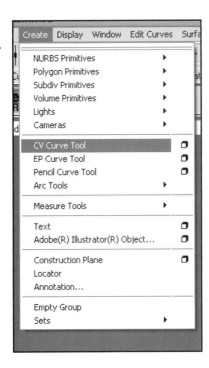

Create > CV Curve Tool

Control vertices (CVs) control the shape of a curve. They pull the NURBS spline into position. Lines between consecutive CVs form the control hull, which can be selected when modifying CVs as a group. The CV Curve tool options box looks like that shown in Figure 4–6.

figure |4-6|

CV Curve tool options box.

Click your LMB on three points in space. Notice that the NURBS curve does not appear until the fourth CV is placed (Figure 4–7). Different types of curves may require fewer CVs, but the default method requires four.

View Shading Lighting Show Panels

figure | 4-7 |

CV curves appear after four points are placed.

Either method works fine for creating a curve. Do not use too many CVs or edit points when creating a curve. Use the fewest points to create the shape you want. The more points you place, the more math must be computed and the greater the likelihood that your surface will not be as smooth as you want. Simpler curves mean a faster rendering and fewer problem areas.

When building surfaces using the Loft and Bi-rail tools, creating an initial construction curve (either a profile or rail) and then duplicating it and modifying the copies will make your modeling tasks easier. This technique will maintain the number of points and the curve direction for rail and profile curves, ensuring predictable results. In Figure 4–8, a profile curve was created, and then three copies were made and repositioned vertically. The curves were then reshaped, and finally the Loft tool was used to create the final surface.

View Shading Lighting Show Panels

persp

figure | 4-8 |

Single curve duplicated several times.

Do not try to make a surface without planning ahead.

When creating curves, plan the desired surface ahead of time. Make the same number of CVs or edit points in all the construction curves for building a surface, and draw them all in the same direction (i.e., left to right, top to bottom, etc.). A simple way to achieve this is to start with one curve and then to duplicate it to create more construction curves.

Control vertices are the most important means for controlling the shape of a curve.

The number of CVs is equal to the degree of the curve plus one. A degree-4 curve has five CVs per span. The more CVs a curve contains, the more control over the shape of a curve you have. Adding edit points can increase the number of CVs in a curve.

To create a degree-4 curve, draw a curve using the following:

Create > CV Curve Tool

Draw a curve containing four CVs.

In Component mode, turn off all objects, and then select the following:

figure | 4-9 |

Parm points in Component mode.

Select by component types: Parm Points

Click your LMB on the curve, and a yellow box should appear on the curve. If you continue to hold down the LMB, you can move the yellow box along the curve. Position it somewhere in the middle (Figure 4–10).

figure | 4-10 |

Inserting the parameter point somewhere in the middle.

Now, use the following tool (Figure 4–11):

Edit Curves > Insert Knot

figure | **4-11** |

Insert Knot tool.

A pink *x* will appear on the curve. Turn on the following (Figure 4–12):

Select by component type: Points

You will see the new CVs. Count them; you now have more than the four you initially drew.

figure | **4-12** |

Select by component type: Points icon.

You should learn to tell the difference between the start and the end of a curve. The first CV (at the start point of the curve) is drawn as a box. The second CV is drawn as a small "U" to show the increasing U dimension from the start point. All other CVs are drawn as small purple squares. Knowing the start and end of your curve will be important when you begin using advanced surface editing tools.

Hulls

Curves get complicated when more CVs are added. A surface built of several curves will have many CVs. The CVs are grouped in rows called hulls and can be selected as a group. Picking a hull allows you to pick an entire curve of CVs at once.

In Component mode, you can select hulls with the following (Figure 4–13):

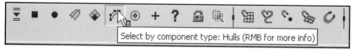

figure | 4-13 |

Hulls in Component mode.

Select by component type: Hulls

Parameterization

Parameterization is the placement of points on a curve. You may use either Chord Length or Uniform parameterization (Figure 4–14).

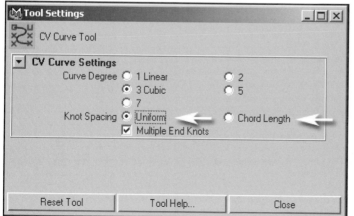

figure | 4-14 |

Selecting the parameterization settings.

For the majority of your needs, Uniform parameterization is the default setting. The difference between the Chord Length and Uniform parameterization resides in how each assigns UV values to the position of edit points. Uniform parameterization bases the value on the actual number of edit points used to create the curve, whereas Chord Length is based on the actual length of the curve.

Do not switch between the two when creating a curve, or your surface will have errors.

TOOLS FOR THE CREATION OF NURBS

We have already experimented with creating and editing a primitive to model a surface. Next, we cover some more difficult territory by creating and editing a curve to model a surface.

Surfaces > Revolve

The Revolve tool does what its name implies. It revolves a profile around an axis to create a symmetrical object like a vase or a wine glass. You draw a profile curve, and then pick an axis to revolve it around. Select the following (Figure 4–15):

Surfaces > Revolve

figure | 4-15 |

Surface Revolve tool.

In the Revolve Options window (Figure 4–16), you have a choice of which axis to revolve around. The default is Y. Figure 4–17 illustrates the different surfaces that result from the same curve revolved on each axis.

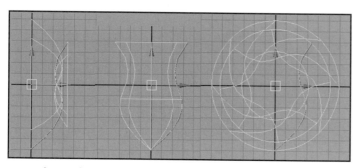

figure | 4-16 |

Revolve Options window.

figure | 4-17 |

Revolving around X, Y, and Z axes.

Surfaces > Loft

Loft skins a surface along a series of profile curves.

Draw a curve. Duplicate the curve using the following (Figure 4–18):

Edit > Duplicate

figure | 4-18 |

Duplicate tool
options window.

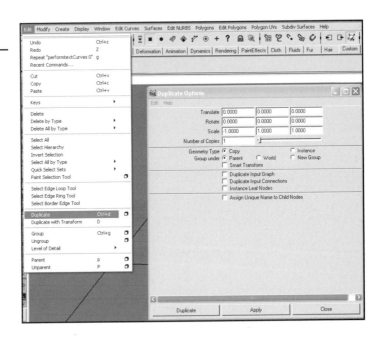

figure | 4-19 |

Duplicate curve moved up in the Y direction.

Move the curve off the original, and move it up in the Y direction
(Figure 4–19).

Select both curves. Select the following:

Surfaces > Loft

You will now have a surface between the two curves (Figure 4–20).

figure | 4-20 |

Lofted surface.

Whenever you use Loft, pick the curves in sequence from first to last. If you do not, your surface will twist back around on itself.

Surfaces > Planar

Planar creates a flat surface within a boundary curve. Planar surfaces can only be created within a closed curve with all points on the same plane.

Create a closed curve by creating a circle as follows:

Create > NURBS Primitives > Circle

Select the circle curve, and then select the following (Figure 4–21):

Surfaces > Planar

figure | 4-21 |

Planar Trim Surface
options window.

You now have a planar surface (Figure 4–22).

figure | 4-22 |

Planar surface.

Surfaces > Extrude

Extruding creates a surface by sweeping a profile curve along a path curve.

Draw a curve. Create a primitive NURBS circle by selecting the following:

Create > NURBS Primitive > Circle

Place the circle at the start of the curve (Figure 4–23).

figure | 4-23 |

Placing the circle at the start of the curve.

Select the curve and the circle, and then select the following:

Surfaces > Extrude

Set your Extrude tool options to those shown in Figure 4–24. Now, select the following:

Surfaces > Extrude

You will get the surface shown in Figure 4–25.

figure | 4-24 |

Extrude Options window.

figure | 4-25 |

An extruded surface.

If you keep the History button on (Figure 4–26), you have the option to continue editing your curve after the surface has been extruded.

Move a CV on the curve, and watch what happens to the extrusion.

figure | 4-26 |

History button.

SURFACE EDITING TOOLS

Now that you know how to create a NURBS surface with curves, you will need to know how to change that surface to add greater detail.

Edit NURBS > Insert Isoparm

Isoparms are lines running along the surface in the U and V directions. They show the shape of the surface as defined by the CVs. After creating the basic shape of your object, you will add extra control vertices to the form. This is like adding extra clay to your sculpture.

In Component mode, turn off all objects, and select the following (Figure 4–27):

figure | 4-27 |

Selecting isoparms in Component mode.

Select by component type: Lines

This allows you to select isoparms. Create a cylinder as follows:

Create > NURBS Primitive > Cylinder

Click your LMB on the top horizontal line in the cylinder. Then pull the LMB to another lower spot on the cylinder (Figure 4–28). The isoparm will turn red and become a yellow dotted line at the spot where the LMB is released. With the yellow line still active, select the following:

Edit NURBS > Insert Isoparms

A new isoparm appears. If you check the CVs, you will notice that more CVs have been inserted at this line (Figure 4–29).

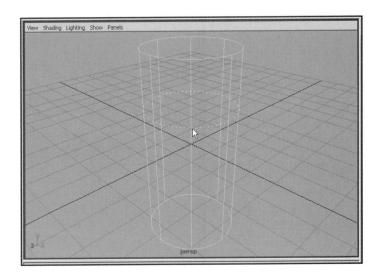

figure | 4-28 |

Selecting an isoparm in a cylinder.

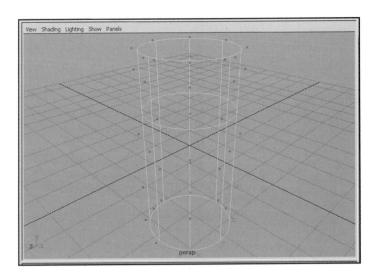

figure | 4-29 |

Inserted isoparm, showing new CVs.

Project Curve on Surface

If you want to cut a hole into a surface, you first need to project a curve onto the surface and then trim the area out.

Create a sphere. With the sphere selected, select the following:

Modify > Make Live

The surface changes to an olive green and can no longer be selected.

Select the CV Curve tool, draw a curve on the surface of the sphere with at least four points, and press Enter to complete the tool. In Object mode, select the curve and then select the following:

Edit Curves > Close Curve

The curve must be closed before it can be used to trim the sphere (Figure 4–30).

figure | 4-30 |

Closed curve on surface.

Before trimming the sphere with the curve, it needs to be made not live so it can be selected. To do this, make sure you have nothing selected and then select the following:

Modify > **Make Not Live**

Trim Surface

You are now prepared to trim the surface.

To trim the surface, select the following (Figure 4–31):

figure | 4-31 |

Trim tool.

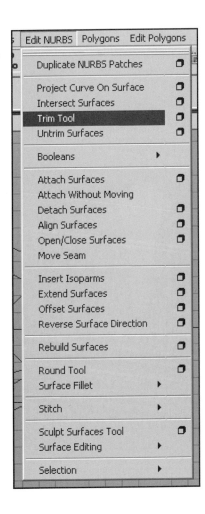

Edit NURBS > Trim Tool

Your mouse icon will turn into a different type of arrow. With this arrow, select the area of the sphere you wish to keep with your LMB. If you prefer to select the areas you wish to discard, change the setting in your Trim Settings options box to Discard (Figure 4–32).

figure | 4-32 |

Trim Setting options box.

When you are done, select the following from your view window. The result is shown in Figure 4–33:

Shading > Smooth Shade All

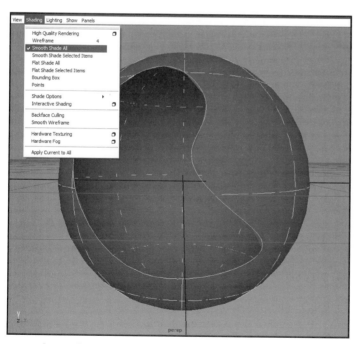

figure | 4-33 |

A trimmed surface.

Bevel

The Bevel Plus tool allows you to extrude a curve but with the addition of a beveled edge at the beginning, end, or both (Figure 4–34).

Example of beveled edges.

The text shown is similar to embossed lettering on a birthday invitation. Sharp edges are not believable since they do not exist on most objects in the real world, and they will detract from a final rendered image. Softening edges, or adding depth with Bevel, allows light to reflect more believably off the surface.

TUTORIAL: CREATING A CURIOSITY CABINET

You will need a place to put all your artifacts once you have completed all the tutorials in this book. A curiosity cabinet is traditionally a place for displaying peculiarities. In this tutorial, you will use the NURBS tool set to build your own curiosity cabinet.

Start by opening the following (Figure 4–35):

Display > Grid (options)

Your grid settings are now the same as those used in this tutorial, which will prevent you from getting results different than shown here. Also, make sure the Modeling menu set is active and make sure History is on (Figure 4–35).

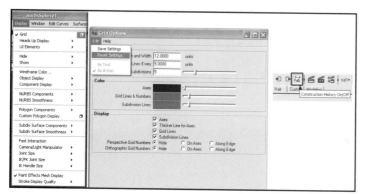

figure | 4-35 |

Reset grid options and History turned on.

Switch to the Curves Shelf, and double-click on the Create EP,

Curve tool to open its options (Figure 4–36).

figure | 4-36 |

Curves Shelf, Create EP Curve tool icon, and Create EP Curve options.

Set the Curve Degree to 1 Linear. Turn on Snap To Grid, and, in the Top view, draw the shape shown in Figure 4–37.

Name the curve "base_profile."

Next, set the Curve Degree for the EP Curve tool to 3 Cubic. Zoom in on the upper-left corner of the curve you just drew. Using the EP Curve tool, click at the endpoint of the previous curve to start drawing a new curve. After you have created one point, turn off Grid Snap and continue drawing a new curve like the one shown in Figure 4–38a. Press Enter when complete. Switch to CV Component mode, and refine the shape of the curve to look similar to that shown in Figure 4–38b.

figure | 4-37 |

Snap to Grid icon: First shape.

figure | 4-38 |

Second curve drawn and reshaped.

Now, rotate the new curve 90 degrees on its X axis, standing it up so it is properly oriented for the next step (Figure 4–39). The first curve you drew is the path; the second is the profile. With these two curves,

you will now use the Extrude tool to make the molding around the base of the cabinet.

Select the profile and then the path. Then go to the following:

Surface > Extrude (options)

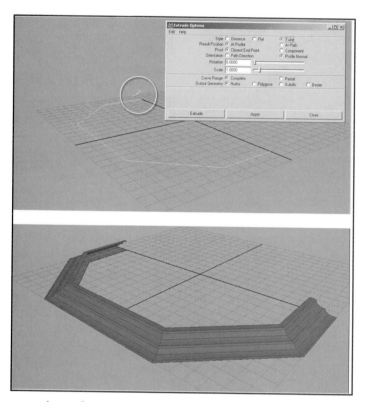

figure | 4-39 |

Extrude Options window and resulting shape.

Reset the tool, which will make your Extrude Options panel look like that shown in Figure 4–39, and click Extrude.

You should have a symmetrical shape (the same on the positive and negative sides of the X axis). If for any reason the shape seems unbalanced, you need to back up and check that your path curve was

drawn symmetrically with Grid Snap turned on and that you rotated the profile curve exactly 90 degrees before extruding (Figure 4–40).

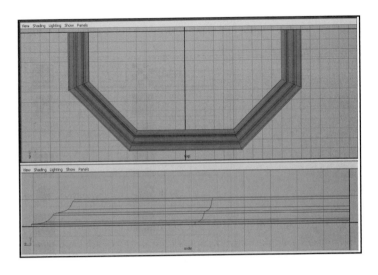

figure | 4-40 |

Looking from top and side to see if object is symmetrical.

Now is a good time to save your work.

Next, you are going to extract some curves and create some new ones to finish the base of the cabinet. This is a good time to start creating some display layers to keep things organized.

Create two new display layers. Call one "curves" and the other "surfaces."

Go to the following:

Edit > Select All by Type > NURBS Curves

Add the selected NURBS curves to the curves display layer (by selecting the curves layer in the Layer Palette, clicking your RMB on it, and then selecting Add Selected Objects). Now, select the molding object and add it to the surface layer. Turn off the visibility for the curves layer (by clicking the V icon next to the layer name to make it disappear). Keeping creation curves and surfaces on separate

layers is a good habit to get into in case you need access to those curves for editing existing objects or creating new ones. It also helps to be able to occasionally hide them to prevent them from being selected.

Make the surfaces display layer active by clicking your middle mouse button (MMB) on it in the Layers Palette. Turn on Curve and Point snapping, and make sure grid snapping is off (Figure 4–41).

figure | **4-41** |

Snap settings and endpoints to draw new curves between.

Open the tool options for the EP Curve tool, and set the curve degree to Linear. Following the guide image in Figure 4–41, create two new curves by drawing them from the endpoints shown. (Click and hold your LMB near the endpoints of the curves, and drag toward the end of the curve to snap to it, letting go when you are in the proper position.) Create one curve between A and B and then another between C and D.

Click your RMB on the molding shape, and select Isoparm from the marking menu. Select the top and bottom inner edges of the molding by selecting one and then holding down the Shift key to select the other. Then go to:

Edit Curves > Duplicate Surface Curves

Turn off the following:

Select by object type: Surfaces

figure | 4-42 |

Select the top two curves, and then select the following:

Edit Curves > Attach Curves (options)

Set the options to the following:

● Attach Method: Connect

● Multiple Knots: Keep

● Keep Originals: Off

Click Attach. If the new curve twists around after applying the Attach Curves tool, undo and use the following on one of the curves:

Edit Curves > Reverse Curve Direction

Then reapply the Attach Curves tool.

When creating curves for any operation, we generally need to create them by drawing them in the same direction (i.e., left to right, clockwise, etc.) and often with the same number of points.

Repeat the Attach Curves operation with the bottom curves.

Now select the new top curve, and go to the following:

Surfaces > Planar

Repeat the operation for the bottom curve. You now have two trimmed NURBS planes that make a top and bottom for your base object. Note that unless you close the curve the planar tool fails. If for any reason the Planar tool fails, your curve is not planar. ("Planar" means all the points exist on a single two-dimensional plane.) This most likely would have happened if you reshaped the CVs of an object or curve that was not part of this tutorial or if your

original profile for the molding was not rotated exactly 90 degrees on the X axis.

Select the curves you made to create the top and bottom surfaces, and hide them by adding them to the curves layer.

The last step for the base is to close the hole in the back. Using a procedure similar to the one you used to make the surfaces for the top and bottom, extract all the curves from the back opening, attach them, and close the hole with the Planar tool. Turn on the following to extract the curves (Figure 4–43):

Select by object type: Surfaces

figure | 4-43 |

Curves to extract, attach, and make the cap with.

Make sure you move all the curves you create to the curves layer after you are through with them.

Select all the surfaces you have created, and go to the following:

Edit > Delete by Type > History

Make sure that the surfaces are all on the surface display layer and that it is set to the current active layer. Group all the surfaces (Edit > Group). Name the group "base."

With the base group selected, go to the following:

Edit > Duplicate (options)

Reset the Duplicate tool, and then set the second Scale value (Y) to −1.0 and Geometry Type to Instance. (Instance makes a linked copy to the original so that changes modify all copies.) Click Duplicate, and you should get a new, vertically inverted copy of the base. This will be the top of the cabinet. Set the Translate Y value to 18. Assuming you have accurately followed the steps in this tutorial and you have an object of similar scale, your model should be similar to Figure 4–44.

figure | 4-44 |

Top and bottom of cabinet.

For the next step, you will make the frames for the front and side walls of the cabinet.

Go to the following:

Create > NURBS Primitives > Square (options)

Reset the tool, and then set the Length of Side 1 to 1.5 and the Length of Side 2 to 0.75. Click Create.

With the NURBS square selected, go to the following:

Edit > Ungroup

A NURBS square is four straight NURBS curves grouped. Since you are going to make some modifications to these lines, we dispose of the group node because it is unnecessary.

Select two adjoining edge curves (curves that touch to make a corner), and go to the following (Figure 4–45):

Edit Curves > Curve Fillet (options)

figure | 4-45 |

Fillet Curve Options window and result.

Use the following settings:

● Trim: On

● Join: Off

● Keep Originals: Off

● Construction: Circular

● Radius: 0.10

● Blend Control: Off

Click Apply to execute the tool and to keep the options panel open.

This tool adds rounded corners to selected curves whose endpoints are within the radius value. Executing the trim function will discard the portions that the newly rounded corners replace. Join is off because we want to manually join after all the corners are rounded. Using Freeform for Construction would not work in this case because it has a scaleable result. Instead, try using Freeform for Construction, and then move one of the original curves around to see the effect. Radius controls the arc size of the corner: A larger value would round more, making a larger corner; a lower value would make a smaller corner.

Repeat the operation for the other three corners, clicking Apply after you select the curves you want to fillet. Close the tool options panel when you are done.

Selecting two curves at a time, use the following to join all the curves:

Edit Curves > Attach Curves

Your settings should be the same as earlier: Attach Method = Connect; Multiple Knots = Keep; Keep Originals = Off. If any of the curves do not attach properly, undo and then use the following to fix the problem:

Edit Curves > Reverse Curve Direction

Then use the Attach Curves Tool again. Name the curve "frame-Profile_01" when done.

When all the curves are attached into one curve, use the following:

Edit > Delete by Type > History

We periodically delete History because it is sometimes required to reposition the NURBS objects that we are creating. With Construction History turned on, movement of the curves used to create objects will actually modify the shapes of those objects because the objects depend on the construction curves. By deleting History when you are done with construction curves, you remove that dependence.

Select the profile curve you just completed, and go to the following:

Surfaces > Bevel Plus (options)

Reset the tool and use the following settings:

- Create Bevel: At Start and At End On

- Bevel Width: 0.025

- Bevel Depth: 0.025

- Extrude Distance: 17.0

- Create Cap: At Start and At End On

- Outer Bevel Style: Convex Out

Click Bevel. You should have a result like that shown in Figure 4–46.

figure | 4-46 |

Profile beveled to make frame piece.

Name the new object "frameVert_01." Move the object up, forward, and to the right so that it rests between the top and bottom of the cabinet and so that its position is at one corner of what will be the front frame (Figure 4–47).

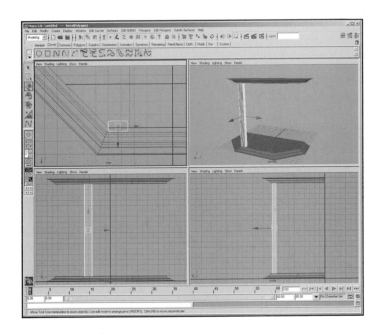

figure | 4-47 |

Position of frameVert_01 object.

With frameVert_01 selected, open the following:

Edit > Duplicate (options)

Reset the tool, and then turn on Duplicate Input Graph. Click Duplicate. Duplicating the input graph will ensure that each duplicate has a unique copy of the creation history, including the settings used to make the bevel. This will become important later.

To move the copy into place, simply set the Translate X value to its inverse. (In the case here, the value is −4.255, so setting it to positive 4.225 will move the copy to the same distance from the origin on the other side.)

Looking at the overall object, we notice that the upright pieces may be too wide. This is a relatively easy fix.

Find the original curve you used the Bevel Plus tool on to make frameVert_01. Switch to CV Component mode, select the CVs that make up the right edge and corners, and move the edge CVs inward as shown in Figure 4–48.

figure | **4-48** |

Moving edge points.

Note that here is another profile curve behind it. When you turned on Duplicate Input Graph in the Duplicate tool, it duplicated everything, including the shape originally used to make the Bevel Plus surface. You will notice that modifications to this shape only affect one of the frame objects. You can individually edit each profile, or you can select both before switching to CV Component mode by pressing the F8 key and selecting the Select by component type: Points pick filter, so you can grab the CVs in both curves and simultaneously move them. Figure 4–49 shows the shape after the CVs on both sides of the profile curves were moved.

Before continuing, delete the History for the profile curves you just reshaped. The tweaking of points you did needs to be deleted before you can continue to make additional copies; otherwise, duplicate objects will not have the same shapes as the originals.

View Shading Lighting Show Panels

Original
shapes

New Shapes

top

figure | 4-49 |

New profile shapes.

Make another copy of the upright piece. Rotate it 45 degrees on the Y axis, and position it against the right-hand front piece so that they make a corner in the front (Figure 4–50).

If you move the front piece at all, try to make the same adjustments to the upright on the left (e.g., if you have to move on X a little, make the same inverse value change to the other copy). There is nothing wrong with having the two uprights that meet at a corner overlap in a case like this. If you want to modify the shapes so they do not overlap and sit flush against each other, you can go back and modify the creation profiles for each. Let us allow them to overlap for the sake of simplicity.

If you double-click on the Move tool to open its options panel, you can switch the Move setting to Object. Now you should notice that the Move tool handles reorient to the object's local axes rather than the world's. Duplicate the most recent copy you made and rotated, and move it on its X axis to make the other upright for the diagonal panel.

Make a copy of the vertical piece you just moved. Set its Rotate Y value to 90, and move it halfway toward the back of the cabinet as in Figure 4–51a.

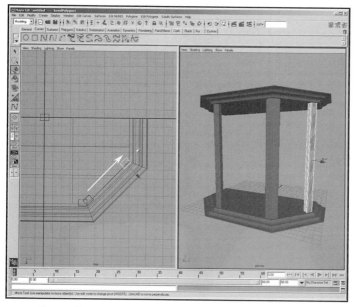

figure | 4-50 |

figure | 4-50 |

Duplicate frameVert_01 object moved on local X to new position.

Find the profile curve that corresponds with the most recent copy. (If you open the Outliner, it should be the frameProfile NURBS curve that appears lowest in the window.) Position the Top view so you can see the profile curve and the last copy you made. In CV Component mode, use the Move tool to reshape the CVs, to widen the profile on the X axis until the vertical object is wide enough to fill the entire side and creates a wall as in Figure 4–51b.

You will notice that we are not scaling the profiles when we make adjustments but grabbing the CVs that make up a side and the corresponding corners and moving them. This is done in order to maintain the rounded corner radius we created on all the corners with the Fillet Curve tool. Using the Scale tool would give us varied corner radii that would tend to look sloppy and inconsistent.

Once again, delete the History for the profile curve you just modified.

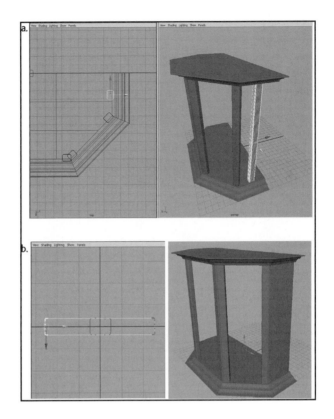

figure | **4-51** |

(a) Position of new copy and (b) reshaping the profile to make a side wall.

Now we need to make the top and bottom pieces for the frames.

Select one of the frameVert objects, and duplicate it. Rotate it 90 degrees on the Z axis, and set its translate X value to −4.4 so that it rests against the vertical piece on the front left (Figure 4–52).

In the Channel Box, select the "bevelPlus" attribute for the selected object.

You should see the Extrude Depth value below the attributes in the Channel Box. Set the Extrude distance to 8.2 (or whatever

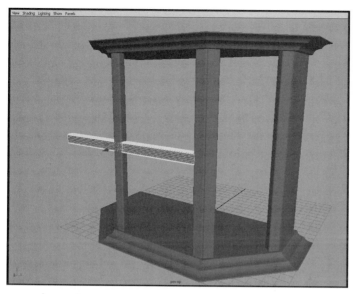

figure | 4-52 |

Duplicate rotated and moved properly.

value makes it the correct width to reach the other vertical; see Figure 4–53).

This is another benefit of having the input graph duplicated: You have the same set of creation controls for each copy so they may be modified individually. You will not need to duplicate the input graph for most modeling jobs, but it is a useful feature to be aware of and used in the right situation.

Move the new horizontal frame piece down to the bottom and duplicate it. Move the copy to the top of the frame so that you create something similar to Figure 4–54. Repeat the operation and use the Rotate tool to position the right side pieces.

Now, select all the frame pieces and side wall and go to the following:

Edit > Delete by Type > History

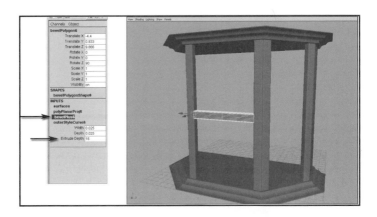

figure | 4-53 |

"bevelPlus" attribute location on the Channel Box and horizontal frame piece with Extrude Depth properly edited.

figure | 4-54 |

Horizontal pieces in place on the right side.

We do not need the connection to the original curves any more because keeping that dependency is no longer useful and could potentially cause problems.

Select the pieces that make up the diagonal frame and the side wall. Select the following:

Edit > Group (options)

Reset the tool, and click Group (Figure 4–55).

figure | **4-55** |

Group right-hand frame and right wall pieces together.

With the new group selected, open the Duplicate tool options panel. Reset the tool, and set the first Scale value (X) to −1.0. Click Duplicate. You should now have the identical geometry for the left side of the cabinet.

To make the door for the front, we will create a profile and use the Loft tool. Switch to Front view, and turn on Grid Snap (making sure all the other snap settings are off).

Create a new display layer, call it "door," and make it the active display layer by clicking on it (Figure 4–56):

Open Display > Grid (options)

figure | 4-56 |

Changing the grid values.

Change the Grid Lines Every setting from 5 to 2.5, and then click Apply and Close.

Create a profile for the door in the Top view similar to the one in Figure 4–57.

With the curve selected, go to the following to align the pivot point with the curve:

Modify > Center Pivot

This will make properly positioning the curve easier. In Front view, position the curve as shown in Figure 4–58 (In this case, curve position coordinates are X = −4.5, Y = 1.5, Z = 0). Duplicate the profile curve, and move it to 18.0 on the Y axis. You may want to create a template for the other display layers so that you can still see the cabinet but the layers are muted and cannot be selected.

figure | 4-57 |

New profile for door.

figure | 4-58 |

Position for new profile curve and position of copy.

With Grid Snap still on, set the EP Curve tool's Curve degree to Linear and draw four 45-degree curves like those shown in Figure 4–59.

figure | 4-59 |

Drawing four diagonal curves.

Select the lower profile curves and then the upper profile curves. Then go to:

Surfaces > Loft (options)

Reset the tool, and click Loft. The results should look like those shown in Figure 4–60.

Duplicate the new door frame piece three times, and position these pieces as in Figure 4–61.

Move them forward so that they sit at the front of the cabinet (approximately 13.5 on the Z axis). Zoom in on the corners, and make sure the edges align.

For each door frame piece, you want to select the frame piece and two curves that cross the ends and then go to:

Edit NURBS > Project Curves on Surface

figure | 4-60 |

New lofted door frame object.

Make sure you are in Front view (Figure 4–62).

Repeat the operation for the other three door frame pieces in the Front view. Select the following:

Edit NURBS > Trim Tool

Click in the center of one of the door frame pieces. Click on the center again so that a yellow diamond appears in the center and the areas of geometry outside the projected curves change to dotted lines. Press the Enter key. Repeat the same operation for the other three door frame pieces (Figure 4–63).

There are only a few things left to do. First, we will create the decorative molding for the top. Then, to finish up, we will add the shelves, back wall, glass panes, and door hardware.

figure | 4-61 |

Three duplicate door frame objects in proper position.

figure | 4-62 |

Project Curves on Surface in Front view.

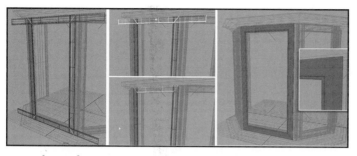

figure | 4-63 |

Curves projected on all door frame pieces, top door frame properly trimmed, and result of all frame pieces properly trimmed.

Move all the construction curves that you have been creating to the curves layer. Create a new display layer, name it "top_molding," and make it the active layer. Create a template for the door layer.

Make sure the EP Curve tool is set to Linear and Grid Snap is on. Switch to the Top view, and draw a curve like the one shown in Figure 4–64a.

Turn off Grid Snap, and, using either the EP or CV Curve tool with Curve Degree set to Cubic, draw a curve in Front view like the one shown in Figure 4–64b.

figure | 4-64 |

Path and profile curve for top molding.

Position both curves as in Figure 4–65.

Freeze the transforms for both curves, and then use the following:

Surfaces > Extrude

figure | **4-65** |

Proper position of molding curves.

Use the settings in Figure 4–66 to create the molding surface.

Open the options panel for the Duplicate tool. Reset the tool, and then set the first Scale value (X) to −1.0. Click Duplicate.

In Front view with either the EP or CV Curve tool, draw the curve in Figure 4–67a. In Object mode, select the new curve, and go to:

Surfaces > Revolve

Delete History for the new revolved object. Open the Duplicate tool, reset it, and set the Geometry Type to Instance. Move and make duplicate versions of the revolved object to get the result shown in Figure 4–67b.

Now open the following:

Edit > Group (options)

figure | 4-66 |

New top molding after being extruded.

Reset the tool, and make sure Group Pivot is set to Center. Select all the revolved objects, and group them. Open the Duplicate tool's options panel, and set the first Scale value (X) to −1. Leave Instance as the Geometry type, and click Duplicate to make copies for the left side of the cabinet.

Now, select the two frameVert beveled pieces shown in Figure 4–68a. Open the Duplicate tool options panel. Reset the tool and turn on Duplicate Input Graph. Click Duplicate. Move the two new objects up on the Y axis above the cabinet, as shown in Figure 4–68b.

In the Channel Box, find the BevelPlus Node in the History, select it, and change the Extrude Depth value to 2.0. (Note that if you have both objects selected, you can simultaneously edit the Extrude value for each.)

Reposition the objects so that they sit at the ends of the rails, as shown in Figure 4–69.

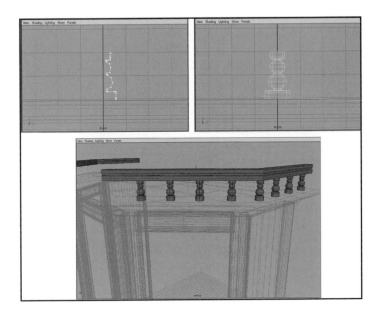

figure | 4-67 |

New profile curve, resulting revolved surface, and position for duplicates.

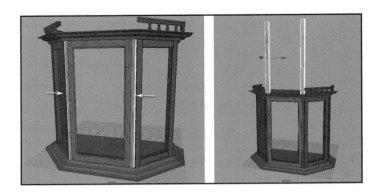

figure | 4-68 |

Select two front frameVert objects and repositioned frameVert objects.

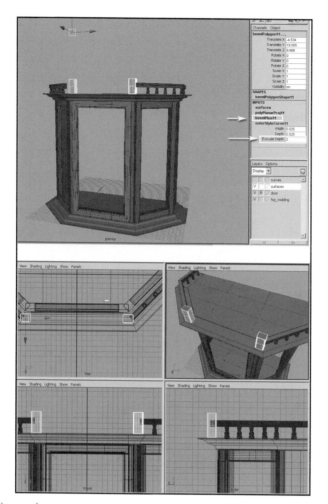

figure | 4-69 |

Extrude value edited and repositioned objects.

In the Side view, draw the shape shown in Figure 4–70a with either the EP or CV Curve tool (whichever one you feel more comfortable with). Reset the Duplicate tool, and duplicate the profile curve. Move the copy forward, and, in CV Component mode, reshape the second curve as shown in Figure 4–70b.

figure | 4-70 |

New profile curve and reshaped duplicate profile curve.

Move the curve back in the Side view so that it aligns with the first curve on the Z axis. Make a duplicate of the second curve, and position them as shown in Figure 4–71a.

Shift + select the three curves one at a time from left to right. Open the following:

Surfaces > Loft (options)

Set the surface degree to Linear, and click Loft. You should get an object like that shown in Figure 4–71b.

Switch to the Front view, and draw two curves like those in Figure 4–72a. With the two new curves selected, open the Duplicate tool options panel, reset the tool, and set the X Scale value to −1.00. Press Duplicate. The duplicated curves are shown in Figure 4–72b. Select the two center curves, and open the following:

Edit Curves > Attach Curves (options)

Set the Attach Method to Connect, set the Multiple Knots value to Keep, and select Remove Originals. (These settings will ensure that

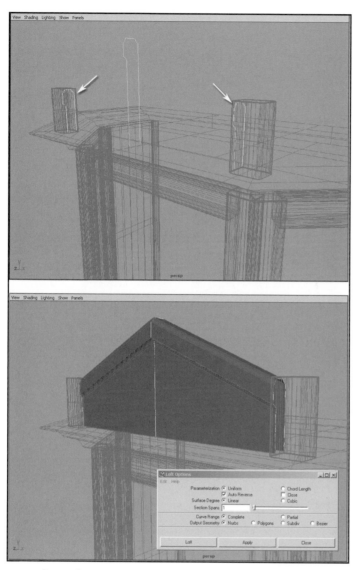

figure | 4-71 |

Position of profile curves and resulting loft surface.

the new curve shape does not change when the two curves are attached and that the originals will be discarded so they cannot be accidentally selected later.) Click Attach (Figure 4–72c).

Select all the curves, and go to:

figure | 4-72 |

New curves, duplicated curves, and attached curves with tool options.

Surfaces > Extrude (options)

Reset the tool and use the following settings:

- Style: Distance

- Extrude Length: 2

- Direction: Specify

- Direction Vector: Z Axis

The Distance setting indicates that you simply want to extrude the curve in a user-defined direction by the user-defined length and that you want to modify the Extrude tool's available choices so you can

enter those other values. Extrude Length is the distance the tool will extrude the curve. Using the Specify for the Direction setting you can choose the axis on which the tool operates (in this case, choose the Z axis).

Click Extrude. Move the newly extruded shapes forward on the Z axis until they intersect and pass through both sides of the triangle-shaped molding you created in the previous step (Figure 4–73).

figure | 4-73 |

Lofted Surfaces extruded from curves and the correct position of extruded objects.

With the three extruded shapes selected, go to:

Edit > Delete by Type > History

Delete the original curves you used to create the extrusions; you will not need them anymore.

Select one extruded shape and the triangle molding. Go to:

Edit NURBS > Intersect Surfaces

This will create curves on both shapes where they intersect. Repeat the operation for each of the other two extruded shapes (Figure 4–74).

Next, you will trim the surfaces using the new surface curves you created.

figure | 4-74 |

Creating intersection curves between surfaces.

Select the following (Figure 4–75):

Edit NURBS > Trim Tool

Click on the Triangle Molding, and then click on it again in the area outside of the extensions (Figure 4–75).

figure | **4-75** |

Trim the extrusions to make the inside areas for cuts in the molding.

Now (for each extrusion) discard all the surface geometry outside the molding by activating the Trim tool by clicking on an extruded surface and then selecting the area inside the intersection curve.

The result should look like Figure 4–76. The model appears a bit rough in your Shaded view; however, if you render it, the surface should look fine.

figure | 4-76 |

Lofted surface.

You can change the fidelity of the NURBS surfaces in their Attribute Editor (by selecting the object and then pressing Ctrl+A). Look for the Tessellation section, and open it. Check Display Render Tessellation, and then increase the Curve Tolerance and the U and V Division Factor settings to increase how finely Maya will sample the curved surface at rendering time (Figure 4–77).

We are almost done, and we are through with the hard stuff!

Make a new surface by drawing a profile curve like the one shown in Figure 4–78. Use the Revolve tool to create a surface from the profile (revolving about the Y axis). Use the following on the new object:

Edit > Delete by Type > History

Then move the new object into position, as shown in Figure 4–78. Make a duplicate, and move the duplicate to the other side as shown.

figure |4-77|

figure |4-77|

Changing and displaying render tessellation.

figure |4-78|

Profile for ornamental detail and ornamental detail objects in place.

Use the same technique you just used to create the ornamental detail to make a door knob like the one in Figure 4–79.

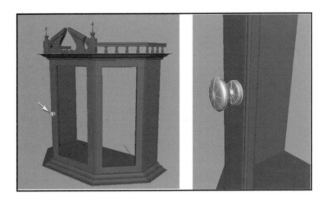

figure | 4-79 |

Creating a door knob.

The last modeling task is to make shelves. To do this, you need to use the base_profile curve you made at the beginning of this tutorial. Select base_profile, and duplicate it making sure the Duplicate tool is reset first. Move the new curve up into the body of the cabinet, and rename it "shelf_profile." Draw a linear curve from one endpoint of the shelf to the other. Attach the two curves into a single curve using the Attach Curves tool. If you have any problems, reverse one of the curve directions using the following:

Edit Curves > Reverse Curve Direction Tool

Delete History for the new attached curve. Use the Scale tool to scale the curve inward slightly so that its boundaries sit just inside the cabinet's walls (Figure 4–80).

Use the Bevel Plus tool to make a shelf from the curve using the following settings:

● Create Bevel: At Start and At End = On

● Bevel Width: 0.05

● Bevel Depth: 0.05

figure | **4-80** |

Steps for creating shelf profile.

- Extrude Distance: .2

- Create Cap: At Start and At End = On

- Outer Bevel Style: Convex Out

You may need to scale the new shelf object a bit with the Scale tool to make it fit cleanly inside the cabinet walls.

Duplicate the shelf, and move it upward to make a second shelf. The final shelf positions are shown in Figure 4–81.

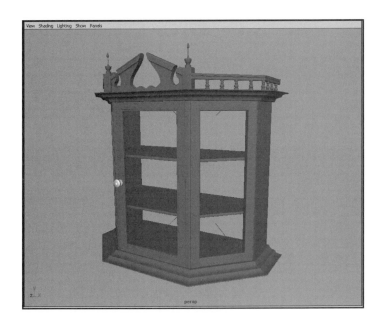

figure | 4-81 |

Final shelf positions.

figure | 4-82 |

Final cabinet model
and author's
textured version.

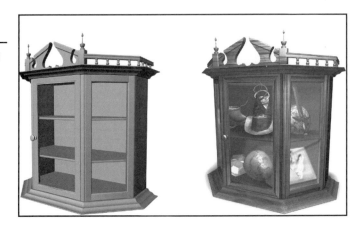

To enclose the back of the cabinet, simply create a NURBS plane with Z as the axis and then scale and position the plane to close the opening.

The glass for the door and side panels can be created in the same fashion. You may wish to add other details on your own such as hinges and additional ornamentation. The final curiosity cabinet is shown in Figure 4–82.

Later, after you complete the texturing chapter, you will have the skills necessary to make the wood, metal, and glass materials for your cabinet.

SUMMARY

You should now have a good understanding of how some of the basic NURBS tools work and when to use them. There are more advanced methods of modeling with NURBS (like patch modeling) that build on the basic skills you have started to learn here. Like with the other modeling tools you have been introduced to in this book, practice is the best method for developing your modeling skills and knowing which tools will best suit both your needs and your working style.

in review

1. What do the letters NURBS stand for?

2. What is a typical NURBS object made of?

3. What are hulls made up of?

4. How do you tell the difference between the start and end of a curve?

▲ EXPLORING ON YOUR OWN

1. Build simple curtains by drawing a curve, duplicating the curve, and raising the duplicate a few units in Y. Then loft the curves.

2. Build a simple lamp base by drawing a curve and revolving it. Make a shade for this lamp by using lofts.

3. Try the sample tutorial on the enclosed CD, and build the talon cup.

notes

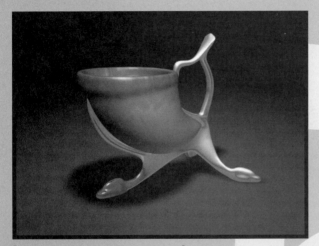

 charting your course

Subdivisional surfaces can be considered a hybrid of polygons and NURBS. You can use many of the same tools available in polygonal modeling but end up with a smooth, NURBS-like object. Subdivisional objects are very heavy with information, so their surfaces are not ideal for games. However, they provide a much simpler way to model organic objects than do NURBS. An understanding of all three surface methods should be mastered so that you can choose the best process for your end needs.

 goals

- To understand the components of a subdivisional object.
- To practice subdivisional editing tools.
- To create and edit subdivisional surfaces.

NAVIGATION

All of our tools for this chapter reside in the Modeling module (Figure 5–1).

figure | 5-1 |

The Modeling module.

HOW TO MODEL SUBDIVISION SURFACES

The modeling workflow requires pulling out the basic shape in Polygon mode and then assigning detail through mesh surfaces created in Subdivision mode.

Subdivision surfaces use polygons as their base, and the artist may create a complex shape out of a single surface. The surface consists of meshes that can be divided into various levels of detail. You have 13 levels of mesh detail, and 0 is the base mesh. Most work can be completed within levels 0–4 with excellent detail. Going any higher can make your model extremely heavy and slow to work with. Use great discretion in assigning meshes beyond 4. This has the same effect as using too many control vertices in NURBS.

In subdivision surface modeling, we first rough out a shape in Polygon mode; details are then added in Subdivision mode. Switching between the two is straightforward.

Let us start by creating a subdivision cube (Figure 5–2):

Create > Subdiv Primitives > Cube

There are two modes in subdivision surfaces: Polygon Proxy mode and Standard mode.

When you click your right mouse button (RMB) on the cube surface, the pop-up menu in Figure 5–4 appears. By default, you are in Standard mode.

Now we will switch to the second mode—Polygon Proxy (Figure 5–4). Select Polygon. The result is displayed in Figure 5–5. You can return to Standard mode by right-mouse clicking on the cube and selecting Standard in the pop-up menu (Figure 5–6).

figure |5-2|

Creating a cube.

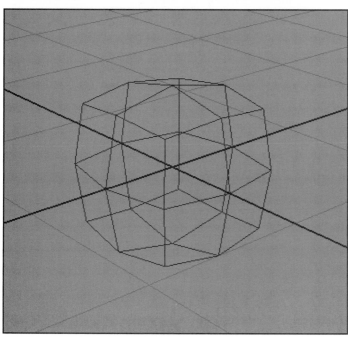

figure |5-3|

Create > Subdiv
Primitives > Cube.

figure | 5-4 |

Menu: Default Standard mode.

figure | 5-5 |

Menu: Polygon Proxy mode.

figure | 5-6 |

Subdivision surface in Polygon Proxy mode.

In Polygon Proxy mode, you can work with the object as if it were polygonal, using all the tools you learned in the previous chapter. The cube is surrounded by a polygon, which affects the base object. Start by selecting a face. Pull the face, extrude it, or delete it, and watch how it affects the subdivision surface.

The polygon box created in Polygon Proxy mode is temporary and works on the base (0) level of the surface. It is deleted whenever you switch to Standard mode.

With the Split Polygon tool, extrude only one of the faces (Figure 5–7). Right-click over the surface again, and select Standard from the menu. The polygonal reference box disappears. You are now left with a subdivision surface that can be refined by assigning detailed meshes. Switch to Vertex Component mode. Do you see the purple squares?

We will next explore the additional tools available for subdivision surfaces.

figure | 5-7 |

Split face, with one face extruded.

TOOLS FOR SUBDIVISION SURFACE

We will be learning the following tools in this chapter:

- Subdiv Surfaces > Refine Selected Components

 Each time you refine, a new level is added.

- Subdiv Surfaces > Component Display Level > Finer

 This tool will display one level of refinement higher than the current.

- Subdiv Surfaces > Component Display Level > Coarser

 This tool will display one level of refinement lower than the current.

- Subdiv Surfaces > Full Crease Edge/Vertex

 This tool creates a full crease.

- Subdiv Surfaces > Partial Crease Edge/Vertex

This tool creates a partial crease.

● Subdiv Surfaces > Uncrease Edge/Vertex

This tool removes a crease.

● Subdiv Surfaces > Mirror

This tool is used to make a mirrored duplicate of the selected surface on the axis specified.

● Subdiv Surfaces > Attach

This tool merges two subdivision surfaces to create a new subdivision surface.

● Subdiv Surfaces > Expand Selected Components

This tool spreads the level of refinement to adjacent areas.

● Subdiv Surfaces > Clean Topology

Use this tool to remove refined components that you created but did not edit.

● Subdiv Surfaces > Collapse Hierarchy

This tool will make a copy of the selected subdivision surface and increase the refinement of the low-detail areas by a user-defined one or two levels up to a maximum of the highest-detail areas.

● Subdiv Surfaces > Sculpt Geometry Tool

You can use this tool to manually sculpt the mesh by pushing and pulling vertices with a paint brush that is controlled by the mouse. This tool is ideal for quickly modeling organic objects.

Subdiv Surfaces > Refine Selected Components

Create a subdivision sphere, and make sure it is large enough to work with in all four views. Make sure you are in Vertex Component mode and in Standard mode (Figure 5–9). You should see 0's on the eight corners of the subdivisional sphere.

It may be necessary to adjust your Custom Settings to display the numbers on the vertices in Standard mode. To do this, go to Window > Settings/Preferences > Preferences. In the Subdiv menu, make sure the Component display is set to Numbers and not Points (Figure 5–8).

figure | 5-8 |

Menu with Standard
selected.

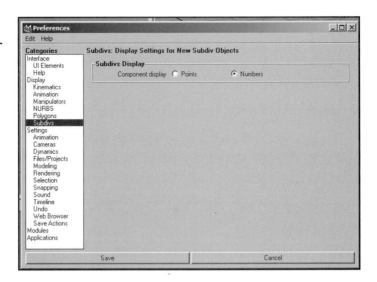

figure | 5-9 |

Component mode
with vertex selected.

Select a 0, as you would a vertex on a polygon. The selection should highlight in a yellow color. Now select the following (Figure 5–10):

Subdivision Surface > Refine Selected Components

figure | 5-10 |

Subdivision Surface
> Refine Selected
Components.

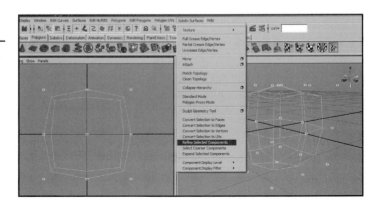

Notice that now the entire surface is covered with several numeric 1's (Figure 5–11).

Select a numeric 1. Then select the following:

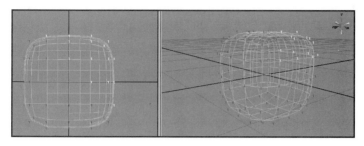

figure | 5-11 |

Subdivisional surface at level 1.

Subdivision Surface > Refine Selected Components

A large area beyond that selected area may refine to level 2. Select one of the numeric 2 symbols (Figure 5–12), and push or pull the surface. Notice how you can move this just like you did a polygonal face.

figure | 5-12 |

Subdivisional surface at level 2.

Take it down another level by selecting a numeric 2, and refining again. This should create a smaller area of numeric 3. Select a 3, and translate the surface (Figure 5–13). Notice how the 3 is spread if the translation is too dramatic.

If you want to move to a different level, right-click over an edge of the surface and select a display level (Figure 5–14). Choosing a different level will bring you back to a different level of detail.

The ability to refine the object without adding excess control vertices, as you would in NURBS, or without having to subdivide hundreds of surfaces, as you would with polygons, is an excellent asset of this program.

figure | 5-13 |

Subdivisional surface at level 3.

figure | 5-14 |

Display levels show
up on the menu after
you have refined the
surface.

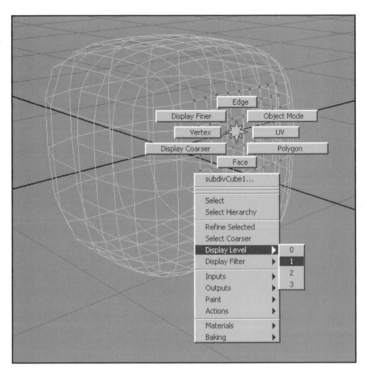

Think of each level as a net over your object. Each square in the net
can be divided into a smaller net.

Subdiv Surfaces > Component Display Level > Finer

In Maya, there are many ways to do the same function.
You can change levels of detail either by right-clicking over the

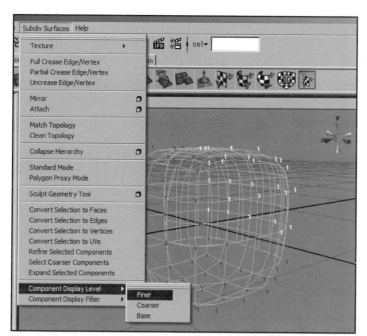

figure | 5-15 |

Changing levels
of detail.

surface and choosing a different level of detail or by commanding (Figure 5–15):

Subdiv Surfaces > Component Display Level > Finer

You must start at a lower level of detail than you wish or the command is fruitless. Start at detail level 0 on your previous sphere, and select a finer component display level. You will be taken to display level 1.

Subdiv Surfaces > Component Display Level > Coarser

This tool is the same as the previous tool expained, however it is reversed. If you are in a high level of display, this will take you back to a lower level (Figure 5–16).

Subdiv Surfaces > Full Crease Edge/Vertex

The Crease Edge tools offer a way to add a crease without adding extra geometry.

The edge referred to is not on the actual sphere but on the polygonal cage external to the sphere. Switch to Edge Component mode by clicking your RMB over the surface and selecting Edge (Figure 5–17).

figure | 5-16 |

Lowering the level
of detail.

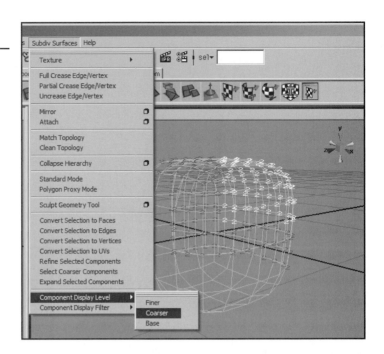

figure | 5-17 |

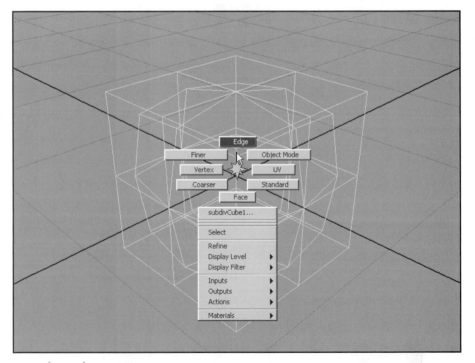

Switching to Edge Component mode.

Select an edge on the sphere. Now select the following:

Subdiv Surfaces > Full Crease Edge/Vertex

It will look dashed when creased (Figure 5–18).

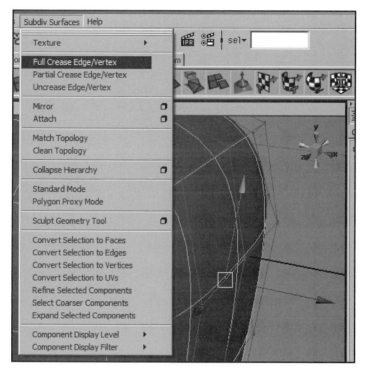

figure | 5-18 |

Adding a crease.

Translate the edge away from the sphere. Go to Shaded view, and you will see the edge appearing (Figure 5–19).

figure | 5-19 |

A crease forms the further the edge is pulled from the object.

A full crease is a sharp edge formed at the selected edge or a sharp point formed at the selected vertex. The surface moves very close to the edge or vertex to form the crease.

Subdiv Surfaces > Partial Crease Edge/Vertex

A partial crease creates a softer edge than a full crease. Use the same method described in the full-crease section but instead next use the following:

Subdiv Surfaces > Partial Crease Edge/Vertex

Translate the edge away from the sphere, and a softer edge will form (Figure 5–20).

figure | 5-20 |

Partial-creased edge on sphere.

Subdiv Surfaces > Uncrease Edge/Vertex

When you find that an edge is undesirable, the uncrease option allows you to release the crease operation.

Select an edge that defines a crease. Maya displays creased edges as dashed lines to help you identify when an edge has been creased.

Apply the following:

Subdiv Surfaces > Uncrease Edge/Vertex

The dashed line will turn solid when the command is successful (Figure 5–21).

figure | 5-21 |

Creased (left),
uncreased edge
applied (right).

Subdiv Surfaces > Mirror

Mirror is much like the Edit > Duplicate command except that it creates an inverse duplicate of the object.

Create a subdivision surface as shown in Figure 5–22 by selecting and deleting the left half of the faces. Select the Subdiv surface at the object level, and apply the following (Figure 5–22):

Subdiv Surfaces > Mirror (options)

An inverse duplicate will appear if you select z in the options window (Figure 5–23).

The same thing will happen with the Duplicate command if you change the scale x (or y or z) in the options window to -1.

Subdiv Surfaces > Attach

Use this command to glue two surfaces together into one new surface.

figure | 5-22 |

The mirror pull-down
menu and options
panel.

figure | 5-23 |

Inverse duplicate.

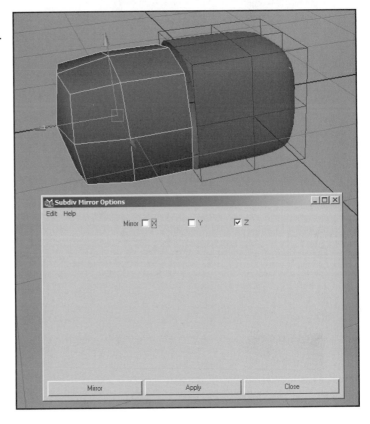

You must be in Standard mode to use this operation.

Create two subdivision surface spheres (Create > Subdiv Primitives > Sphere). Move them so they are sitting next to one another but barely touching on the X axis. For each sphere, switch to Polygon mode, switch to Face Component mode, select the side face on each sphere that touches the other sphere, and delete it. Switch back to Object mode, select both the half-sphere objects, finally switch back to Standard Mode and go to the following (Figure 5–24):

Subdiv Surfaces > Attach (options)

figure | 5-24 |

Subdiv Attach
Options box.

Threshold increases the distance over which the attachment will happen. Increase the Threshold (Figure 5–25), and click Apply. A new surface is created (Figure 5–26).

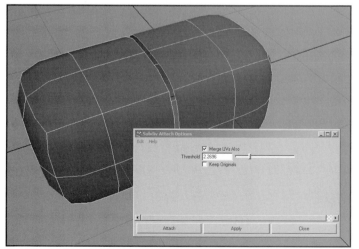

figure | 5-25 |

New subdivision
surface.

figure | 5-26 |

Expanding
refinement region.

Subdiv Surfaces > Expand Selected Components

Use this command to expand the refinement of a selected region to bordering regions. You must be in Component mode to use this operation.

Create a subdivision surface sphere. Switch to Vertex Component mode, and select one vertex. Now select the following:

Subdiv Surfaces > Refine Selected Components

Now select one of the "1" icons in the refined area, and use the Refine Selected Components tool again. Select a "2" icon at the border of the refined region, and then select the following:

Subdiv Surfaces > Expand Selected Components

Notice how the region with the "2" vertices has expanded.

Subdiv Surfaces > Clean Topology

This tool will remove refinement in regions that have not been edited.

Create a subdivision sphere. Switch to Vertex Component mode, and select all the vertices. Use the following:

Subdiv Surfaces > Refine Selected Components

Select and refine all the vertices two more times. Be sure to keep all the vertices selected when you use the tool. All your vertices will

change to "3's." Now select one vertex, and move it. Switch back to Object mode, and select the sphere. Now, select the following:

Subdiv Surfaces > Clean Topology

You should see that the detail in the sphere reduces as it moves away from the vertex you moved (Figure 5–27). Use this tool to clean your models of unnecessary vertices in areas where you have not made changes.

figure | 5-27 |

Cleaning out unnecessary vertices.

Subdiv Surfaces > Collapse Hierarchy

This tool makes a copy of the existing geometry and increases the lowest level of detail in the model by a user-defined step of one or two levels in the tool's options panel. This tool essentially does the opposite of what the Clean Topology tool does; it increases detail in low-detail areas. Each time you use the tool, it will make a copy of the selected geometry and make the changes to the copy.

Create a subdivision surface sphere. Switch to Vertex mode, select one vertex, and use the Refine Selected Component tool. Repeat this operation twice, selecting only one vertex each time. A sphere with varying levels of refinement should appear. Switch back to Object mode, select the sphere, and use the Collapse Hierarchy tool. Move apart the two copies. Select the new copy, use the Collapse Hierarchy tool again, and move away the new copy. Repeat this operation

once more on the newest copy. Select all four of the spheres, and press the 3 key to see them at their highest-resolution display. You should see something similar to Figure 5–28, with each new sphere having slightly more refinement overall.

| Original refined sphere | First sphere (left) and final sphere (right) |

figure | 5-28 |

Results of repeated use of Collapse Hierarchy tool.

Subdiv Surfaces > Sculpt Geometry Tool

The Sculpt Geometry tool for subdivision surfaces is new to Maya 7. This tool allows you to push and pull vertices with a paintbrush directly on the mesh. The Sculpt Geometry tool is a quick way to rough out organic shapes. To use this tool, do the following:

Create a subdivision surface sphere. Switch to Vertex mode, and refine all the vertices to level 3. Then select:

Subdiv Surfaces > Sculpt Geometry Tool (options)

When you select the options box for the Sculpt Geometry tool, the brush options will open in the Attribute Editor. In the Sculpt Geometry tool options box, change the brush size to Radius (U) of 0.4 with a Max. Displacement of 0.5. Select the Operation to Pull under the Sculpt Parameters options (Figure 5–29).

To use the Sculpt Geometry tool, left-mouse click over the sphere. Experiment with different brush options for different effects. Use the Smooth options to clean up overlapping vertices.

figure | 5-29 |

Using the Sculpt
Geometry tool.

TUTORIAL: MODELING A TALON CUP

Subdivision surface modeling is a hybrid of NURBS and standard
polygon modeling. You can model in much the same fashion as you
did in Chapter 3 but with the added benefit of being able to refine,
modify, and crease the smoothed surface without adding geometry
to the overall cage. Working strictly in quads is important with sub-
division surfaces. For this tutorial, you will start with a polygon and
convert it to a subdivision surface. You will use the polygon model-
ing tools you are already familiar with while using some of the new
features of subdivision surfaces.

When you work with subdivision surfaces, you can work in two
modes:

1. **Standard mode,** in which you work directly on the subdivision
 surface and can manipulate its components as well as crease and
 refine areas of the surface

2. **Polygon Proxy mode,** in which you can use the polygon model-
 ing tools you have already learned in previous chapters to mod-
 ify existing geometry as well as add new geometry

When you switch between these two modes, Maya will delete the
History for that object. You may wish to save your file under a new
name before switching modes if you think you may want to back up
or have access to the object's history.

In this tutorial, we will model a talon-shaped cup (Figure 5–30).

figure | 5-30 |

Talon cup.

To begin our cup, first create a polygon cube with subdivisions set along width to 1, height to 3, and depth to 1. This will be the tooth object (Figure 5–31).

figure | 5-31 |

The beginning of the cup.

Change your view layout so you can see the Front and Side views. Switch to Vertex Component mode.

Use the Scale and Move tools to reshape the cube so that it looks like that shown in Figure 5–32. Select the following:

figure | 5-32 |

Reshaping the cube.

Modify > Convert > Polys to Subdiv

Press the 3 key to show the model at maximum smoothing. Right-click on the model, and select Edge.

In Perspective view, select the four edges that make up the top of the model. Select the following:

Subdiv Surfaces > Partial Crease Edge/Vertex

You should see the top flatten out and the edges you selected change to dashed lines (indicating that a crease has been applied), as shown in Figure 5–33.

Press F8 to return to Object mode. Switch to the Animation menu set (F2), and select the following:

Deform > Create Nonlinear > Bend

figure | 5-33 |

Crease applied.

Press the T key to show the bend deformer's manipulators. Drag the middle manipulator out until the Curvature value (in the Channel Box inputs with "bend01" selected) is approximately 1.0. Your object should look like that shown in Figure 5–34.

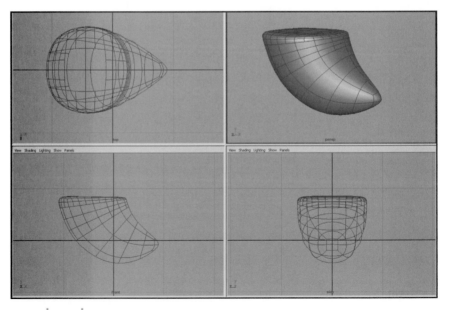

figure | 5-34 |

Bend applied.

Select the following:

Edit > Delete by Type > History

In the Front view, rotate the tooth so that the top is level with the ground plane (approximately 56 degrees on the Z axis), as shown in Figure 5–35.

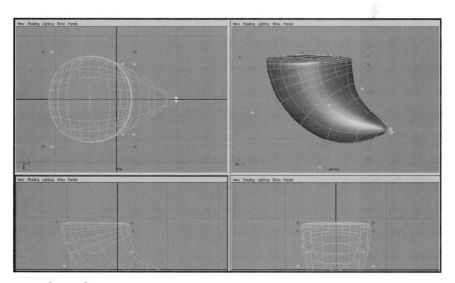

figure | 5-35 |

Tooth.

Switch to Vertex Component mode, and tweak the vertices to get a more tooth-like or claw-like shape, as shown in Figure 5–36.

The tooth is done for now. Let us move on to creation of the handle for the cup.

Create two new display layers: cup and handle. Add the tooth to the cup layer, and set the layer's Display mode to template. Create a new cube (which will become the handle) with the following settings:

- Width: 0.25

- Height: 2.0

- Depth: 0.125

- Subdivisions Along Width: 1

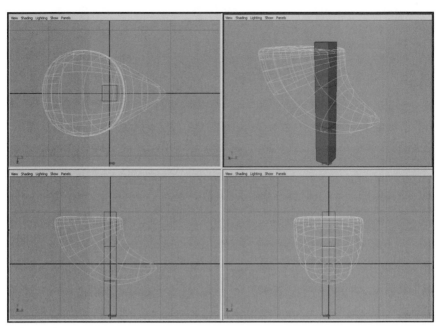

figure | 5-36 |

Tweaked shape.

- Subdivisions Along Height: 3

- Subdivisions Along Depth: 1

Your handle should look like that in Figure 5–37.

Add the new object to the handle layer. Switch to Vertex mode, and reshape the cube as in Figure 5–38.

Reset the Extrude Polygon tool and create new sections, using the rotate part of the tool to follow the form of the cup as closely as possible (Figure 5–39).

Select the following:

Modify > Convert > Polygons to Subdiv

Press the 3 key to display the object at maximum smoothing.

Right-click on the object, and select Edge. Select all the edges that make up the inside curve of the object that run along the X axis (anywhere it touches the cup). Select the following:

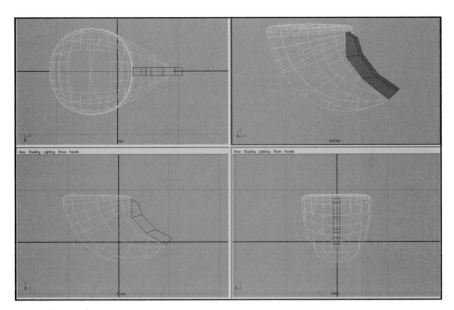

figure |5-37|

Handle.

figure |5-38|

Reshaping the cube.

figure | 5-39 |

Forming the handle.

Subdiv Surface > Full Crease Edge/Vertex

With the added crease, your object should look like the shape shown in Figure 5–40. You may want to switch to Vertex Component mode

figure | 5-40 |

Crease.

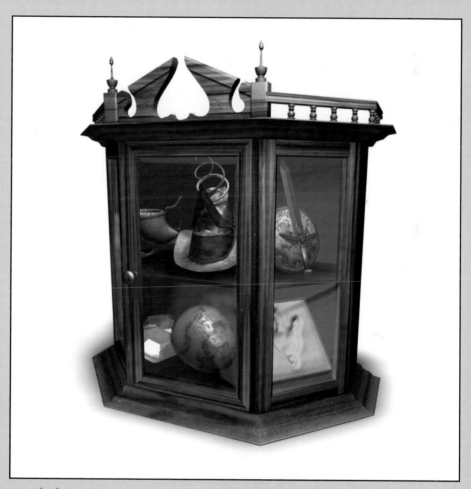

figure 1

figure 2

figure 3

figure | 4 |

figure | 5 |

figure 6

figure 7

figure |8|

figure |9|

figure | 10 |

figure | 11 |

figure | 12 |

figure | 13 |

figure | 14 |

figure | 15 |

figure | 16 |

figure | 17 |

figure | 18 |

figure | 19 |

figure | 20 |

figure 21

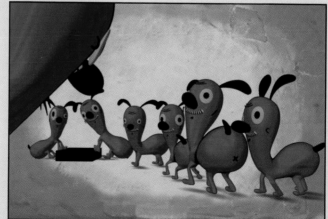

figure | 22 |

figure | 23 |

figure | 24 |

figure | 25 |

figure | 26 |

figure | 27 |

figure | 28 |

© 2002 DongSool Shin

figure | 29 |

© 2002 DongSool Shin

figure | 30 |

figure | 31 |

figure | 32 |

figure | 33 |

figure | 33 |

figure | 34 |

figure | 35 |

figure | 36 |

figure | 37 |

figure | 38 |

figure | 39 |

figure | 40 |

figure | 41 |

figure | 42 |

figure 43

figure 44

figure | 45 |

figure | 46 |

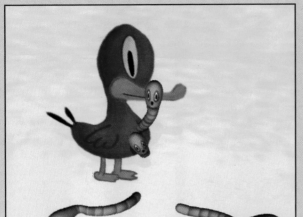

figure | 47 |

figure | 48 |

figure | 49 |

figure | 50 |

figure | 51 |

figure | 52 |

figure | 53 |

figure | 54 |

figure | 55 |

figure | 56 |

figure | 57 |

figure | 58 |

figure | 59 |

figure | 60 |

figure | 61 |

and (in Wireframe display) tweak the vertices of the handle object to more closely match the curvature of the horn.

With the handle object selected, select the following:

Subdiv Surfaces > Polygon Proxy Mode

Select the face shown in Figure 5–41, and extrude it five times to create a leg. Reshape it to get the shape shown in Figure 5–41.

figure | **5-41**

More reshaping.

Select the vertices shown in Figure 5–42a. Scale it on the Z axis until it is about twice as wide. Using the Split Polygon tool with Number of Magnets set to 9 and Magnet Tolerance set to 100, cut a new edge in as shown in Figure 5–42b. Then change the Number of Magnets to 3, and cut another edge in as shown in Figure 5–42c.

Make sure the following is off (not checked):

Polygons > Tool Options > Keep Faces Together

Select the two faces on either side of the last split you just made, and use the Extrude Faces tool in the Front view to create the shape shown in Figure 5–43.

figure | 5-42 |

Tweaking.

figure | 5-43 |

Result of extruding
faces in Front view.

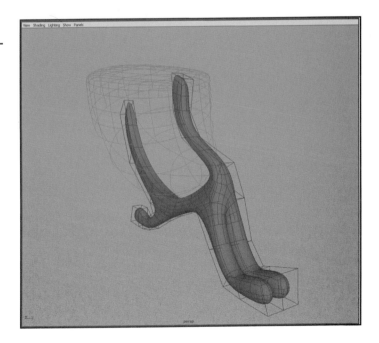

With Keep Faces Together turned off, you should have two separate
legs next to one another (Figure 5–44). For the time being, leave the
back legs in their current position; you will rotate them to the sides
later.

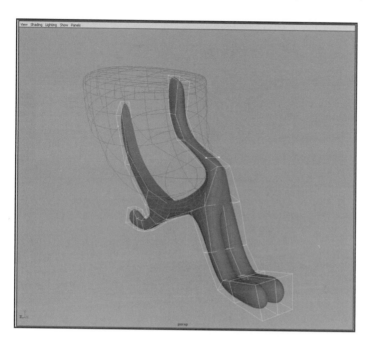

figure | 5-44 |

Two separate legs.

The last step in making the basic shape of the handle object is to create the handle itself.

Use the Split Polygon tool to cut in the base of the handle (Figure 5–45).

Use the Extrude Polygon tool several times to create the shape shown in Figure 5–46.

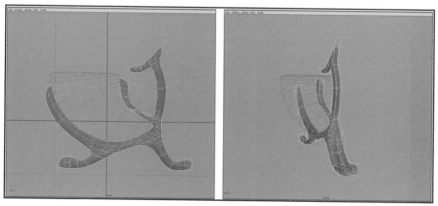

figure | 5-45 |

Cut in the base of the handle.

figure | 5-46 |

Using the Extrude
Polygon tool.

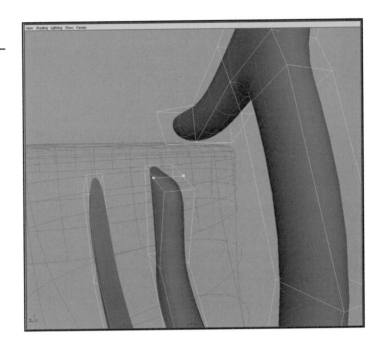

Use the Split Polygon tool to cut in a new face at the top of the handle (Figure 5–47). Select and delete the faces shown in Figure 5–48. Then use the Append Polygon tool to connect the handle to the top (Figure 5–49).

figure | 5-47 |

Using the Split
Polygon tool.

Now that the basic form exists, you need to rotate out the rear legs, which you will do shortly, and fine-tune the surface to get the final result.

Subdivision surface modeling allows you to fine-tune detail and modify the underlying surface without adding geometry to the control

figure | 5-48 |

Delete these faces.

figure | 5-49 |

Connecting the handle to the top.

cage, which is a convenient aspect of this feature. When you work with a polygon model and use the Smooth tool, any detail needs to be created in the base object. With subdivision surfaces, you can work on the surface itself and refine the detail of the surface separate from the polygon reference object. You can also create edges without needing to build up geometry by using the Full/Partial-Crease tools.

Select the handle object, and switch to the following:

Subdiv Surfaces > Standard Mode

Right-click on the handle object, and select Edge. Select the bottom edges of the feet, and select the following (Figure 5–50):

Subdiv Surfaces > Full Crease Edge/Vertex

figure | 5-50 |

Creasing the bottoms of the feet.

There are a few other edges that should have partial creases applied to enhance the shape of the handle.

Select the edges on the top of the handle area where the thumb would rest. Apply Partial Crease to those edges. You may also want to tweak the vertices a little to enhance the shape of the thumb rest (Figure 5–51).

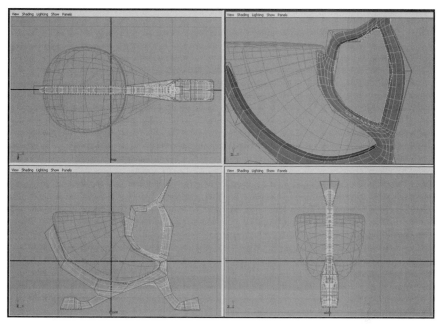

figure | 5-51 |

Tweaking the thumb rest.

Select the edges inside the handle indicated in Figure 5–52, and apply Partial Crease.

Some other areas that would benefit from having creases applied are the back of the front foot and the back of the rear foot. Select those edges, and apply Partial Crease (Figure 5–53).

Now you will tweak the overall shape and then rotate the legs out 45 degrees to get close to the final model.

Select the face at the rear left leg above the foot, and scale it to about one-third its width. (You can do this in either Standard or Poly Proxy mode.) Repeat for the right leg. Figure 5–54 shows the result.

For each rear leg, scale the width of the face at the front side of the foot down to about 20 percent of its width. Using the snap settings in the Snap tool's options panel will make this easier by forcing the tool to work in predefined stepping values (set the Step Size to 0.25 or so). Figure 5–55 shows the result.

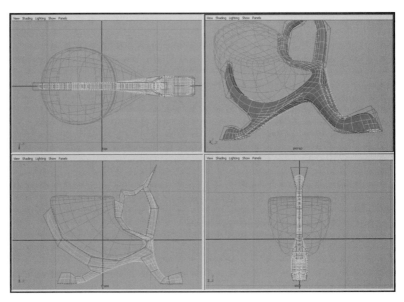

figure | 5-52 |

Applying Partial Crease.

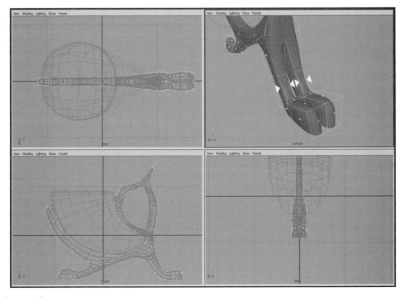

figure | 5-53 |

Adding partial creases for the remainder of edges.

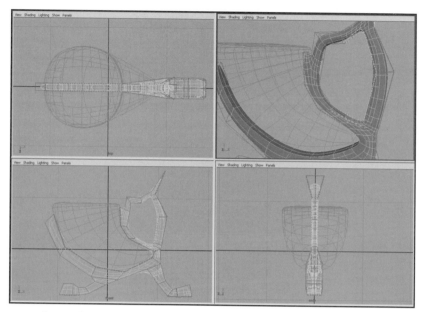

figure | 5-54 |

Scaling face.

figure | 5-55 |

Scaling the width.

Scale the widths of the face at the top of each foot (front and back) down to about two-thirds of their initial values. Scale the faces at the bottom of each foot up to about one and one-half times their width (Figure 5–56).

figure | 5-56 |

Scaling the faces up.

Finally, scale the width of the faces that make up the back of the handle and the leading edge of the front of the handle object down to about one-third of their original widths (Figure 5–57).

You can now tweak the vertices to refine the shape in any way you want to make the overall look more pleasing (Figure 5–58).

Switching to Polygon Proxy mode (Figure 5–59), select the vertices on the outside of one of the rear legs. Expand the selection (Shift + >) three times or until you have all the points selected except the ones where the leg meets the handle.

From the Perspective view, looking at the model from the back, activate the Rotate tool, press the Insert key, and hold down the V key

figure | 5-57 |

Scaling width.

figure | 5-58 |

Tweak the vertices until it pleases you.

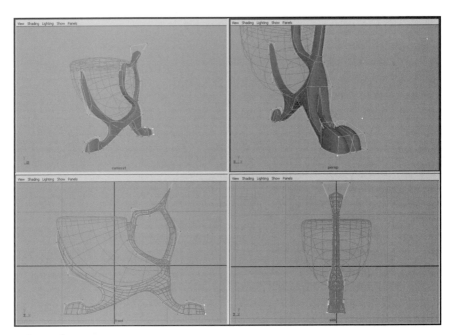

figure | 5-59 |

Polygon Proxy mode.

(point snapping). Move the crosshair for the tool's pivot point to the vertex at the front outside base of that leg (Figure 5–60).

Press Insert again to return to the tool. Rotate the leg outward 45 degrees (Figure 5–61). (Using the snap settings for the Rotate tool makes this more precise.) Repeat the operation for the other leg.

Selecting the middle vertices for both of the rear legs and scaling them inward, as well as grabbing the outside middle vertices and slightly moving them backward, should eliminate the twisted appearance (Figure 5–62).

Turn off Template Display mode for the cup layer, and make sure both objects are set to Polygon mode.

Switch to Face Component mode. Select the top face of the cup and use the Extrude Face tool with the scale manipulator (do not move it) to create a new face inset from the original. Use the Extrude Face tool again, but this time move it downward into the cup. Repeat twice using the scale, and rotate handles in addition to moving the handles to create an interior for the cup (Figure 5–63). You will need to switch

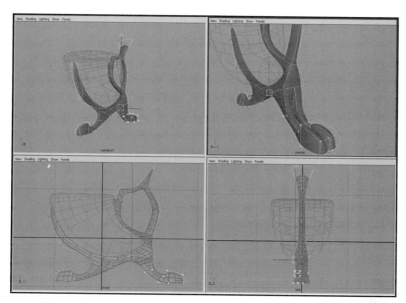

figure | 5-60 |

Tweaking the handle.

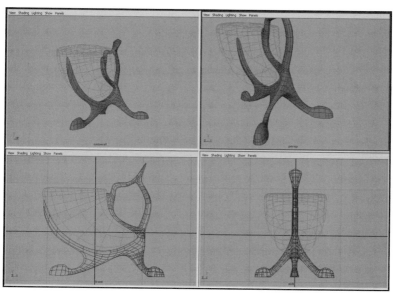

figure | 5-61 |

Rotating the leg outward.

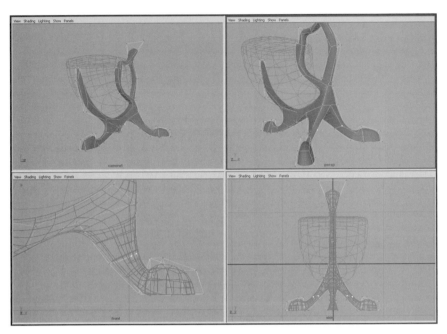

figure | 5-62 |

Eliminating the twisted appearance.

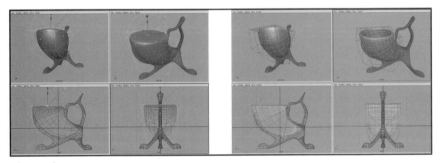

figure | 5-63 |

Creating an interior for the cup.

back to Standard mode and check the edges to ensure that the rim has a partial crease applied and the interior edges have none (indicated by the dashed line).

Now you will refine and tweak the subdivision surface to get the final result.

Switch to the Front view, right-click on the horn, and select Vertex. Drag a box around the first two rows to select them. Drag the first two rows of vertices, which should be indicated as the number "0".

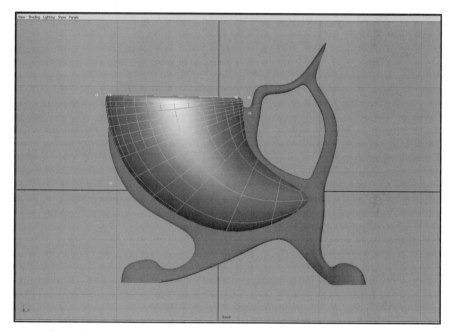

figure | 5-64 |

Refining the surface.

Right-click and select Refine from the menu. You will notice the 0's turn into 1's, and there are more of them. Select all the 1's in the same region and right-click Refine again. Repeat the operation one more time so that all 1's turn into 3's (Figure 5–65).

Select the vertices that make up the top and the first four rows, and use the Scale tool to slightly and uniformly scale up the vertices (Figure 5–66).

Using this technique of refining and tweaking the surface, add detail to the handle object either by making it like the version pictured in Figure 5–67 or by choosing your own design.

The final step is to texture and light the model, which you can do now or after you have completed Chapter 6, the texturing chapter.

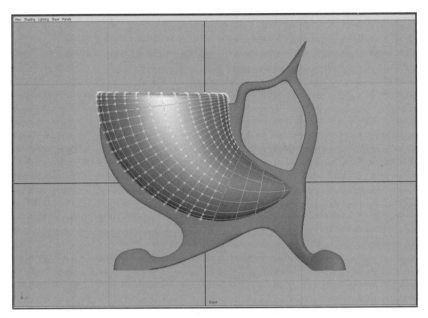

figure | 5-65 |

Refined to level 3.

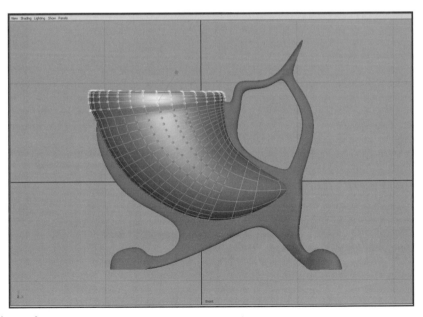

figure | 5-66 |

Scaling up the vertices.

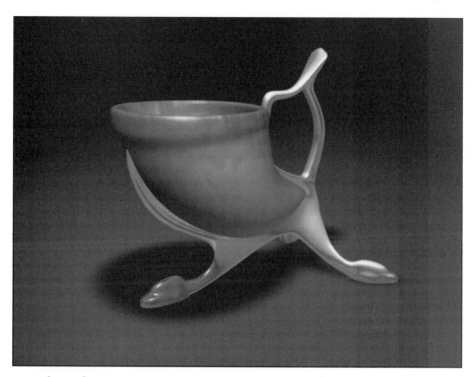

figure | 5-67 |

Final rendering of the talon cup.

Remember, some of the detail you may want to add can be handled more quickly and easily with texturing methods instead of modeling.

Check out designs of ancient potters. The MIHO museum of Japan has some interesting cups with dragon handles.

One contemporary cup artist, Irvin Tepper, makes nontraditional designs with ceramic cups.

Another ceramic artist, Krista Grecco, makes cups inspired by the human form (Figure 5–68).

figure | 5-68 |

Human-form cup, Krista Grecco. (Photo by Krista Grecco.)

SUMMARY

Do not spend all your time in a darkroom on the computer—go to museums and art shows. Your work will be much less predictable when you open your eyes to the influence available in art, nature, and your community.

You now have some exposure to Maya's modeling tool set. By starting with the basic polygon tools and building on those skills with the subdivision surfaces tools, almost any object you see or can imagine is within your grasp. Experiment with these tools as often as you can; as with most things, skill comes from practice.

in review

1. How do you create areas of extra detail in a subdivision surface object?

2. How do you create a detail in a primitive using Subdiv surfaces?

3. How do you switch from Standard mode to Polygon Proxy mode?

4. How do you combine two subdivision surface objects into a single object?

5. How many levels of detail are available in subdivisional modeling?

6. What two modes of modeling are available to you in subdivisional modeling?

▶ EXPLORING ON YOUR OWN

1. Convert several objects from NURBS, polygons, and subdivisional surfaces into each other and note the differences conversion incurs.

2. Look up books on sculpture and ceramics. Find an appealing artist, and use his or her work as an influence for a cup design.

3. Create a cup based on your favorite flower or plant.

notes

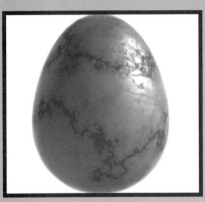

color texture

 charting your course

Objects in the real world have varying qualities of color, reflection, smooth-
ness, and transparency as well as other more subtle characteristics based
on the substances they are made from. In this chapter, you will learn the
concepts associated with creating materials in Maya, the basic building
blocks of a material, and how to modify these attributes and apply them to
your objects.

 goals

● To understand the definitions of the basic material types.

● To learn how to edit the basic material types to create your
 own materials.

● To learn how to build basic shader networks for more complex
 surfaces.

NAVIGATION

The tools used in this chapter reside primarily in the Hypershade and Attribute Editors (Figure 6–1).

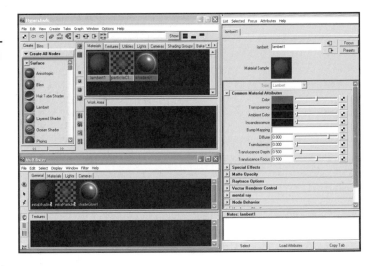

EXPLANATION OF MATERIALS AND BASIC SHADER NETWORKS

A material is a description of an object's surface used by Maya's rendering engine.

Materials are also a collection of simple nodes with their own individual functionality that are connected in such a way as to create a more interesting or complete surface description. These connected nodes are collectively referred to as a shader network (Figure 6–2).

In some cases, a shader network may consist of only a material and a shader group node. (This is the default.) In other situations, dozens or even hundreds of nodes may be connected in a network to create a material that not only may be unique and visually interesting but also has the functionality to react to things outside of itself, such as light, the camera, and its position in 3D space. Shader networks can be connected to the current frame number to make them evolve as time passes in your animation. Although it lies outside the scope of this book to go into examples of these more sophisticated shader networks, it is useful to be aware of what is possible as you develop your skill set.

THE STARTING POINT—CREATING SURFACE MATERIALS

When you want to create a new material using either the Multilister or the Hypershade Editors, you have several options. The most basic five options are Anastropic, Blinn, Lambert, Phong, and Phong E materials. With the exception of Lambert, the main difference among these surfaces is in the way they each handle specular shading (the highlight created by a light source). A "specular highlight" is not something that exists in the real world: The highlights you see on objects are actual reflections of light sources. Since this would otherwise require time-consuming processes, like ray tracing, to accomplish in Maya, an effective alternative has been devised in which shiny spots are automatically created on surfaces, with these spots corresponding to positions of light sources in your scene. Therefore, picking a material with specular shading that corresponds as closely as possible to the type of material you are trying to simulate is important.

Blinn tends to have softer specular shading, whereas Phong and Phong E have a more concentrated, high-contrast highlight. Anastropic is used for surfaces that require a highlight that is broken up by grooves in the surface (e.g., brushed metal, hair, or the underside of a CD). Lambert has no specular shading and is used primarily for dull, nonreflective surfaces.

In addition to the five basic material types, other materials include Hair Tube Shader, Layered Shader, Ramp Shader, Shading Map, Surface Shader, and Use Background. These are more specialized materials with specific functionality. A Layered Shader is used to assemble several materials into one master material. Good examples

are a paper label on a glass wine bottle or metallic paint with a clear-coat finish. In these examples, the need to describe different material qualities on the same surface can often be more easily achieved by separately building each one and then assembling them into one surface description. Finally, there is the Ocean Shader, which is used for Fluid Effects objects.

There are several methods of applying a material to an object:

- Click your right mouse button (RMB) on the object, and then select the following:

Material > Assign New Material (or Existing Material)

- Open either the Hypershade or the Multilister Editor, and select a previously created material. Use your middle mouse button (MMB) to drag the material to the object in one of the viewports.

- Select the object you want to apply the material to, right-click on the material in the Hypershade Editor, and select Assign Material to Selected. Or, you can select the following in the MultiLister Editor:

Edit > Assign

When you select a newly created material that has been applied to an object and open the Attribute Editor, you should see several surface characteristics in the Common Material Attributes area such as color, transparency, ambient color, and bump mapping. (The characteristics will vary based on the type of material.) They can all be modified directly; for example, you can click on the color chip to the left of the Color slider and assign a color with the color editor. You can also click on the Checkerboard icon to the right of each attribute and assign one of the varieties of nodes to create more complex surface descriptions. These surface descriptions range from procedural (generated mathematically inside of Maya) textures—such as Ramp, Noise, Grid, Checker, Wood, Marble, and Cloud—to File and Movie, which allow you to apply images, animation, and video created in other packages or captured from a video source as textures.

Open Maya, and create a new NURBS sphere. Right-click on the sphere in your viewport, and select the following (Figure 6–3):

Materials > Assign New Material > Blinn

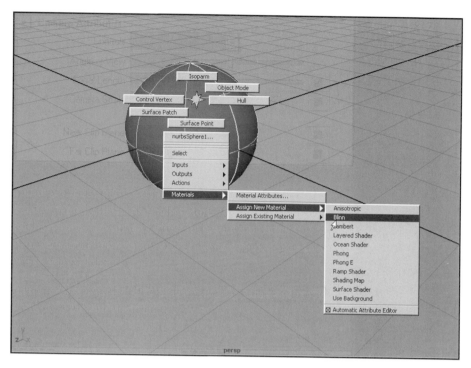

figure |6-3|

Assigning new Blinn material.

The Attribute Editor will open. Click the MMB in your viewport to make it current, and press the "6" key to switch to Texture Shaded view so that you can see the effects of the changes you will be making.

Now left-click the color chip to the left of the Color slider; when the color picker appears, pick a bright red color. Notice the change to the sphere in your viewport (Figure 6–4).

Now left-click on the checkerboard chip to the right of the Color slider. When the Create Render Node window appears, make sure Normal is selected and click on Checker. Notice the change to your sphere (Figure 6–5).

Click on the Go to Output Connections button to get back to the Blinn material (Figure 6–6). Right-click on the word Color next to its slider. From the pop-up menu, select Break Connection (Figure 6–7). The Checker texture is now gone. Click on the icon to the right of the Color slider and select File this time. When the File tab

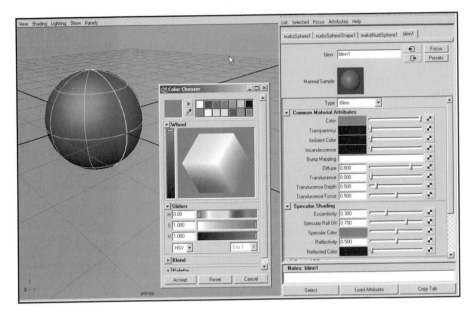

figure 6-4

Changing color.

figure 6-5

Assigning checker
texture.

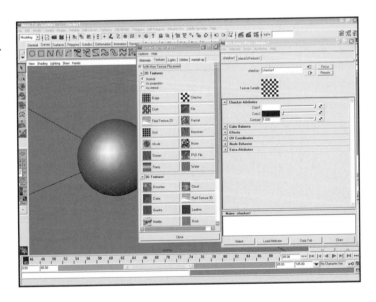

appears, click on the Folder icon to the right of the Image name
field. Navigate to the Chapter 6 source images directory and select
"dots.iff." Notice the change to the sphere (Figure 6–8).

figure |6-6|

Go to Output
Connections button.

figure |6-7|

Breaking the
connection.

figure |6-8|

Image textured
sphere.

Left-click on the IPR (interactive photorealistic rendering) icon in
the upper right. This will preview the rendering of the sphere and
will allow rapid previewing of the changes you make to the material
(Figure 6–9). Once IPR is complete, left-click + drag a box around

the image of the ball. This tells IPR to update that region when changes are made.

figure | 6-9 |

IPR rendering of sphere.

Return to the blinn1 tab in the Attribute Editor and drag the Color slider next to Transparency to the right. Watch IPR to see the result.

Set the Transparency slider back to zero (to the far left) and click on the Checker icon to the right of the Transparency slider. With Normal checked, select the Checker material. Notice the change in IPR. Maya is rendering the image as transparent where the texture is white and opaque where it is black. This will be true of any texture you apply to the attributes of the Blinn material with the exception of color and reflected color. Whatever the effect is, it will be applied at its maximum where the texture is white (1.0) and not at all where the texture is black (0.0).

Try applying another Checker texture to Specular Color. In this case, you will get a highlight in the transparent regions and none in the opaque ones. This is because you are getting a maximum specular effect in the white and none in the black. In this case, if you wanted

to have your highlight on the opaque areas and not on the transparent ones (which would seem logical), edit the checker attached to Specular Color so that color 1 is black and color 2 is white.

Try experimenting with bump mapping and editing the bump depth value on the bump2d tab.

Reflection on your materials can be generated by two methods: ray-traced reflections and environmental map shading. The former requires you to turn on ray tracing in the Render Global window (Window > Rendering Editors > Render Settings > Raytracing Quality. Check the Raytracing option); Maya will then calculate accurate reflections for all objects in the scene. Try placing several objects in a scene, assign Blinn or Phong materials to each, turn on ray tracing in the Render Settings window, and do a test render.

IPR does not work with ray tracing, so you will get an error if you try to do an IPR render with ray tracing turned on. Use the standard render or Mental Ray to see the effects of ray tracing.

Environmental mapping is a method of getting color information for the reflection from an existing bitmap or procedural texture. This often will produce satisfactory results when true reflections are not required and has the bonus of rendering much quicker than ray tracing.

Load the file "simpleModel_02_Pen.mb" from the CD. When the scene loads, do an IPR render and click + drag a box around the pen. Then select the body of the pen and open the Attribute Editor. Go to the pen_phongE tab and click on the Checkerboard icon to the right of Reflected Color. Scroll down to the bottom of the Assign Material window until you see Environment Texture. Click on Env Ball to apply it. Next, click on the Folder icon to the right of Image Name on the Env Ball tab. Assign a File texture and, when the file tab appears, load the file "SilverReflection.iff" from the source images directory on the CD. Notice that your pen now has a reflective appearance in the IPR window (Figure 6–10). This effect becomes even more believable when the pen or the camera is animated and the reflections slowly change.

As you add these new texture attributes to a material, you are building a shader network. Try the following:

Create a new scene and make a NURBS sphere at the default settings. Open the following:

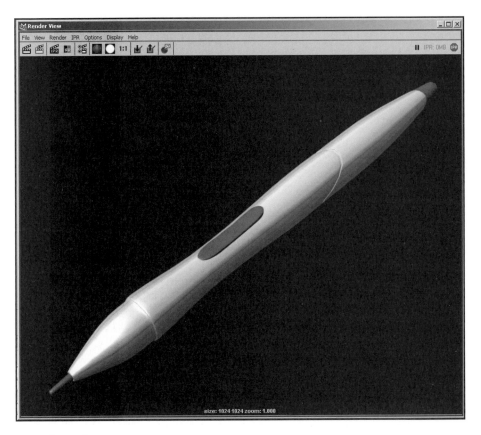

figure | 6-10 |

Rendering of pen with environmental reflection.

Window > Rendering Editors > Hypershade

Make sure the Create bar on the left and the top and bottom tabs to
the right are visible. (These are accessed by clicking the Checker-
board icon in the upper left for the Create Bar and the Show Top and
Bottom Tabs button in the upper right.) Figure 6–11 shows the
screen shot.

Make sure the Create Bar is set to Create Materials as in Figure 6–11
(from the pull-down menu on top of the bar) and the Surface sec-
tion is open. Click on Blinn. You should see a surface called blinn1
in the work area. Click your MMB on the Blinn material and drag it
onto the sphere you just created. (Make sure you are in Texture
Shaded view when you do so you can see the effects by clicking your
MMB in your viewport and pressing the "6" key.) If the Attribute

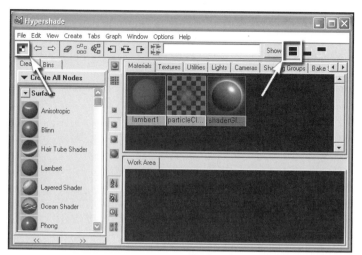

figure |6-11|

Hypershade with all views visible.

Editor is not already open, select the Blinn material again and press Ctrl A to open it. (You can also simply double-click on the material.)

Click on the Checkerboard icon to the right of Color. When the Create Render Node panel appears, select Normal as the method and click on the Checker 2-D material. The panel should close, and your ball should now have a checkerboard pattern applied. You should also notice that, in the work area, your material is now made up of three connected nodes (Figure 6–12): the original Blinn material, a new checker material node, and a 2-D placement node.

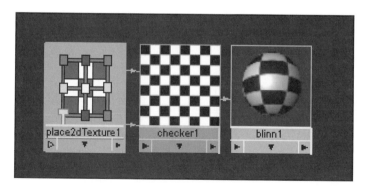

figure |6-12|

Three nodes in a shader network.

Click back on the Blinn material and, in the Attribute Editor, click on the Checkerboard icon next to the Bump Mapping attribute. This time, select the Bulge texture. Although you will not see a change in the viewport, your material swatch should be updated to look somewhat bumpy, and you will notice that there are now

more nodes in your network (albeit a little jumbled and hard to interpret). Right-click in your work area, and select the following (Figure 6–13):

Graph > Rearrange Graph

figure | 6-13 |

Shader network with bump texture added.

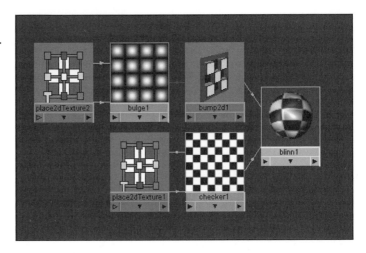

Now your shader network should make more sense.

This is a basic demonstration of how shader networks are built in the simplest form. Each part describes some aspect of the surface and feeds it forward to the next node for additional processing. We will go into more methods for constructing these networks later in the chapter.

Photoshop Textures

Maya 7 has added support for the Adobe Photoshop file format. You can import layered Photoshop textures into Maya as well as create them from within Maya.

To add a Photoshop file as a 2-D texture for an existing material, do the following:

Create a texture image in Photoshop (it is a good idea to always work with square image maps such as 512 pixels by 512 pixels or 1024 by 1024 pixels). Use Layer Sets to group your layers if you want to have multiple maps from a single PSD file (i.e, color, bump, diffuse, etc.); otherwise Maya will treat your Photoshop file as one flattened image. Having multiple maps in the same file is a good workflow habit

and can make creating maps that need to correspond with one another easier (like color and bump information, for example). It is a good idea to name the layer sets as they will be used so they will be easy to understand and select in Maya.

In Maya, click on the Checkerboard icon in the Attribute Editor next to the material attribute for which you want to load a map. When the Create Render Node window appears, select the PSD File node in the 2-D Textures section (Figure 6–14).

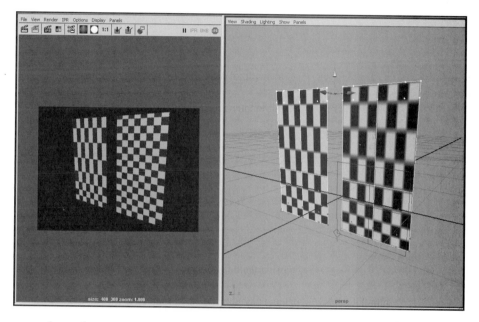

figure | 6-14 |

Create Render Node window with new PSD texture node.

The PSD File Texture node looks and functions almost exactly like the File Texture node you are already familiar with. Load your PSD file by clicking on the Folder icon next to the Image Name field and selecting the file on your hard drive just like you would with the File Texture node. If you have layer sets in your PSD file, the Link to LayerSet pull-down menu will become active and allow you to select a layer set as your source (otherwise, as stated earlier, Maya will treat the PSD file as one flattened image); (Figure 6–15). If you need to edit an existing PSD File Texture node, simply select the Rendering menu set and go to Texturing > Edit PSD Network.

figure | 6-15 |

Link to Layer Set
pull-down menu.

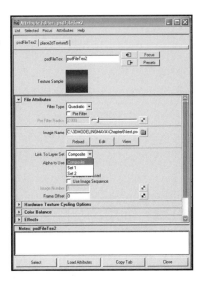

To create a PSD file from within Maya, assign a material to the object you want to create the PSD texture for. Select the object, switch to the Rendering Menu set and select Texturing > Create PSD Network. When create PSD Texture Options window appears, you will need to make some choices before Maya can create the file (Figure 6–16).

figure | 6-16 |

Create PSD Texture
Options window.

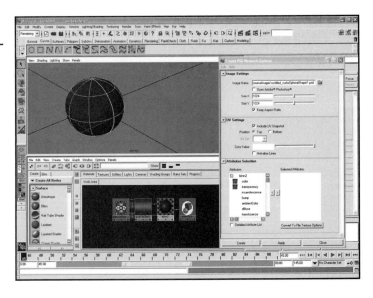

In the Image name field, you can tell Maya where and with what name to save your new PSD file. The Size X and Y sliders are the pixel dimensions for the new file (by default they will be linked to create a square image). Checking Include UV Snapshot is useful

because it will include an unrolled wire frame image of your model in the PSD file for reference when painting your maps in Photoshop (the wire frame will not appear in your textures by default). One note, depending on how the object has been modeled, the UV Snapshot information may or may not be useful and may require "rebuilding" the UVs for an object prior to this operation. The final two columns allow you to select what attributes of the current material you want linked to the PSD file, which will create and name layer sets for each. You can add or remove attributes to the right-hand column until you click the Create button at the bottom of the window.

One note, Layer Effects are not supported from within Maya so you will need to rasterize or flatten any Layer Effects you have applied in Photoshop for them to appear in Maya.

Hypershade Sorting Bins

Maya 7 has added a SORTING BIN feature to the Hypershade Editor for organizing your materials and textures. This can be found by clicking on the Bins tab in the left column of the Hypershade Editor (Figure 6–17).

Sorting Bins function as organizational filters so you can view your materials based on categories you define. This will be most useful in complex scenes with a lot of materials and textures (Figure 6–18).

You can create new bins by clicking the Create Empty Bin icon (or right-clicking in the Bins area and selecting Create Form from the pop-up menu). You can then add materials and textures to the new bin by selecting and middle-clicking + dragging them to the bin name or right-clicking on the bin name and selecting Add Selected from the pop-up menu.

You can also preselect materials and click on the Create Bin from Selected icon (or right-click and select Create Bin from Selected from the pop-up menu). To remove items from a bin, select the bin, select the item or items in the Hypershade Editor and then, right-click on the bin name and select Remove Selected.

The Select Unfiltered button will select any material nodes that do not currently belong to any bin (other than the default Master Bin). Items can belong to more than one bin at a time unless you use the Make Selected Exclusive option by right-clicking on the bin name with a material or texture belonging to that bin selected.

figure |6-17|

New Hypershade Sorting Bins tab.

figure |6-18|

Sorting Bin tool
icons.

You can delete, duplicate, empty the contents of, and rename any bin
you create by right-clicking on it and selecting the appropriate
choice from the pop-up menu.

UV AND PROJECTION MAPPING

For textures you apply to your materials, you can choose the application method, which means how the texture gets wrapped to or projected onto a surface when you add it.

For 2-D textures, the options are Normal (UV) and As Projection. The third choice, Stencil, is provided to mask out areas of the image being applied either by deciding what color in the texture will become transparent (Color Key masking) or by using a black-and-white image loaded in the mask channel of the Stencil node. In any case, this option will use either the UV or projection method to apply information.

Normal (or UV) breaks down the surface into two-dimensional coordinates (U and V) with values between 0 and 1. This method assigns surface colors based on how pixels in the texture correspond to any given spot on the surface. Imagine if you could take a sheet of wrapping paper and wrap an object, but rather than folding or wrinkling, it would "shrink-wrap" to fit tightly and exactly to the surface and be glued to it. This is UV mapping. Projection mapping, in contrast, uses one of several methods of projecting a material or texture onto a surface that, rather than following the surface, follows their method of projection. (Think of your texture being applied by a movie projector.) Methods of projection mapping used by Maya are Planar, Cylindrical, Spherical, Ball, Cubic, TriPlanar, Concentric, and Perspective. The easiest way to learn the differences is to set up a couple of objects with a projection-mapped texture and set up IPR so that you can watch the effect as you change the Proj Type setting on the Projection tab. You can also look at the placement node in your Perspective view to learn how each method applies itself. (Try moving it around and watch the effect it has on the texture.)

Taking the earlier example, if you imagine a movie projector, the image would appear fairly accurately on an adjacent wall or any surface facing the projector, but it would streak when it hit surfaces that were turning farther away from the projection source. Taken a step further, in Maya, the colors that appear on the front of an object would also appear on the back side because the texture would project through the surface. A point on the front of an object can share color information with a point on the back, and moving the surface around in relation to the projection source will cause the texture to slide or smear. The point of distinction to remember is that the UV method actually wraps the texture to the surface, whereas the projection

method, much like its name indicates, uses a method of projecting texture onto the surface.

Try the following quick example to illustrate the difference:

Create a new scene in Maya, and make two NURBS planes with the Width and Length set to 1.00, the U and V patches set to 2, and the axis set to Z. Offset them on X so that they sit to the right and left of one and other.

Create new materials for each plane. Assign a checker color texture to the one on the left using Normal as the method. Assign a checker pattern to the one on the right using the As Projection method. When the Projection tab appears in the Attribute Editor, click on the Fit to Box button to fit the placement node exactly to the plane's size. For each plane, right-click and select Control Vertices to switch to CV Component mode. Select the top two rows of CVs, and move them upward. They should both appear to stretch out their texture in the top half of the model. Now conduct a test render. You will notice that the one on the left is stretched, but the one on the right is not (Figure 6–19). This is because the UV texture is attached to the underlying geometry, whereas the projection map is not and will only tile itself to fill up the space.

figure | 6-19 |

The difference between two projection methods.

Why would you use one method over another? By default, when you create a primitive NURBS or polygon object in Maya, it has UV coordinates associated with it. However, you may find that in some cases the default method does not produce the results you are looking for. Additionally, if you create objects from Scratch, Merge, Stitch, or Extrude or import them from other programs, generally the UVs associated with these objects become useless (particularly with polygons). If you want to use them, they would need to be reconstructed through various means. This can be complicated, confusing, and tedious. Often all you need is a method of simple projection to get the surface onto your object. A good example is a head: Often a simple cylindrical projection will work fine and can be set up in a few seconds. However, if you need very specific placement in your texture that has no distortion or smearing, projection mapping will not necessarily work well for all types of objects. UV mapping also allows you to export unrolled snapshots of your mesh that can be painted over in a program, such as Photoshop, so that when the resulting map is applied, the texture will apply exactly as you anticipate it should.

TUTORIAL: COLORING AND TEXTURING A GRIFFIN EGG

The material for our griffin egg will re-create the qualities of the substance agate, a colorful, milky, translucent gemstone with veins of color running through it. In this exercise, you will use texture maps supplied on the CD to build the agate material.

Launch Maya and load the file "GriffinEgg.mb" in the Chapter 6 scenes folder on the CD. The egg scene file is displayed in Figure 6–20. You will be creating a surface material for this model and then adding four bitmaps to control various aspects of its surface description.

You will be asked to name nodes as you create them. This is an important habit to develop because shader networks can get complex and hard to decipher rather quickly without proper labeling. And, if others are going to be sharing your files with you, naming all the nodes will make the job of understanding your work easier.

Right-click on your egg model. When the marking menu appears, select the following:

Materials > Assign New Material > Blinn

The Attribute Editor will appear with the material you have just created and assigned to your egg.

figure | 6-20 |

Egg scene file.

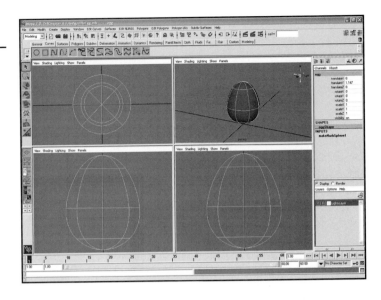

Name the material "eggSurface_blinn." Click on the Checkerboard icon for Color. Under 2-D textures, make sure Normal is selected and click on the File material to select it. Normal is used as the method of application because the textures you will assign are created specifically for UV texturing. When the File options appear in the Attribute Editor, name the file "color_file," click on the Folder icon next to Image Name, and load images/blueAgate-egg.tga. If you have your Texture Shaded view active, you should see something similar to Figure 6–21.

figure | 6-21 |

Adding color texture to the egg.

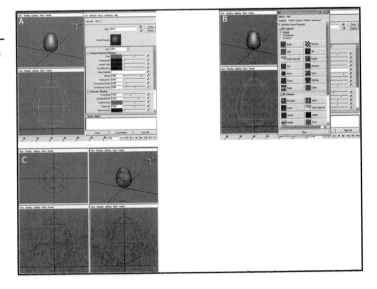

Now you have a more interesting surface, but color is not the only characteristic we associate with objects in the real world. Qualities like bumpiness, shininess, reflectivity, and opacity are all characteristics that you can control to make more convincing materials.

Click on the Checkerboard icon for Bump Mapping. Apply the File material again with Normal as the method. The "bump2d1" options should appear in the Attribute Editor. You will edit the Bump Depth value in this tab, but first click on the Go to Input Connections icon to the right of Bump Value (Figure 6–22). This will take you to the File tab. Name it "bump_file." Click on the Folder icon and load "sourceimages\bump_spec-egg.tga".

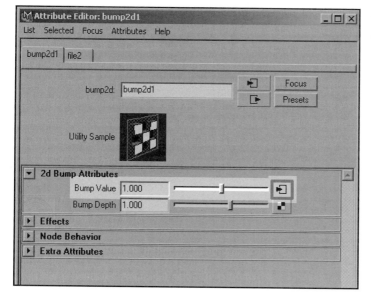

figure 6-22

Input Connection for Bump Value.

Click your MMB on your Perspective viewport. Then click on the IPR button on the upper right of your screen. You should notice that the bump seems a bit too high (Figure 6–23).

Click + drag a box around the egg in the IPR window. (This will make IPR refresh that area as you fine-tune the shader.) Click on the Go to Output Connections button at the top of the File Shader tab. This will take you back to the "bump2d1" tab (Figure 6–24). Slowly drag the Bump Depth slider to the left, gradually decreasing the value toward zero. Observe the changes in the IPR as you do. Using the IPR in this fashion is a fundamental method for quickly tuning your materials in Maya.

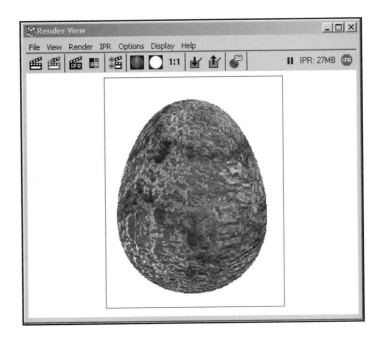

figure |6-23|

Initial bump map results.

You should set the value to 0.005; you want just a hint of surface variation for visual interest but not true bumps (since eggs are generally fairly smooth). The result should look like that in Figure 6–25.

Next, apply a new File texture to the Specular Roll Off attribute, and use the same image you used for the bump map. Watch IPR to see how each change affects your material. Name the new file node "specular_file."

Finally, apply a File texture to the Specular Color attribute and load "sourceimages\ramp_egg.tga". This adds some subtle color to the highlight area of the egg. Name the file node "Spec_color_file." You could also have used a Ramp texture. (Try it, and experiment with editing the colors and watching IPR.)

You are almost done. You have a textured model with some interesting surface characteristics. One additional quality that you will now add is a slight amount of transparency to the model. You could simply use the Transparency attribute, but this effect would be uniform

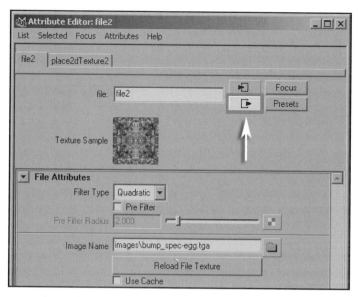

figure | 6-24 |

Going to the Output Connections button.

figure | 6-25 |

Egg with bump map fine-tuned.

and flat. It would not mimic what the effect that would result in real life: that the transparency would appear near the edges where the surface is thinnest, which would allow light to pass through, and not in the center where the greatest mass resides. There are several ways

to accomplish the intended effect in Maya. The simplest way is to combine the work you have done with a Ramp Shader and then use its transparency controls to finish it.

Open the following:

Window > Rendering Editors > Hypershade

Select the "eggSurface_blinn" material in the top area with your MMB and drag it into the work area. Click the Show Input and Output Connections button to see your current shader network (Figure 6–26).

figure | 6-26 |

Graph of existing egg material.

Now click on the Ramp Shader under the Create Materials bar to create a new Ramp Shader (Figure 6–27). Name the Ramp Shader "masterEggSurface_rampShader."

You can close the top panel to make more room for working by clicking on the Show Bottom Tab Only button, which is the middle button on the upper right of the Hypershade window (Figure 6–28).

Double-click on the new Ramp Shader in the Hypershade window to open its Attribute Editor. Rearrange your screen so you can see both the Attribute Editor and the Hypershade window (Figure 6–29).

figure | 6-27 |

Creating a Ramp
Shader.

figure | 6-28 |

Rearranging the
Hypershade window.

Click your MMB on "eggSurface_blinn", and drag it to the Selected
Color Attribute of the Ramp Shader. When you let go, look at the
Hypershade window to see that the two shaders are now connected
(Figure 6–30).

Set the Color Input to Brightness (Figure 6–31).

You have told the Ramp Shader to take its color information from
the Blinn material you built, which will also include the bump and
specular information.

figure | 6-29 |

Arranging the
window for working.

figure | 6-30 |

Connecting "eggSurface_blinn" to the color of the Ramp Shader.

figure | 6-31 |

Setting color input for Ramp Shader to Brightness.

Click your MMB on the new material and drag it to the egg. IPR will now update with changes made to the new material.

Click on the Selected Color chip under Transparency, and set it to R 0.800, G 0.800, B 0.800. Set its Selected Position to 0.100. Add a new ramp color by clicking in the middle of the ramp area for Transparency. With the new color added, set its Select Position to 0.450 and its color to black. IPR should now display your egg with a slightly soft, translucent edge (Figure 6–32).

Congratulations! You have finished. In this exercise, you have learned some of the fundamentals of materials and making connections between different nodes to build more complex surface descriptions.

The bitmaps used in this exercise were created in Maya from a shader network made by the author using a combination of bitmaps and procedural textures. This was accomplished by using the Convert File to Texture feature found under the Edit menu in the Hypershade window. When you use this feature, Maya will "render" all the nodes that contain image information to bitmap files and create a new material that uses the bitmaps instead of the original network.

figure | 6-32 |

Egg with translucent edge.

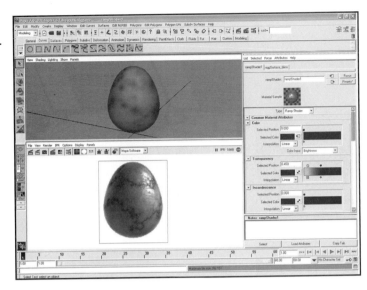

You have options to bake the lighting and shadow information into your textures, eliminating the need to calculate them again. This feature is most useful to game developers, but it can be a useful utility to speed up rendering times in other situations as well.

TUTORIAL: RENDERING GEMSTONES AND SIMULATING CAUSTICS

In the real world, transparent materials such as glass, water, plastics, and gemstones bend and refocus light that passes through them to a greater or lesser extent based on the type of material, the shape of the object, and its thickness. The light then forms patterns of light and dark on any surface it strikes beyond the transparent object. This phenomenon is known as refraction.

In Maya, this effect is referred to as caustics. True refraction is calculated by having the rendering software run a simulation based on the physical properties of light and materials. The results can be stunning but often at the expense of time required to complete the rendering. (The effect can add minutes, hours, or even days to a rendering depending on complexity.) Often, you can use tricks to simulate the effects that are much less expensive in terms of rendering time using shader network tricks or light maps that you paint. Figure 6–33 shows an example. Refraction is most useful for still renderings, but it can be used in animation as well. After completing

this tutorial, experiment to familiarize yourself with the tools used so that you will learn how to judiciously use caustics.

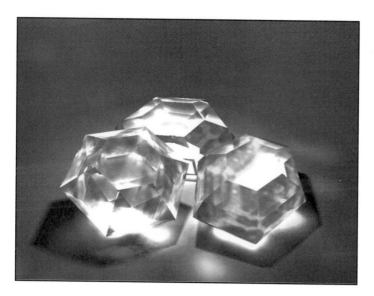

figure | 6-33 |

Gemstones rendered with caustics.

Maya provides an extremely powerful caustics simulation in its alternate rendering engine–Mental Ray. Mental Ray uses a technique known as photon mapping in which a light (or lights) emits photons that are cast and bounced around the scene based on the material qualities and the number of objects intersected. You generally will set up and test render your scene using preview quality settings to rapidly refine the effect of the caustics.

Load the scene "gemstones_start.mb" from the CD (Figure 6–34).

The first step is to set Mental Ray as the current render engine. From the Rendering menu set, select the following:

Render > Render Using > Mental Ray

Now open the following:

figure |6-34|

Gemstones scene.

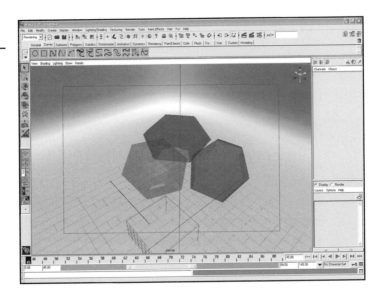

Window > Rendering Editors > Render Settings

In the Mental Ray tab of the Render Settings, select Preview Caustics form the Quality Setting pop-up menu.

If you scroll down to the Caustics and Global Illumination section, you will see that Caustics has been turned on (Figure 6–35).

figure |6-35|

Caustics and Global
Illumination settings.

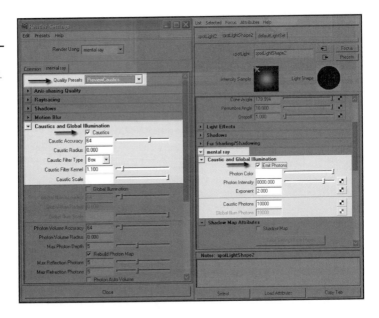

After turning the Caustics feature on in the Render Settings, the remaining step is to activate Photo Emission for the spotlight in the scene. Select Spotlight1, and go to the Mental Ray section in its Attribute Editor. Check Emit Photons, and leave all the other settings at their default.

Click on the Render Current Frame button in the upper right. The results will look like Figure 6–36.

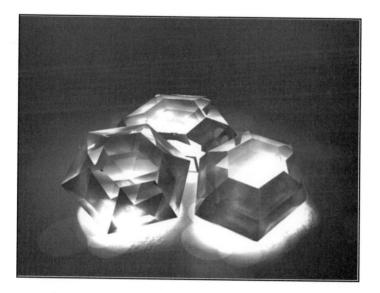

figure | 6-36 |

First rendering of gemstones.

The caustic effect can be further improved by fine-tuning some settings:

• In Render Settings on the Mental Ray tab, try increasing the Radius value by 0.25 increments, being careful not to go any higher than 3.0.

• Increasing the Accuracy value will refine the quality of the rendering at the expense of longer render times. Try increasing the value by 2–4 at a time, and do test renderings to see the results.

● Changing the Caustic filter type to Cone will produce softer results.

You can also modify some settings on the light by selecting it, opening its Attribute Editor, and editing the following settings:

● Under Caustics and Global Illumination, increasing or decreasing Photon Intensity will increase or decrease the brightness of the caustic effect.

● Also under Caustics and Global Illumination, increasing the Caustic Photons value will improve rendering quality (at the expense of rendering time).

Your final image after fine-tuning should look like Figure 6–37.

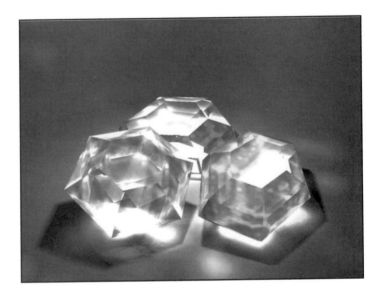

figure | 6-37 |

Final gemstones rendering.

TUTORIAL: CREATING A GRIFFIN FOOTPRINT USING DISPLACEMENT MAPPING

Displacement mapping is a method of altering the geometry of a model through the use of an image map. More specifically, Maya will look at the brightness of each pixel in an image and physically offset or displace the closest corresponding vertex or control vertex. The resolution (density of polygons or UV patches) will have some effect on the final results; Maya takes the initial resolution and factors it in with the initial sampling rate found in the Displacement Map section of the object's Attribute Editor. (A NURBS geometry is more adaptable and will require fewer UV divisions than an equivalent polygon mesh.) Maya will show the results of the displacement map at render time, but it will not automatically calculate the effect in your OpenGL shaded views. To see the result of your displacement map without rendering, use the following for a polygon object:

Modify > Convert > Displacement to Polygons

You can also select the NURBS surface and then turn on Display Render Tessellation (in Hardware Shading mode) for NURBS surfaces (Figure 6–38).

To do this exercise, you should have a working knowledge of Adobe Photoshop. If you do not, you can use the image provided on the CD and skip ahead, but it is useful to go through the process of creating a map to understand how to create your own.

Launch Photoshop. Select the following:

File > Open

Look on the CD in the Resources folder for a file called "gryphon-Foot.ai." When the open options pops up, set the mode to Grayscale and make sure the image size is set to 4203573.

Name the layer "Footprint Outline." Set your Canvas Size to 7003700. Create a new layer and drag it below the outline layer. Name it "Middle gray," and fill it with 50% gray (R 128, G 128, B 128).

At this point, it is worth talking about how Maya will interpret the image. White will move points upward, black will move points downward, and the effect will diminish as values approach 50% gray. A middle gray value will not move points at all, so it makes a good

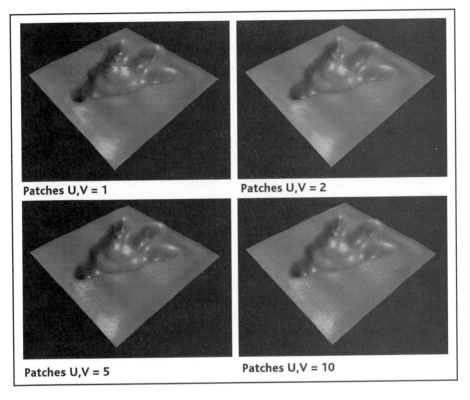

Patches U,V = 1

Patches U,V = 2

Patches U,V = 5

Patches U,V = 10

figure | 6-38 |

NURBS planes with increased resolution showing the effect of the same map.

background color to start with, allowing you to push and pull on top of it with lights and darks.

Holding down the Ctrl key, click the left mouse button (LMB) on your footprint layer to load its outline as a selection. Then select Save Selection so that you have a copy of the original outline that you can load if necessary.

Gaussian Blur the footprint layer with a 15-pixel radius. Set the layer opacity to 60%.

Create a new layer on top of the footprint layer and call it "Footprint Details." Load the selection from the footprint layer (not the selection mask you created), and create a layer mask for the new layer selection "Reveal selected." With the layer active (not the mask), load the alpha channel selection you saved earlier. Select the following (Figure 6–39):

Modify > Contract

figure |6-39|

Footprint outline.

Set the value to 12 pixels. Now feather the new selection by 4 pixels. Set the foreground color to black. Using a soft brush (ideally with a pen tablet), paint in the talon areas of the footprint as shown in Figure 6–40.

Continue painting in areas that would correspond to the pads on the bottom of a griffin's foot using black for the lowest points. It helps to think about it as if you were looking at a cross section of your footprint with a gradient next to it. To achieve a given depth, you need to match the gray value in the ramp (Figure 6–41).

The indentation of a footprint displaces the substance into which it is impressed. This usually would cause some upward swelling of the ground right around the impression.

Make a new layer behind the original footprint layer, and call it "Raised area." Using a color brighter than the background, paint in a soft area around the footprint, making the areas around the deepest impression a bit thicker, as shown in Figure 6–42.

figure | 6-40 |

Painting talon
displacement.

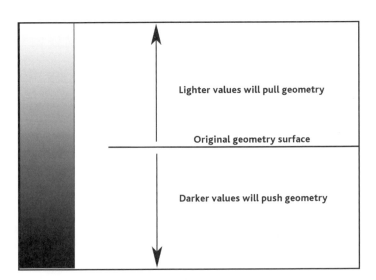

Lighter values will pull geometry

Original geometry surface

Darker values will push geometry

figure | 6-41 |

Effect of pixel value on displacement.

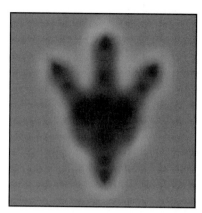

figure |6-42|

Raised area around footprint.

As a final step, create a new layer, place it just above the Middle gray layer, and call it "Details." Use your paintbrush to add some unevenness to the ground to make it appear more natural. Darkening the edges will also help promote the illusion that this is a plaster cast. You may also find that adding an adjustment curves layer will help you control contrast of the overall image for fine-tuning. Your final displacement map should look like the one shown in Figure 6–43. Save your Photoshop file, and save a flattened copy in either iff, tiff, or tga format.

In Maya, create a NURBS plane with width and length dimensions of 5 × 5 and UV patches each set to 10.

Create a new Blinn material for the plane and, in the Hypershade window, click on the Input and Output Connections button. Then select its Shader Group node (Figure 6–44).

In the Attribute Editor, click on the Blinn1SG tab. In the Shading Group Attributes, click on the Checkerboard icon next to Displacement Mat. Select File with Normal selected. Set your texture as the file's source. Do a test rendering of your plane; you should see something similar to Figure 6–45. (Be patient; it can take a little while to render.)

figure | 6-43 |

Final displacement map.

figure | 6-44 |

Blinn Shader Group
node.

If you are unhappy with your result and need to make adjustments, go back into Photoshop and rework your image as needed. Click Reload File Texture every time you update your texture file.

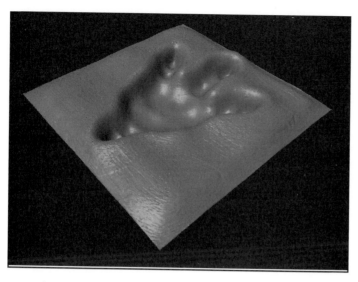

figure | 6-45 |

Final footprint rendering.

TUTORIAL: ANIMATING TEXTURES

So far, you have created textures that are static, meaning there is no inherent change in the texture over time. In Maya, it is possible to animate your textures in several ways. You can key-frame individual attributes of a material and change their settings (e.g., color or transparency) over time. You can also import animated footage from other animation programs, stock libraries, or captured video in the form of sequential numbered bitmap files (e.g., tiff, tga, or iff) or video files (e.g., QuickTime or AVI). It is also possible to create dynamic relationships through set driven keys and expressions that change attributes of your shader based on time, light, camera angle, or any number of other possible connected influences. You will focus on the first two methods in this exercise, animating attributers of a material and importing footage that will be applied as a texture map.

Animating Texture Attributes

Create a new scene in Maya.

Create a NURBS sphere with the default settings. In your Perspective view, select the sphere and press the "f" key to frame it in your view. Press the "3" key to view the sphere at its highest resolution, and then press the "6" key to see it in Texture Shaded view.

Right-click on the sphere, and, when the Marking menu appears, select the following:

Materials > **Assign New Material** > **Blinn**

When the Attribute Editor appears, click on the color chip and pick a color for the sphere. Once you have chosen a color, right-click on the word "Color" and select Set Key from the pop-up menu. Move forward to frame 24 by clicking and holding your LMB on the time line at the bottom of the Maya interface and dragging the black current frame marker to frame 24. Pick a different color, and, when you are done, set a key for the material color again. You have just key-framed one second of animation (in this case, the color of your material). By default, Maya is set to a 24-frame-per-second time base (24 frames of animation will play back in one second when previewed). If you were doing video work, you would want a 30-frame-per-second time base. You can pick which time base you want to use by going to:

Window > **Settings/Preferences** > **Preferences**

Select Settings in the left-hand column, and pick a time base from the Time pull-down menu in the center of the window.

To see the animation you just created, locate the VCR-like playback controls in the lower-right corner of Maya's interface and click the play button.

Now set your frame to frame 1, and click on the Checkerboard icon next to Bump Map. Apply a Bulge 2-D texture using Normal as the method of application. Your Attribute Editor should now be displaying a bump2d node. If it is not, make sure you have the sphere selected. Open the Hypershade window and graph the material for the sphere by selecting the following (in the Hypershade window):

Graph > **Graph Materials on Selected Objects**

Now double-click on the bump2d node to open the Attributes Editor. In the 2-D Bump Attributes section, set the Bump Depth to 0.000 and set a key the same way you did with color. Go to frame 30, set the Bump Depth to 0.500, and set another key. Render an animation to see the effect.

Keep in mind that you can use this method on almost any attribute on any node in a shader network. For example, you could key-frame the color of the squares in a Checker material or the size of the lines in a Grid material. Take some time and experiment to begin to understand the possibilities.

Applying Multiframe Textures

Create a new scene, make a NURBS plane, and zoom in so that it fills your Perspective viewport. Create a new Lambert material for the plane, and click on the Checkerboard icon next to Color in the Attribute Editor to assign a texture. Select File with Normal as the application method. The File panel should be active in the Attribute Editor. Under File Attributes, click on the Folder icon to the right of the Image Name field. On the CD, go into the sourceimages/animated_texture folder and select "finalAnimTexture_.iff.0000" (the first frame in the sequence). You will need to set the file type to "Best Guess (*.*)" to see the files because Maya requires that the frame number come after the file extension for it to see the images as a sequence. (This makes the files initially unrecognizable because they do not end in their file extension.) If you are in Texture Shaded view, the texture will appear (Figure 6–46).

figure | 6-46 |

Plane successfully textured.

If you scrub in your time line ("scrubbing" is clicking and holding your LMB in the time line at the bottom of Maya's interface and dragging back and forth), you will notice the image does not change. This is because you need to tell Maya how to handle the movie. In the Attribute Editor on the file1 tab under File Attributes, check Use Image Sequence Extension. Notice that the Image Number field becomes active (Figure 6–47).

figure | 6-47 |

Use Frame Extension
window.

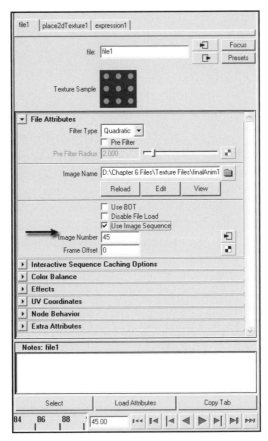

Make sure you are at frame 1 and that Image Number is set to 1; right-click on the field and select Delete Expression (Figure 6–48a). Right-click again on the field and set a key (Figure 6–48b). Go to frame 60, change the Image Number field to 60, and set another key (Figure 6–48c). When you play back or scrub your animation, you should see an animated texture. Setting the in and out points for your footage may seem a bit tedious, but this allows the kind of flexibility that is prevalent throughout Maya, giving the animator infinite possibilities. For example, your movie could be a series of mouth positions for a cartoon character. If you have a printout of a chart of mouth positions with frame numbers for reference, you can key these to the Frame Extension number and treat the movie as a database rather than a linear movie. This would be useful for lip-synching.

figure | 6-48 |

Set Key on Image
Number Attribute.

ANIMATED TEXTURE MAPS

Sequential bitmaps that are to be used for an animated file texture need to be named in the name.#.ext (myfile.001.iff) or name.ext.# (myfile.iff.001) format for Maya to utilize them correctly. If you don't have a video or composition package that will output sequences this way, you can either rename them by hand or search the popular computer graphics websites on the Web, like highend3d.com, for utilities that will do it for you.

SUMMARY

This chapter presented some of the basic building blocks and techniques for creating your own materials. By familiarizing yourself with the different types of nodes available to you and analyzing carefully the characteristics of the material you would like to create or reproduce, you should eventually be able to create almost any look you want. You should also experiment with connecting material nodes in new and interesting ways to discover possibilities that no one may have tried. (Remember that almost any two attributes can be connected.) Many nodes (like Ramp) can function in ways that go beyond their obvious applications.

1. How do you apply a ramp texture to a polygon sphere as a spherical projection?

2. How do you apply a grid texture to a NURBS plane in UV space?

3. How do you apply a bitmap file as a color texture?

4. How do you make an irregular (not circular) specular highlight on an object?

5. How do you apply a bump map?

6. How do you animate the color of an object?

▲ EXPLORING ON YOUR OWN

1. In the Hypershade window, do the following:

 ● Create a Blinn material from the Create Materials tab by clicking your MMB on the material and dragging it into the work area of the Hypershade window.

 ● Create a grid texture from the Create Textures tab by clicking your MMB on the texture and dragging it into the work area.

 ● Click your MMB on the Grid texture and drag it on top of the Blinn material. (Notice the pop-up menu that appears.) Select Color.

 ● Experiment with creating textures and connecting them to the Blinn material's different attributes by dragging them with the MMB.

2. Similar to the previous step, create a Blinn material and a ramp texture. Double-click on the Blinn material to open the Attribute Editor. Click your MMB on the ramp texture in the Hypershade window, and drag it directly to the color chip in the Blinn texture's Attribute Editor.

 You can drag many nodes from the Hypershade window directly to material attributes in the Attribute Editor. Try the following:

3. Create a Blinn material, a ramp texture, a Checker texture, and a marble texture. Using the technique described in this chapter, place the Checker texture in the color attribute for the Blinn material, then make one of the

checker colors the ramp texture and the other one the marble texture by attaching the nodes using the MMB.

4. Try experimenting with images you may have and Maya's built-in materials and textures to reproduce as closely as possible some everyday materials, such as tree bark, rusty metal, marble tile, beachwood, asphalt, and dirty glass.

notes

notes

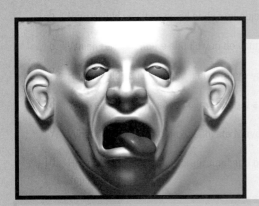

lighting

7

 charting your course

Light is your most important tool. It allows you to see color and depth, and it dictates saturation, hue, and luminance. Light has a tight relationship with color. No color exists without light, and every lighted area in a picture bears a scaled relationship of both value and color from the lightest area to the darkest area appearing within the light.

Light persuades the viewer to notice specific information. Our eyes are sensitive to contrast. Bright images come forward, and darkness recedes. Brightly lighting a specific object in the scene will direct the eye to the area of highest contrast. A photo with very little contrast (Figure 7–1) will require other methods to manipulate the eye.

Lights in Maya can work like lights in the real world. In the real world, your control over nature resides in a 50-pound tool kit of lenses, filters, and light sources. All of these tools—as well as a few more—exist in Maya.

However, in Maya, your control over believability resides in your understanding of nature. This requires practice and training beyond software manuals. You are urged to pick up black-and-white photography and study how light is captured on different film stocks. Then move on to movie film. When you have mastered the basics, move on to color stills and color movie film.

 goals

- To understand the lights available in Maya.
- To practice lighting.
- To make changes in lighting attributes.

figure | 7-1 |

Photo by Patricia
Beckmann.

NAVIGATION

All of our tools used in this chapter reside in the Rendering module
(Figure 7–2).

figure | 7-2 |

The Rendering
module.

SCENE FILES

Use the scene file "Lighting_practice.mb" on the enclosed CD to
practice the lights you are learning.

WHAT ARE LIGHTS, AND HOW DO
I USE THEM?

In Maya, you are able to adjust the overall strength, color, texture, an-
gles, or anything to do with how lights react to your subject. Shadows
can be hard edged, soft edged, color reflective, or nonexistent based on
your art direction. In Maya, you become a painter with light.

Contrast determines the brilliance of light. Contrast is emphasized by shadows. The relationship of shadow to light should remain consistent throughout the entire image. Pay attention to your changes. If the light value of an area in the image is lowered, the shadow value must be lowered by the same ratio.

Foundation drawing gives us the principle of tonal arrangement. There are four basic tonal arrangements as determined by Arthur Loomis (Figure 7–3). One of the values should dominate the rest.

figure | 7-3 |

Four basic tonal arrangements.

When determining values, consider your subject as being made up of four basic patterns of lightest gray, light gray, dark gray, and darkest gray. The concepts of white and black are rather specialized cases because these represent the limit of our palette. The painting in Figure 7–4 exhibits a range of tonal values.

It is a good idea to sketch out your scene to decide the tonal values before adding your lights in Maya.

Maya provides you with a default directional light if you have no lights set up in the scene (Figure 7–5). This light is parented to your camera and works like a flash. Everything facing the camera is lit. When the rendering is done, this default directional light is deleted. This lighting looks flat, but it allows you to see your model when rendered.

Light allows you to sculpt depth. A directly lit object with no background light will appear flat, making the relative distance to other

figure | 7-4 |

Painting by Patricia
Beckmann.

figure | 7-5 |

The difference
between choosing
your lighting and
default lighting.

objects tough to gauge. Use light to give information about the
subject by placing light sources in various locations within your
scene.

A popular basic setup for initial lighting is called "three-point light-
ing." It requires three lights at three locations. The three lights are
intended to sculpt the object away from its background to provide
the illusion of depth, as shown in Figure 7–6.

Open the file "lighting_practice.mb" on the attached CD. Render an
image from the file. Which lights are the key, the fill, and the high-
light? The easy way to tell is to click on each light in the Outliner
window. They are all named according to purpose. Notice where the
lights are placed. The following will describe why each is considered
a fill, key, or highlight light.

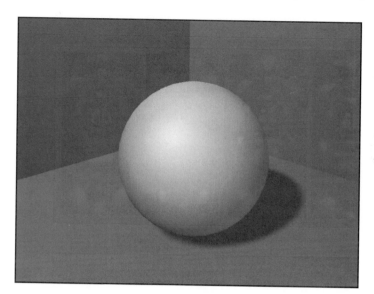

figure | 7-6 |

An example of three-point lighting.

Key Light

The key light is the primary light of the scene and is usually the light that will cast the most dominate shadow. This light should have a greater intensity than other light sources. If we use values of 0% to 100%, this light should always be 100%.

Use the key light to manipulate the eye of the viewer to a point of interest in your scene. Bright lights and colors attract the eye. If you want the viewer to look at the apple in a bowl of fruit, make sure to have a key light directed to the apple.

The key light is the only one to have the Emit Specular box checked (Figure 7–7). If all lights have Emit Specular checked, the object will have multiple highlights.

figure | 7-7 |

Spot Light Attributes window.

Figure 7–8 shows the object lit only with the key light.

figure | 7-8 |

Object lit only with
the key light.

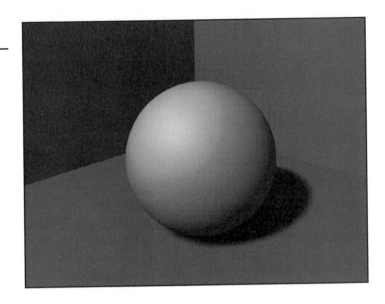

Fill Light

The fill light adds light to the shadows created by the key light. It decreases the contrast and rounds out the form of the object. This light should be somewhere between 20% and 70% as intense as the key light, depending on the contrast ratios you are setting up in the image. Settings for the fill light are shown in Figure 7–9.

Figure 7–10 shows the object with the fill light only. Remember to turn off Emit Specular in the Attribute Editor.

Highlight Light

The highlight light sits behind the subject, almost facing the camera. It catches the extreme edge of the subject and provides a highlight to the edge. This highlight provides depth to the subject, pulling it from the background. Settings for the highlight are shown in Figure 7–11.

Figure 7–12 shows the object lit with the highlight light only. Remember to turn off Emit Specular in the Attribute Editor.

Combining all three types of light together should result in a sculpted look. Adjust the percentages of intensity to suit your subject.

figure | 7-9 |

Fill light settings with the depth map shadows turned off.

figure | 7-10 |

Object lit only with the fill light.

figure | 7-11 |

Settings for the highlight.

High Key Lighting

High key lighting is a lighting scheme in which the fill light is raised to almost the same level as the key light. This produces images that are usually very bright and that feature few shadows on the principal subjects. This bright image is characteristic of entertainment genres such as musicals and comedies. The tonal value with the white background best represents high key lighting.

Low Key Lighting

Low key lighting is a lighting scheme that employs very little fill light, creating strong contrasts between the brightest and darkest parts of

figure | 7-12 |

Object lit with only the edge light.

STUDYING THE ART OF LIGHTING

Cinematographers in the black-and-white era used hundreds of lights just to make background drinking glasses sparkle. They used special lights to make a heroine's eyes look luminous and young. Lighting was even different for men and women. It is a complicated and precise art requiring an understanding of film, light temperature, and mood.

Study photography first to understand things like high key and low key lighting, candles, and ratios. Go on to the history of cinematography to study film lighting and how it affected the mood of scenes.

An excellent documentary on the subject of lighting is *Visions of Light: The Art of Cinematography* directed by Arnold Glassman and Stuart Samuels. This documentary spans nearly 100 years of cinematography with sequences from 125 movies. After you see the documentary, you should also see the movies cited within the documentary.

Lighting can be a career in itself, but it requires that you know more than just the buttons in a software package.

Don't rely on default lighting. You are an artist. Choose a mood, time of day, point of interest, and texture. Soon you will realize how boring the default is!

In 3D lighting, artists often begin with three-point lighting and then move on to create clustered groups of light aimed to create different highlights and areas of interest. Changing the color of light is often very necessary, as special attention is given to bounce, reflection, ambient shadows, time of day, and other factors.

an image and often creating strong shadows that obscure parts of the principal subjects. This lighting scheme is often associated with suspense genres such as film noir. The tonal value with the black background best represents film noir.

LIGHTS AVAILABLE IN MAYA

We will be learning the following lights:

● Area light

● Directional light

● Ambient light

● Spot light

● Point light

● Volume light

Each light is associated with a unique icon (Figure 7–13).

figure | 7-13 |

Icons for each light.

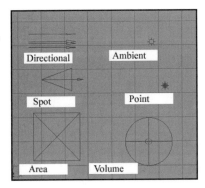

figure | 7-14 |

Creating a
directional light.

General Attributes You Can Change in Lights

To create a light, select the following (Figure 7–14):

Create > Lights > Directional Light

Next, open the Attribute Editor by selecting the following
(Figure 7–15):

Window > Attribute Editor

Notice all the variables you can edit. All lights share the same attributes and options available in the directional light. If you choose a light other than directional, you will find additional attributes specific to your light choice that you can modify.

Type

If you create a directional light but decide an area light would be a better choice, you can make a simple change in the Attribute Editor.

Select the pull-down menu and notice that all the lights available in Maya are represented (Figure 7–16).

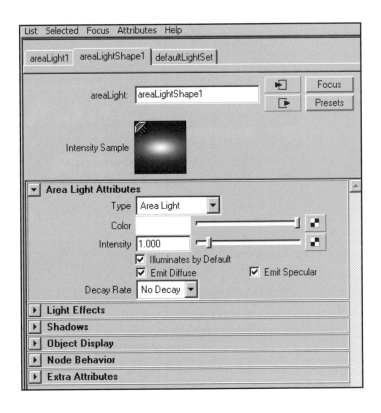

figure | 7-15 |

The Attribute Editor for a directional light.

Select different lights, and look to see your icon change in the Camera view and the attributes change in the Attribute Editor.

Intensity

Intensity represents how bright the light is. The default value is 1. For each of your light sources, you can change this number to any value (Figure 7–17). A light can have a negative value (–1), a decimal number (0.1), or a higher value (100).

Experiment with different values of light intensity in your scene.

TEST RENDER

To view the changes you make to the scene, render a test image. Rendering is like taking your film to the one-hour-photo store—but it usually takes much less than an hour to process.

Make sure the Perspective window is active. Click your LMB in the window and make sure the window is outlined by a blue frame.

Now select the following (Figure 7–16):

Render > Render Current Frame...

A new window pops up. Wait a few seconds, and your scene will appear as a color "photograph" called a render (Figure 7–17).

figure | 7-16 |

Rendering the current frame.

figure | 7-17 |

Render window.

Color

Light need not remain default white. Think of the colors of light in a sunrise or the reflections of color found in a marsh. Cool and warm tones are emitted in light. In 3D, light comprises a color palette that assists you in painting your scene. You can model everything in a default gray and then color and texture the model with your lights.

You can change the color of the light by clicking your left mouse button (LMB) on the Color swatch (Figure 7–18).

figure | 7-18 |

Type pull-down menu.

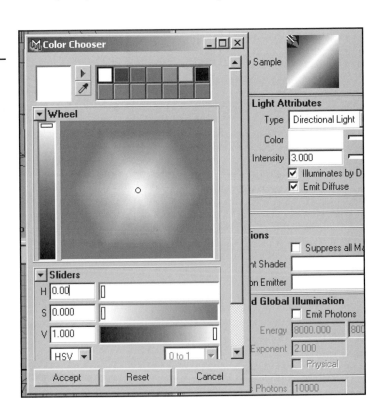

figure | 7-19 |

Intensity.

A Color Chooser opens (Figure 7–19). Use your LMB to select a color on the wheel, or enter the Hue (H), Saturation (S), or Value (V) with the sliders beneath.

Click on Accept, and the color is now represented in the Attribute Editor.

Render an image of your file with a colored light.

Shadow Color

Just as light has many colors, so does shadow. The default shadow color is black.

Change the color of the shadow (Figure 7–20) just as you did the color of the light and render an image.

figure | 7-20 |

Color swatch.

When you render color shadows, think of the source from which the shadow falls as well as the source receiving the shadow. Depending on the surfaces involved, the shadow may also be a reflection. A believable shadow will contain reflections of colored light from the surrounding objects.

The color of an object is reflected onto objects surrounding it. Take a piece of cardboard, and paint it a solid color (e.g., orange). Go into a brightly lit room with white walls, and hold the cardboard about three inches from the wall. Tilt the cardboard so that the color faces the wall. You will see an orange patch of reflection against the wall. Then try other colors. Go to a darker wall, such as a green wall, and try the same colors.

Note the different colors resulting. Note also the different types of shadows that result in each room. Some are crisp, some are light

gray, and some are ghostly—but they all have a slight influence of color within them.

Render an image of your file with a colored shadow.

Depth Map Shadows

If you want an object to cast a shadow, two things need to be turned on: Use Depth Map Shadows and Casts Shadows.

Use Depth Map Shadows must be turned on for the light illuminating the object. It is off by default. You will find this option in the Attribute Editor of the light (Figure 7–21).

figure | 7-21 |

Depth Map Shadows can be either on or off.

The surface must also be available to receive cast shadows. Select the surface receiving the shadow. In the render stats of the Attribute Editor for this surface, make sure Receive Shadows is turned on. By default, this feature is already turned on, so you really do not need to check it.

❗DON'T
GO THERE

Do not practice lighting in a vacuum. Get out of your room and look at the world. Practice from source footage.

Depth map shadows are generally used for test images. The default setting is 512. Turn this down to 70 when you are just practicing, and use 1024 when you are looking for the final result.

When high-quality output is desired, you can certainly use ray-tracing. Be careful what you choose: A long list of variables needs to be considered when deciding whether or not to ray trace. The quality of the rendering and the time it takes to render are your two most important considerations. Depth maps provide a lower-quality quick option, whereas raytracing gives a higher-quality, time-intensive option.

Another useful practice is to set up a mock-up of your model. If you are lighting a woman in a field of orchids, take a picture of a friend sitting outside surrounded by colored fabrics and use that as reference.

Artist Johannes (Jan) Vermeer is credited with being one of the first painters of real light. Although his work seems very precise and detailed, on closer inspection we are really observing his interpretation of light. Check out his work on the Internet and look for the painting *The Pearl Necklace* (Figure 7–22).

figure | **7-22** |

Vermeer's *The Pearl Necklace.*

Pick a favorite artist and notice his or her use of light. Consider Spanish artist, Francisco Goya; low-brow artist, Robert Williams; American painter, John Singer Sargent; or the impressionist, Helmut P. Beckmann (Figure 7–23). It is valuable to look at these paintings in grayscale to study the lighting values.

figure | 7-23 |

Helmut P. Beckmann
paintings showing
his use of light.

Change the color of the depth map shadow if you want to control
the shadow color. Some people abhor this method, saying all color
change should happen in light, not in shadow. However, you can
easily play with contrast ratios in the image by adjusting this color.
Make it a lighter gray or a warm dark blue.

Raytraced Shadows

Raytracing is used to create glass and transparent surfaces. Raytraced
shadows are more accurate than depth map shadows, but they take
more time to render.

Raytracing is turned on in the rendering options (Figure 7–24):

Window > Rendering Editors > Render Settings

You can also go to Render Settings by clicking the Render Settings
icon on the Status Line (Figure 7-24).

A new pop-up box appears. Select the Maya Software tab. Under
Raytracing Quality, select Raytracing (Figure 7–25).

Now see if you can render a transparent object.

Open the file "Light_ray.mb" on the enclosed CD and render the file.
Then open up the Render Settings under Window > Rendering
Editors > Render Settings and in the Maya Software tab turn on
Raytracing. Do you see the difference? You should be able to see
through the ball on the right.

Decay

Decay is the decrease in intensity from the source light to infinity. In
real life, light intensity decays as it gets further from the source. In

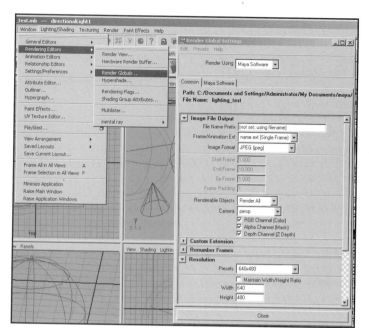

figure | 7-24 |

Render options
window.

figure | 7-25 |

Raytracing Quality
options.

computer graphics, the intensity does not decay unless you execute the appropriate commands. Area, point, and spot lights all allow you to modify decay.

Maya offers you three formulas of decay: linear, quadratic, and cubic.

Quadratic is the closest to real-world light decay. Linear light decreases more slowly than real-world light, whereas cubic decreases faster than real-world light. If you use one of these formulas, you will need to significantly increase the intensity of the light.

Because you are a novice Maya user, this section will discuss the basic attributes of lighting. There are many more attributes you can modify once you become more advanced.

Area Light

An area light is much like the light box used by portrait photographers. It is a flat, rectangular light source. To create an area light, select the following (Figure 7–26):

Create > Lights > Area Light

figure | 7-26 |

Effect of an area light and placement.

Area lights produce some of the best quality light and shadows, and they are great for still images. However, be careful when using them for animation because they significantly slow the rendering.

The light may be selected and resized. If you want more area of the light shining on an object, select the light and resize it.

Directional Light

Directional lights are used to convey light coming from a very large and faraway source, like the sun. Photographers who use

bounce from a white board sometimes manipulate light like this. Directional light can be created by selecting the following (Figure 7–27):

Create > Lights > Directional Light

figure | 7-27 |

Effect of a directional light and placement.

Ambient Light

Ambient light is a flat fill light with no defined source. It has an even and impartial dispersion, like adding a base of neutral gray to all the colors in a painting. Ambient light is used to control the brightness of a scene. It should not be relied on as the sole source of light, as it does not allow for contrast. Most studios do not use this at all, because it "deadens" a scene.

To produce ambient light, select the following (Figure 7–28):

Create > Lights > Ambient Light

figure | 7-28 |

Effect of an ambient light and placement.

Ambient light is a good tool for filling in a neutral bounce light. However, keep in mind that it also lightens the shadows.

Ambient light can also be made similar to directional light if the Ambient Shade slider is moved to a value of 1. If you want it to appear to be coming from even more directions, move the value closer to 0.1.

Spot Light

A spot light in Maya acts like a spotlight in the theater. It creates a cone of light from a defined source based on changeable parameters. You can modify how large the circle of light is or how hard or soft the edges are, and you can project images that read as textures within the light. A spot light is the most commonly used light in production as it is so easy to control. You can create a spot light by selecting the following (Figure 7–29):

Create > Lights > Spot Light

figure | 7-29 |

Effect of a spot light and placement.

A spot light has many attributes that can be altered. It is particularly useful for creating simple special effects.

Cone Angle, Penumbra Angle, and Dropoff are the most interesting modifiable attributes.

Cone Angle is the width of the light beam. If the value is high, the beam will be large. If the value is low, the beam will be small. The default value is 40, but you may insert values from 0.006 to 179.994.

Penumbra Angle is the falloff in the intensity of light from the center to the edge. The falloff linearly goes from full intensity to zero. Think of how an old flashlight works at midnight. The center of the beam is bright, but the edge of the beam is not. The default Penumbra Angle is zero. You can modify it from −179.994 to 179.994.

Dropoff controls the rate of change in intensity from the center of light to the edge. The default value is zero (no dropoff), but you may insert values from 0 to 50.

Experiment with these values in your spot light, and note the changes.

Point Light

A point light is best described as a light bulb. It is a light source that emanates in all directions from one point. You can create one by selecting the following (Figure 7–30):

Create > Lights > Point Light

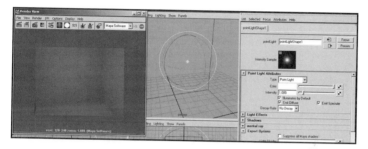

figure | 7-30 |

Effect of a point light.

Volume Light

Volume lights are like the lights within a house. They light the interior of the house, but walls keep them from lighting the outdoors as well. Volume lights emanate within a walled area, giving you control over where the light shines. It is similar to a point light with a sharp decay. Volume light is created by selecting the following (Figure 7–31):

Create > Lights > Volume light

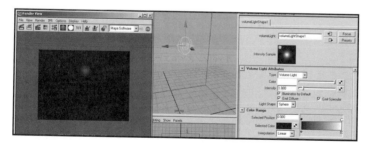

figure | 7-31 |

Effect of a volume light source moved forward to touch the wall.

You can, of course, make a much more elaborate example of the beauty that a volume light can create, but this example is given only to illustrate the difference of each light at the same intensity.

Light Linking

Light Linking is one of the best ways to control your lighting in Maya. Light Linking gives you the ability to light specific objects in

a scene. Using light linking can help speed up render time and give you more control over lighting objects in Maya.

To use Light Linking, open the file on the enclosed CD.

Render the scene. You will see that both spheres are illuminated by the key light (Figure 7–32). For this example we want to turn off the key light on the left sphere. Select the following:

Lighting/Shading > Light Linking > Light-Centric

figure | 7-32 |

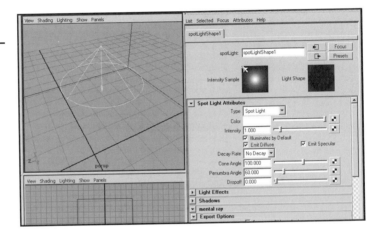

In the Relationship Editor pop-up window, left-mouse click on Key Light in the Light Sources window, and leftSphere in the Illumated Objects window (Figure 7–33).

figure | 7-33 |

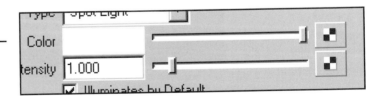

The key light will no longer light the leftSphere. Render the scene to test the results (Figure 7–34).

figure | 7-34 |

SPECIAL EFFECTS WITH LIGHTS

Look around the room you are in. It may have light drifting in through a window. If there is a tree by your window, sporadic shadows are drifting around on the floor. There is wonderful texture in light, just as there is in color. Bring some of that texture into your light to add interest to shadows.

Open the file "light_spot.mb." It is a file containing a spotlight aimed at a plane. We are going to add a texture to the light to make it look like the light is behind an object and the object is in profile.

First, select the spotlight. In the Attribute Editor (Figure 7–35), find the color. To the right of the Color attribute is a black-and-white box (Figure 7–36). Click on this box.

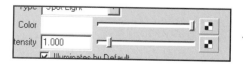

figure | 7-35 |

figure | 7-36 |

Available textures.

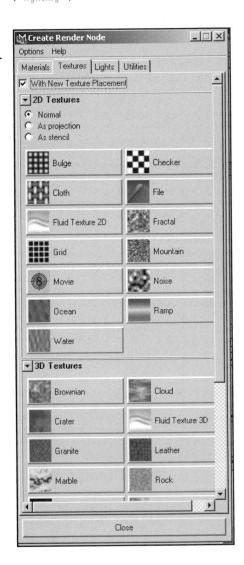

figure | 7-37 |

Checker Attributes

A new set of values is made available to you (Figure 7–37). All of these files may be used to add texture to your light. One of these files will act like a mask. We are looking for a value of black and white. Black will block light and white will allow light to pass through. Click your LMB on the checker pattern.

Another new window of attributes opens (Figure 7–38). Look at the Checker Attributes.

Before you make any changes, render a test image of the window by selecting the following:

Render > Render Current Frame

You should have something like that shown in Figure 7–39.

There is much more you can do with this feature. Suppose you want the profile of a figure in the light source. You would create a figure in Adobe Photoshop and then import the file using the following method.

figure | 7-38 |

Checker Attributes.

figure | 7-39 |

Checkered effect of spotlight.

Open the file "lightProfile.mb" and select the spot light.

In the Attribute Editor, click on the black-and-white button, which is to the right of Color (Figure 7–40).

figure | **7-40** |

Available textures.

This time, instead of Checker, select File (Figure 7–41). A new window reflecting attributes for the file (Figure 7–42) replaces the old window.

Select the File icon to the right of Image Name (Figure 7–43). A Find window opens (Figure 7–44). In this window, you navigate to the

figure | 7-41 |

2D Textures
window.

folder containing your image. If you properly set up your project, your rendered images will default to the "sourceimages" folder. When you locate it, click on Open. The file name and path will show up in the Attribute Editor. Find the "profile.jpg" from the book's CD, and select it.

figure | 7-42 |

File Attributes
window.

figure | 7-43 |

File icon beside
Image Name.

Render the Perspective window. The image will affect the look of
the light. If you model a room full of furniture and place this
light as coming through an unseen door, it will look as if a char-
acter is ready to shoot someone and add suspense to the image
(Figure 7–45).

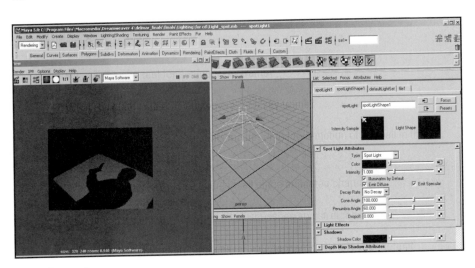

figure | 7-44 |

Rendering of a shadowy figure.

figure | 7-45 |

Rendering of a
shadowy figure.

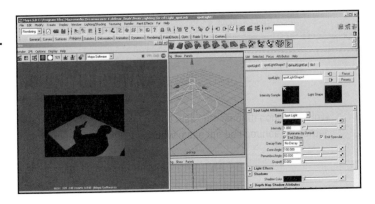

SUMMARY

Now that you know the many lighting options available in Maya, you can see why default lighting is a dull way to go. Your options include adding color, shadows, depth, and highlight. A mood can be decided just with tonal gradient. Interesting shadows can be placed in your light to add depth and character to a room.

Much of what you do with the software to create art harkens back to basic color and lighting theory. The old books on photography and painting are still very necessary and useful. Find artists like Ansel Adams, Vermeer, and others, and read about how they create light. You will be surprised by the rich images you can create once you understand the "why" with the "how."

in review

1. What are the six lights available in Maya?

2. How does the default lighting work in Maya?

3. What is a key light?

4. What is an edge light?

5. What is a fill light?

6. Is there color in light?

7. What is light linking?

8. Why do you use depth map shadows?

▶ EXPLORING ON YOUR OWN

1. Identify a well-lit room in your home. Re-create it in Maya using simple primitive objects. Take four pictures of the room at different times of day. Take one photo at the crack of dawn when light is beginning to affect the room. Take another photo at high noon. Take another photo at mid-afternoon. Finally, take a photo in evening light when the electric lights are turned on. Put these photos side by side and look at how the light is different. Then emulate the different times of day in Maya using the six lights you have learned in this chapter. You will need to change the light temperatures as well as the colors of the light and shadows.

2. Create four boards representing the four tonal arrangements, and put them in your notebook or on the walls of your studio. Experiment with changing the patterns within but keep the tonal dominance.

3. Go to the library and look up film noir. What other genres can you find? How is lighting handled in each?

4. Watch the documentary "Visions of Light: The Art of Cinematography" and pay special attention to the first half of the film. The master lighters of black-and-white cinema sometimes use over 50 lights in a scene to achieve a special look.

notes

notes

 charting your course

A camera is an actor in your scene. How a shot is staged can communicate subliminal details to a story line, increasing the value of information presented. To make the best use of this opportunity, you must understand the traditional camera. There is more to the Maya camera than default settings. You can emulate very interesting theatrical shots by understanding simple things like f-stop, lens angle, and depth of field in addition to your sense of composition.

 goals

- To understand the difference between views and cameras in Maya.

- To practice navigating views.

- To learn the basics of the traditional camera.

- To apply basic attributes of the traditional camera to the Maya camera.

- To tweak attributes to obtain controlled effects.

- To look at your scene as a composition of texture, value, and light and to form appealing groups.

CINEMATOGRAPHY

NAVIGATION

Most of our tools for this chapter reside in the default pull-down menus. The first five pull-down menus are available in every module. Cameras are found under the Create menu (Figure 8–1).

figure 8-1

The Create menu.

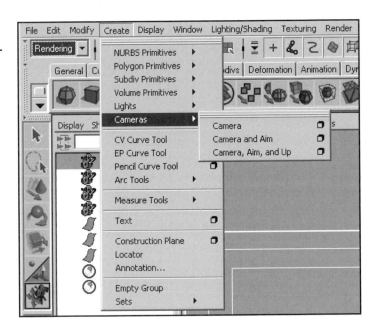

WHAT ARE VIEWS?

When you first open Maya, the default view is either Perspective (Figure 8–2) or Four-Panel Orthographic/Perspective (Figure 8–3).

You need to understand the difference between Perspective and Orthographic views because the final image derives a great deal of information from the camera used in the rendering.

Orthographic

Orthographic views are like blueprints. Blueprints give you plan, elevation, and profile of a building or object. In Maya these correspond to Top, Front, Left, Back, Right, and Side Orthographic

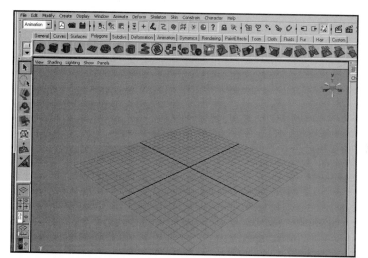

figure | 8-2 |

Perspective camera view.

figure | 8-3 |

Three Orthographic views and one Perspective view.

views, respectively. A comparison of Orthographic and Perspective views is shown in Figure 8–4.

The Orthographic view does not allow lines to diminish with distance.

Perspective

Perspective means lines converge to a point in the distance. Perspective emulates how we perceive space in real life.

figure | 8-4 |

Orthographic view of a one-eyed helmet versus Perspective view of a one-eyed helmet.

When modeling, it is best to view your work in the Orthographic views. The tools for moving an object around in the Perspective view are so easy to work with that many people forget about checking their object in other views. This chapter will show you why you should pay attention to more than one Camera view.

MODELING IN ORTHOGRAPHIC AND PERSPECTIVE VIEWS

An object in 3D space still has a front and back, underside, and top view even though you are only working on one view at a time. You may make a change to an object in the Front view that makes an unintended change in a Top view. Make sure you check all of the views while modeling or you could wildly distort your model (Figure 8–5). For this reason, it is recommended that you toggle between Orthographic and Perspective views when modeling.

The default Orthographic and Perspective Camera views are only used for preparing your scene. When you are ready to render out a shot, you will create a new camera. You will modify this new camera to give you the composition and look you want for the final render. A few options you can consider are focal length, f-stop, aperture, and shutter angle. These are familiar terms to a photographer. This new

figure | 8-5 |

A distorted model in one view looks normal in another.

camera will be used to frame the shot, and you will render the image from this view.

ON LOCATION

The tools for navigating the view through a camera are derived from the film industry. Dolly, pan, and track are names given to camera moves for a traditional film camera used on a movie set. These are also names for movements you can emulate in Maya.

Dolly

Dolly means to move a camera closer or farther away from an object. To dolly in Maya, you need to hold down the three buttons and move the mouse delete as follows:

First, select the Alt key on your keyboard. Keep holding it down while also pressing down the left and middle mouse buttons (LMMB; see the right-most image in Figure 8–6). With all three buttons selected and held down, move the mouse. You should be moving in and out of your workspace.

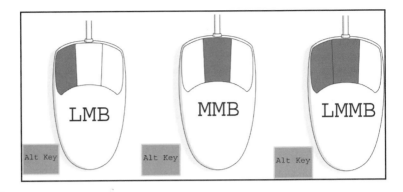

figure | 8-6 |

Using the Alt key with left and middle mouse buttons.

You can also use a pull-down menu to access two variations of this tool. Select the following (Figure 8–7):

View > Camera Tools > Zoom Tool

figure | 8-7 |

Drop-down Zoom tool.

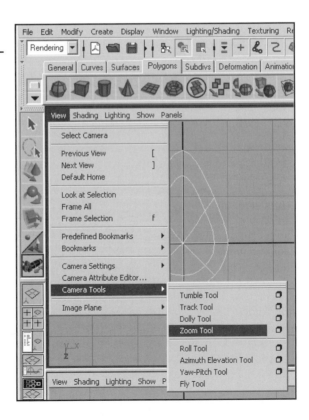

The Zoom tool changes the focal length of the camera. In a manual camera, this would be like exchanging the wide-angle lens for a tele-photo lens. Zooming in is like using a telephoto lens, whereas zooming out is like using a wide-angle lens.

If you do not want to change the viewing angle, use Dolly by selecting the following (Figure 8–8):

View > Camera Tools > Dolly

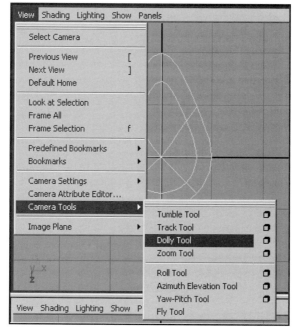

figure | 8-8 |

Drop-down Dolly tool.

Dolly will allow you to zoom in and out without changing the focal length.

With pull-down commands, you only need to use the left mouse button (LMB), leaving your other hand free. You also remain in control of the focal length.

Pan (Track)

Pan means to move left to right in the Camera view. To pan in Maya, you need to hold down two buttons and move the mouse as follows:

First, select the Alt key on your keyboard. Keep holding it down while also pressing down the middle mouse button (MMB; see the middle

image in Figure 8–6). With both selected and held down, move the mouse. You should be moving left to right in your workspace.

You can also use the pull-down menu. Select the following (Figure 8–9):

View > Camera Tools > Track Tool

Click on your LMB.

figure | 8-9 |

Drop-down Track tool.

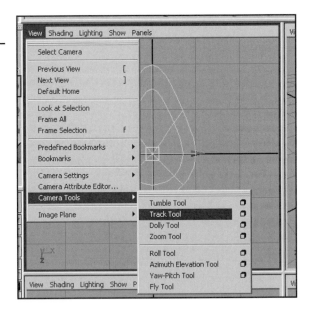

Fly Tool

The Fly tool lets you navigate a scene like you are in a first-person player game. The Fly tool is primarily used by game developers to look at an environment from the perspective of the player.

View > Camera Tools > Fly Tool

To use the Fly tool, simply hold down the Ctrl key and drag the mouse. Drag the mouse up to move forward, and drag the mouse down to go backwards. As well, drag the mouse left and right while holding down the Ctrl key to move from side to side.

Tumble

Tumble is not a stage term, but it means to move around the object in a Perspective view. It is like riding a crane for an aerial shot. This

is a handy tool for modeling. To track in Maya, you need to hold down two buttons and move the mouse. Hold down the Alt key and move your LMB.

You must also be in the Perspective window. This tool does not work in Orthographic views.

You can also use the drop-down menu by selecting the following (Figure 8–10):

View > Camera Tools > Tumble

Click on your LMB.

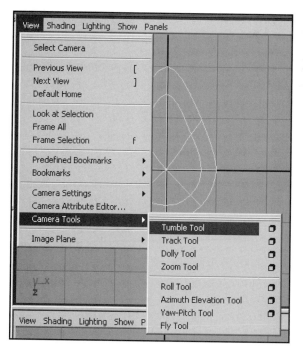

figure | **8-10**|

Drop-down Tumble tool.

If you tumble, zoom, or track to the point of destroying your camera, use the following drop-down (Figure 8–11):

View > Default Home

This will reset the camera to its default setting.

Now, let us navigate a scene using the tools you just learned.

figure | 8-11 |

Default camera view.

First, create a cube by selecting the following (Figure 8–12):

Create > NURBS Primitives > Cube

Now pan, track, and dolly around the cube.

figure | 8-12 |

The NURBS
Primitives pull-down
menu for Cube.

If you lose the cube or get lost in the window, you can also try selecting the following in the Camera view window (Figure 8–13):

View > Frame All

The camera will center on the object, and you will return to Default view.

figure | 8-13 |

Frame All command.

CREATE A NEW CAMERA

Your final image should be derived from a camera separate from the default cameras. Always create a new camera for the final rendering.

There are two easy ways to create a camera: One is to select the following from the View window (Figure 8–14):

Panels > Perspective > New

figure | 8-14 |

Creating a new perspective camera from the view window.

Another way is to select the following from the drop-down menu (Figure 8–15):

Create > Cameras > Camera

figure | **8-15** |

Using the drop-down menu to create a camera.

Do you see all the cameras already in your scene? There are four default cameras representing the four default views on your desktop. They are named persp, top, front, and side. If you made another perspective camera earlier, it would appear as persp1.

Select the persp (perspective) camera.

We will now look at the options you can change in this camera. Open the Attribute Editor by selecting the following (Figure 8–16):

Window > Attribute Editor

A new window opens (Figure 8–17). This window contains all the editable options for our camera. Many of these options you will recognize from your manual cameras.

Those of you who practiced photography before automatic cameras will recognize such buttons as aperture, depth of field, and focal length. The manual photographer can control how much of the image is in focus, how close the background appears, how much light enters the camera, and how fine the detail is.

Automatic cameras average all of the information into the best middle values. Thus, all your images end up with a similar appearance. Once you learn how to use these extra controls, you will make

figure | 8-16 |

Selecting the
Attribute Editor.

figure | 8-17 |

The Attribute Editor
window.

a greater individual impression with your image. Knowing the
camera will allow you to understand lighting effects such as film
noir, high key lighting, and low key lighting—all terms with which
successful film directors are familiar.

The manual attributes of your camera can be great tools to set your
work apart from the mainstream.

Those of you who are not familiar with these terms will need to study basic photography texts before you can fully understand the artistic techniques available to you. The most common sign of a beginner artist is using the default cameras supplied in Maya for renderings. Use attributes to assist in telling the story of the graphic.

Let us take a look at a few of the camera attributes available to you.

figure | 8-18 |

Rendering module.

Open the file "Helmet.mb" on the CD. Go to the Rendering module (Figure 8–18). Click your LMB in the Perspective view to select it. This will select the camera view as the image to render. Then select the following (Figure 8–19):

Render > Render Current Frame...

figure | 8-19 |

Selecting to render the current frame.

An image will open in a new window (Figure 8–20).

This is a rendering of the current Perspective Camera view. Maya has "developed" the picture you have created in the selected camera view.

Now, let us learn some basic attributes.

Angle of View and Focal Length

Angle of view represents the type of lens you are using. Remember telephoto, portrait, wide-angle, and 50-mm lenses? This is where you tweak the numbers to represent one of these lenses.

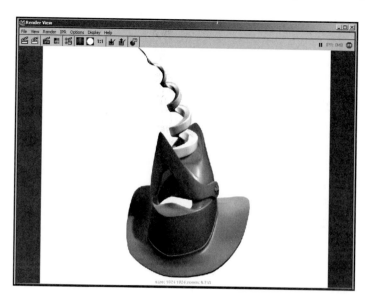

Angle of view is related to focal length. If you adjust the camera's focal length, the angle of view narrows and expands. Objects will get larger or smaller in the frame. As you extend the focal length, the angle of view gets narrower (telephoto lens). As you shorten the focal length, the angle of view gets larger (wide-angle lens). The image will also appear larger with a larger angle of view. The default angle of view value in perspective camera is 54.43 degrees (Figure 8–21), roughly the equivalent angle of view of the human eye. Experiment by making changes to this value and rendering an image.

▼ Camera Attributes

Controls	Camera ▼
Angle of View	54.43
Focal Length	35.000
Camera Scale	1.000
	☑ Auto Render Clip Plane
Near Clip Plane	0.100
Far Clip Plane	1000.000

▼ Film Back

Focal length is the distance from the center of the lens to the film plane. The longer the lens, the fewer objects appear on film, and the bigger those objects appear.

Focal length (Figure 8–22) is determined by what lens you use in the angle of view. Which focal length you choose could determine whether the object is distorted, the background is far or near, or how much of the scene is visible.

figure | 8-22 |

Focal length.

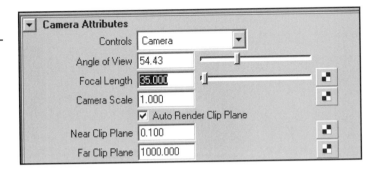

Focal length distorts the shorter and longer you go. Portrait photographers use 200-mm lenses for the most true-to-life proportions. Keep this in mind when photographing your scene.

When you increase the angle of view, the focal length changes to an increasingly wider view. When you lower the angle of view, the lens acts like a telephoto lens.

Figure 8–23 shows the effect of changing the angle of view to 75 from the default 54.43 and then to 38. Note the changes in the Perspective view. Look at where the lines converge.

figure | 8-23 |

Angle of view for default, extended (telephoto), and shortened (wide).

Make changes to this value and render an image.

Clipping Plane

The clipping plane (Figure 8–24) is very useful when modeling a character. It acts like a slicing tool, removing objects within a sandwiched distance from the camera.

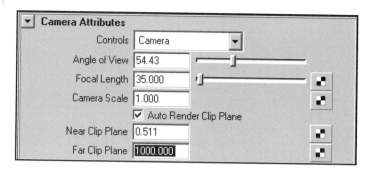

figure | 8-24 |

Clipping plane.

You may decide that the front of a box is getting in your way when you try to model the back of a box, and it would be handy if you did not have to see anything within 3 inches of your camera. A clipping plane can make this area invisible, allowing you to focus on an otherwise eclipsed detail.

Figure 8–25 shows the effect of changing the value of the Near Clip Plane to 99.5 from the default.

figure | 8-25 |

Changing the clipping plane value from default to 99.5.

Make changes to this value and render an image.

Film Gate

The Film Gate section (Figure 8–26) determines what type of camera you are operating. You can choose 16 mm (like an old Bolex), 35-mm Academy (like a regular film camera) or even IMAX size (70 mm). Consider your output when selecting these film gates.

The choice of film gate is not a major consideration when entirely creating something in Maya, but it is imperative when trying to match a live-action shot.

figure | 8-26 |

Film backs available.

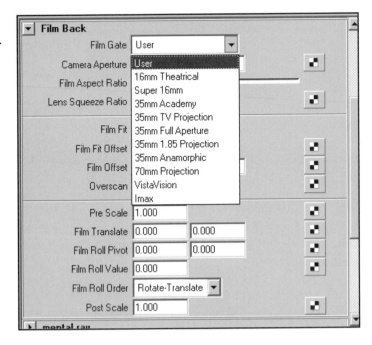

The result of changing the value to 35-mm Academy from the default, User, is shown in Figure 8–27.

Make changes to this value and render an image.

figure | 8-27 |

Comparison of use: default (right) to 35-mm Academy (left).

Camera Aperture

Maya's Camera Aperture setting differs from the aperture on the manual camera. Camera aperture is the height and width of the camera's Film Gate setting, measured in inches (Figure 8–28). This setting has no effect on f-stop, but it does affect the angle of view.

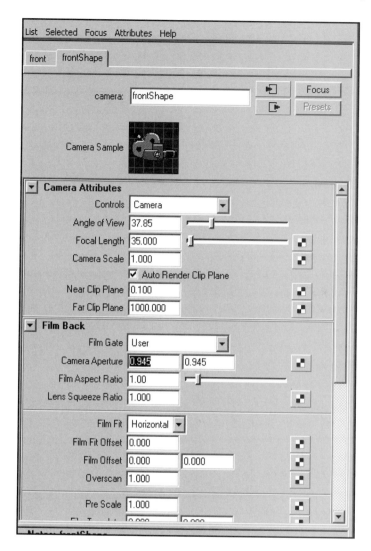

figure | 8-28 |

Aperture is
measured vertically
and horizontally.

These settings are chosen for you when you select a film gate. If you
look at a picture shot in 50 mm and then try to create a picture using
the 50-mm lens in Maya, the distortion will be a bit off. A 50-mm
camera in Maya is closer to 38–42 mm in reality.

Depth of Field

Depth of field (Figure 8–29) is the area from near to far in a scene
that is sharp in a photograph. Changing the aperture changes the
depth of field. The two are interrelated. This section allows you to
set a distance that remains in focus, as well as determine the aper-
ture through the f-stop feature.

figure | 8-29 |

Depth of field.

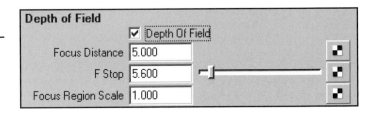

In the Depth of Field menu, change the Focus Distance to 12, F Stop to 2.4, and Focus Region Scale to 2.0. The result is shown in Figure 8–30.

Make changes to this value, and render an image.

figure | 8-30 |

Comparison of default (left) and altered values (right).

F-Stop

The size of an aperture is determined by its f-stop number. The aperture determines the amount of light that enters the lens. With a film camera, f-stops in the high numbers (allowing in very small amounts of light) enable photographers to shoot a highly detailed work of art when used with long exposure settings and a tripod.

Such exposures were the trademark of landscape photographer, Ansel Adams.

In Maya, the lower you make the f-stop, the less depth of field your photo will have (Figure 8–31). The higher you set the f-stop, the greater the amount of depth of field.

Make changes to this value and render an image.

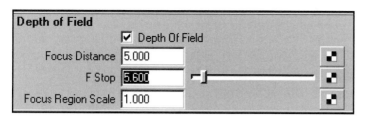

figure | 8-31 |

F-Stop slider.

Shutter Speed Selector

Maya does not have this exact feature, but it does have blur. You can simulate a slow shutter speed by turning on blur when you render. You will find this in the render options, discussed in Chapter 9.

Display Options

Depending on your output, all of the graphics you see through the Camera view may not show up on a television or film screen. Be aware of the display options and of the differences among Display Resolution, Display Safe Action, and Display Safe Title (Figure 8–32).

figure | 8-32 |

Display options show how much of the image will show up in the final medium.

Display Resolution displays the renderable area. The viewport is generally larger than what will render, so turning on Display Resolution will forecast the areas cut off (Figure 8–33).

figure | 8-33 |

Image with Display
Resolution area off
(left) and on (right).

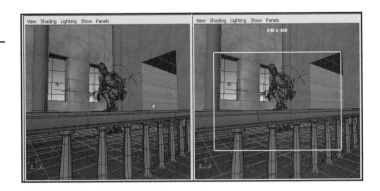

Display Safe Action is the area in which you can place action and still
see it in the rendering (Figure 8–34).

figure | 8-34 |

Image with Display
Safe Action on.

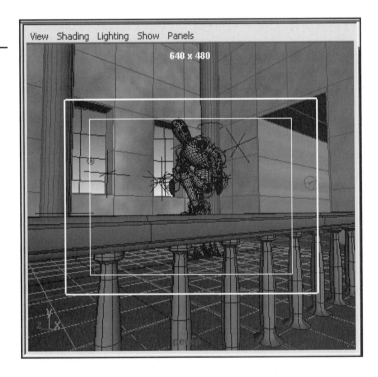

Display Safe Title is the area where you will want to put text for best
readability (Figure 8–35).

THE POWER OF THE CAMERA

Unity is the goal of composition. The process of achieving unity is
difficult to describe, but it begins with design and pattern. Design

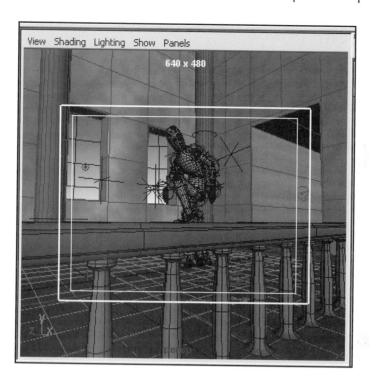

View Shading Lighting Show Panels

640 x 480

figure |8-35|

Image with Display
Safe Title on.

and pattern create balance. Balance is the distribution of values (lights, middles, and darks), their placement, and their amount in a composition.

Every picture is composed of lines. Arthur Loomis, in his book *The Eye of the Painter*, says "Horizontal lines are associated with tranquility, vertical lines with growth, diagonal lines with drama, and curves with graceful movement. The greater the curves, the more energy and motion are expressed."

Lines also lead the eye where you want it to look. When we make art, we are commenting on reality. If we merely copy it, we may as well use a camera. To tell a story with the image, we rearrange the components chosen to suit our goal of imparting information. That information tells the story. The eye likes to travel in a line. Create a "vision path" for the eye to follow, and it will help you to tell the story. One of the most beautiful and rhythmic lines is an S-shaped curve; it is useful when sheer beauty is the objective.

Light and value also have power over the eye. An area of high contrast will draw the eye to the smaller mass of the two. A small black sphere on a white canvas (or the reverse) will be noticed before spheres closer in value to the dominant quality.

SUMMARY

Artists are storytellers. We can make powerful statements with visuals, just like a writer can with words. Like a writer, you must learn to use your vocabulary to achieve your purpose.

In general, you should avoid using the default setting for any tool. Decide what you want to achieve before you even open the Maya program, then sketch it out, find resource materials, and dream about the idea. Use Maya to achieve your vision, but do not allow the program to take over that vision.

in review

1. What is the difference between Orthographic and Perspective views?

2. What happens when you make adjustments to the depth of field?

3. What does the clipping plane allow you to do?

4. Which display do you turn on to make sure you see text?

5. What is depth of field?

6. What is the Fly tool used for?

7. What does the aperture determine for the lens?

8. What are a few rules of composition according to Arthur Loomis?

▶ EXPLORING ON YOUR OWN

1. Set up a few primitives and change the depth of field.

2. Take the same primitives and adjust the focal length.

3. Experiment with different lenses and try to emulate a 50-mm, 100-mm, and 200-mm lens.

notes

notes

ADVENTURES IN DESIGN

DEVELOPING PROPOSAL GRAPHICS

A fairly common situation you may find yourself in as a computer graphic artist will be one in which you must quickly create an image for a project proposal that demonstrates how you or your studio might develop a concept for a client. Often you have a short turnaround time of days or hours to do this.

In this case, I was asked to create a prototype screen of classroom gravity simulation for a well-known educational media client. I was told what the controls needed to be and that they were looking for a 3D sand lot/treehouse look and feel that would appeal to 8- to 13-year olds. Oh, and I was given approximately three work days to complete it (time that was further limited by other ongoing projects).

Making the highest quality image in the shortest possible time was the goal. As always, starting with black-and-white pencil sketches is a good idea so that you can work out your approach quickly with your art director or project manager and get to the business of building your scene in Maya with as few open questions as possible.

The project manager approved the sketch shown in Figure C–1 to move forward with.

C-1 Approved pencil sketch.

Once the project manager and I were in agreement, I started my modeling in Maya. Just about all of the objects in the scene (e.g., the tree model of Figure C–2) were created from simple polygon cubes that I modified and smoothed to get the final shape.

C-2 Tree model.

The scene needed to look like a lot one kids might play in. All the foliage and grass were handled with Maya's Paint Effects. The results (Figure C–3) looked good, and they were produced far more quickly than if I had modeled them myself. This step only took a few hours. Most of my time in Maya was spent in texturing, paint effects, and lighting.

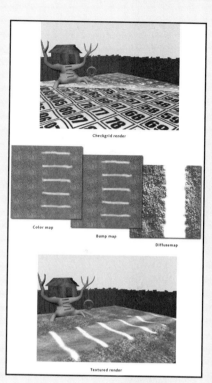

C-4 Check-grid rendering, textures, and textured rendering.

C-3 Scene with basic modeling complete.

For the texture on the ground plane, a quick rendering was done with a check-grid texture so that I could easily identify the positioning for my textures. I used the Sculpt Polygon tool to slightly reshape the ground plane so that the projectile area was raised as if sand had been piled on the existing ground (Figure C–4). Often, using a repeating texture will produce a pattern that is undesirable (look at the color and bump textures in Figure C–4). Using a different image in the diffuse channel helps break up this repeating effect in the final rendering.

Some NURBS geometry was added for the ground plane and the large tree. This geometry was needed to paint the foliage in with Paint Effects. A bit of

time was spent tweaking the brush settings to get what I was looking for, but it was more than worth it for the effect the detail created. The final wireframe is shown in Figure C–5.

C-5 Final wireframe.

Five directional lights were used to light the scene. A few lights lit the entire scene, and some were light-linked to individual objects to refine the lighting.

Due to time constraints, I offloaded much of the image tweaking and some of the texturing to Photoshop. Getting the shadows right and balancing lighting overall were handled by putting the two versions of the rendering (with and without shadows) on top of one another on layers in Photoshop and then painting a layer mask for the top (shadow) layer. This also made certain details much simpler such as getting a broken lighting pattern on the treehouse where the light comes through the leaves. The tree bark was painted over a shaded rendering of the tree using Maya's Paint Effects, painting so that the bark pattern followed the trunk or limbs as it should. The resulting image was then added to the tree using the Overlay layer transfer mode in Photoshop, and the layer was masked to the shape of the tree.

The user interface was built entirely within Photoshop using layer filters on photographic textures (Figure C–6) similar to those in the rendering to create a congruent look for the entire piece. The final proposed image is shown in Figure C–7.

The effort was well worth it. My client won a sizable project based in part on the vision of the project we were able to put forward in our proposal.

Figure C-6 Two versions of rendering used to composite the final one.

Figure C-7 The final proposal image.

Project Guidelines

1. Develop a simple concept for a game or short film and identify one key screen or frame that you would use to communicate or pitch your idea. Alternately, you may want to find something that exists that you think you can improve upon.

2. Write a simple bulleted list or one-paragraph description of the purpose, functionality, and/or intent

of the image you will create. This is what you will use later to evaluate your success.

3. Set a short timeframe to produce the image. (One to three days is a good.) Once you start, stick to this. Try to create a situation where it is expected by peers, classmates, or teachers that you will present the image at the end of the effort. The deadline is as important as the time you spend: Eight hours of effort with a deadline of two calendar days is very different from the same eight hours whenever you feel like fitting it in.

4. Do several pencil sketches and review them with a person or group whose opinion you respect. Settle on one and move forward. (This counts as part of your production schedule.)

5. Figure out how you're going to produce the image—identify what elements and effects need to be made and determine the fastest quality way to get each done.

6. When you finish, present the work and get feedback. Post the work in computer graphics users' groups on the Web and get critical feedback on both your aesthetic decisions as well as your production techniques. This is a goldmine for learning tricks and techniques of other artists.

Things to Consider

The idea with this project is to test your skills, creativity, and ingenuity under pressure. Deadlines can be a great test for you as an artist. Many artists do their best work with the constraints of time and guidelines placed on them.

- You may want to try this project several times to prepare yourself for work in the industry. Vary the subject matter and those who review the project to get a feel for working with different clients.

- Try designating someone you respect as an art director and agree to give him or her aesthetic control over your project. This will give you experience in dealing with losing total creative control.

- You may wish to spend some time experimenting with combining 3D elements created in Maya with 2D composited effects in Photoshop or After Effects to familiarize yourself with quick ways to achieve different looks and effects.

- Pick a product and make a commercial graphic for it.

- Use this project to fill in gaps in your portfolio.

rendering

 charting your course

Rendering is the process of getting a final image or series of images of your work out of Maya. This process can be a relatively straightforward one in which you simply finish your project, make a few decisions about your output, and then render it. Rendering can also be a more involved process in which you break up your animation into separate pieces for composition later (known as multipass rendering). Although you will initially approach your projects with the former approach, in time you may gravitate toward some form of multipass rendering for greater control, flexibility, and efficiency in your projects as your skills evolve. For now, we will go over the general topic of rendering in Maya.

 goals

- To learn the different methods of rendering in Maya.
- To practice using some of the quality settings.
- To understand naming and file saving options.

SCENE FILES

You will be using several files on the enclosed CD referred to throughout this chapter to practice building materials.

NAVIGATION

The tools for this chapter reside primarily in the Render Settings window (Figure 9–1).

figure | 9-1 |

Render Settings window.

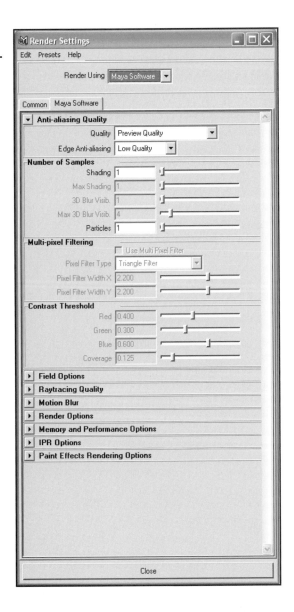

RENDERING IN MAYA: OVERVIEW

When your work is done and you have completed all the modeling, lighting, texturing, animating, and camera setup, it is time to use one of Maya's rendering engines to output your final animation. Maya offers four rendering engines: Maya Software, Mental Ray, Vector, and Maya Hardware.

Maya Software is a very useful and complete render engine that will suit most of your rendering needs. Mental Ray is a third-party render engine included in your package; it has some extended capabilities beyond those provided by Maya's render engine, including features such as caustics and global illumination.

The Maya Hardware render engine takes advantage of your graphics cards' capabilities to output animations in real or near-real time. There are, however, some limitations since many features available in the software render engines are not available in the hardware engine. The upside is speed. (Often, creating an effect in the hardware render engine is significantly faster than creating the same effect in a software render engine). There are two ways to access the hardware renderer. First, you can select the following:

Window > **Rendering Editors** > **Hardware Render Buffer**

You could also select Maya Hardware as the render engine. The latter is the preferred method as it will produce superior results. This option is only available when a supported graphics card is present.

All three of the aforementioned render engines output bitmap (pixel-based) images.

The Vector render engine, as its name implies, outputs vector (curve and shape-based) images. This is most useful for incorporating 3D graphics into Macromedia Flash applications or for preparing artwork for vector drawing packages, such as Adobe Illustrator.

RENDER SETTINGS

The Render Settings window is where you make decisions about characteristics of your rendering, such as quality settings, resolution, file format, and naming convention, as well as some more advanced settings, such as caustics, that were covered in Chapter 6. Some of these decisions affect not only the look of your final rendering but the amount of time required to calculate it as well. The

Common Settings tab covers settings that are common to all the render engines, such as resolution, naming options, and target directory for your render. The second tab will display the settings specific to the rendering engine you have selected.

TUTORIAL: USING THE MAYA SOFTWARE RENDERER

Open the file "Warior_01.mb" in the scenes directory of this chapter on the enclosed CD. You should see a screen that looks like Figure 9–2.

figure | 9-2 |

Warrior scene in Maya.

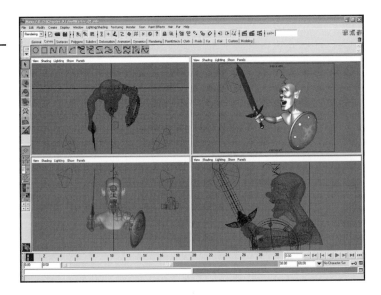

Select the following:

Window > Rendering Editors > Render Settings

Make sure Maya Software is selected in the Render Using menu at the top of the Render Settings window. Select the Common tab if it is not already selected, and then open the Image Size section. Make sure a resolution of 320 × 240 is selected in the Presets menu (if it is not, select it). Do a test rendering by clicking on the Render Current Frame icon (Figure 9–3) in the upper right portion of your screen.

The Render view should open, and Maya should do a rendering of the scene (Figure 9–4).

figure | 9-3 |

Render Current
Frame icon.

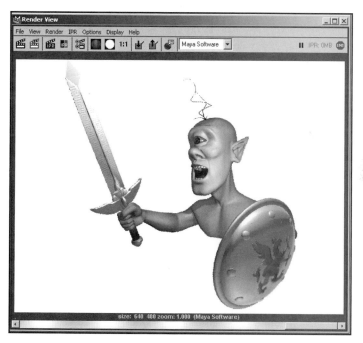

figure | 9-4 |

First test rendering of scene.

Click on the 1:1 icon in the Render view to make sure you are seeing the rendering at full size. (Maya will attempt to scale the display of the image to fit the size of the open screen.)

Now, select 640 × 480 from the presets in the Render Settings window. Do another test rendering, and be sure to click 1:1 when it is completed. You should now have a rendering that is twice the size of the previous one. This setting affects both the test renderings you do

inside Maya as well as those you output through the Batch Render command (Render > Batch Render).

Right-click anywhere inside the Render view, and a pop-up menu will appear. Select the following:

Options > Test Resolution

Look at the options you are presented with. You have the choice of rendering at some percentage of the Render Global setting or at the size of the active viewport you are rendering from. Select 50%, and do another test rendering. You should have an image that is the size of the first one you rendered. This feature allows you to set your render settings in the Render Global window but do test renderings at a lower setting for efficiency in your workflow.

Use the lowest resolution and quality settings you can for test renderings while working to save time. Often half- or quarter-screen previews with preview anti-aliasing are enough to get a sense of what is going on in your scene. Also, use the interactive photorealistic rendering (IPR) function whenever possible when tuning lighting and texture settings. IPR will be slower on the first rendering, but subsequent refresh renderings will be quicker than multiple test renderings.

You can also type your own pixel dimensions in the Width and Height fields if you need a custom dimension. Set the resolution to 640 × 480 before proceeding.

Select the Maya Software tab in the Render Settings window, and open the Anti-aliasing Quality section. Do another test rendering and inspect the edges of the silhouette of the image (Figure 9–5). You should notice that there is a jagged quality to it. You may also notice texture-mapped areas that have a similar jagged quality.

Anti-aliasing is a process in which the rendering engine looks for contrast between pixels at the edge of objects and in their texture maps and attempts to smooth those pixels, creating a softer transition between contrasting regions. This is done at differing levels of sampling that will produce better results as the samples are increased at the expense of time.

Click on the Keep Image icon in the top center of the Render view. This will store a copy of the current rendering for comparison.

In the Render Settings window, increase the Quality setting in the Anti-aliasing Quality section to Intermediate Quality, and do another test rendering (Figure 9–6). You should notice much smoother edges

figure | 9-5 |

Preview
Anti-aliasing Quality.

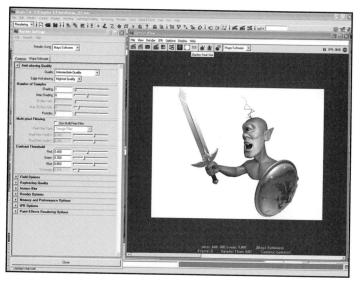

figure | 9-6 |

Intermediate Quality
Anti-aliasing.

and a slightly longer rendering time. Use the scroll bar at the bottom of the Render view to compare the two renderings.

If you save the current rendering and do another rendering at Production Quality, you will notice that the image takes even longer to render, and the resulting rendering is a little softer than the previous (intermediate) one (Figure 9–7). The softness is a result of Maya looking at all the pixel values throughout the image (including in the texture maps) and applying a better method of sampling when necessary.

figure | 9-7 |

Comparison details between three Anti-aliasing settings.

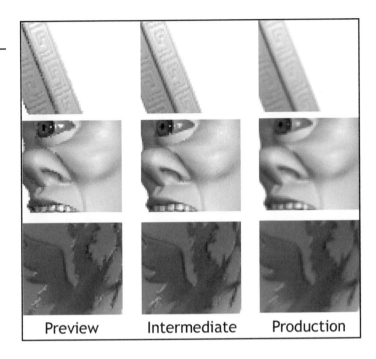

Preview Intermediate Production

You should have also noticed that more settings become available as you increase the quality (i.e., some text fields are no longer grayed out). You can also edit the Edge Anti-aliasing setting independent of the preset. These settings are explained later in this chapter.

If you try out the remaining settings (Contrast Sensitive Production and 3D Motion Blur), you probably will not notice any significant differences in the final image. These settings are for special case situations and generally will not do much except slow down your renderings unless you have a special case where they are required (e.g., when you use 3D Motion Blur).

TUTORIAL: USING THE MENTAL RAY RENDERER

Change the current render engine by setting the Render Using pull-down menu to Mental Ray. In the Render Settings window on the Mental Ray tab, set the Quality to Draft and render the current frame (Figure 9–8).

You should notice a few things right away. First, the eye is no longer visible in the Render view. Second, there is a slightly different appearance to the Mental Ray rendering overall compared to the Maya Software rendering. This brings up an important point: Be sure to

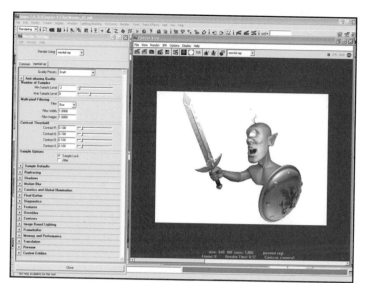

figure | 9-8 |

Mental Ray draft
rendering.

adequately test render your projects in the render engine you intend
to use for your final output because some things will change be-
tween the rendering engines.

In the case of the eye, it is actually still there, but a difference in the way
Mental Ray handles specular highlighting has resulted in a completely
"blown-out" look. If you open the Hypershade or the Multilister, find
the "transColor" material, and open its Attribute Editor, you can fix the
problem by dragging the Specular Color slider about 20% to the left.
Re-render and you should be able to see the eye again (Figure 9–9).

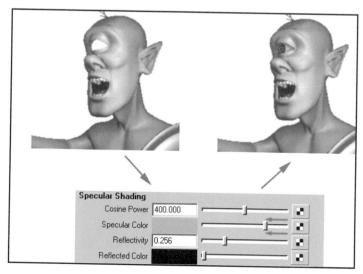

figure | 9-9 |

The eye before and
after.

The other differences are due to the nature of each render engine. As mentioned earlier, you should test render in the render engine you plan to use to avoid unexpected results later.

Try rendering at Preview and Production settings to compare quality and render times for each.

TUTORIAL: USING THE MAYA VECTOR RENDERER

Change the render engine to Maya Vector. In the Render Settings window on the Maya Vector tab, look at the Fill Options section. Select Single Color, and render the current frame (Figure 9–10).

figure | 9-10 |

Rendering with
Maya Vector Single
Color.

You should notice that you get a single color for each object. Under Edge Options, turn on Include Edges and set the Edge Weight Preset to 1.0 pt. Redo the rendering to see the result (Figure 9–11).

Now try Two, Four, and Full Color to see the difference in each (Figure 9–12). Notice that each successive increase in the number of colors increases the render time.

Highlights, Reflections, and Shadows are available options depending on what your current rendering settings are. To get shadows to render in Vector, you need to use point lights and Shadows set to Ray

figure | 9-11 |

Maya Vector Single
Color with edges
turned on.

figure | 9-12 |

Detail of Two (left), Four (middle), and Full Color (right).

Trace on your shadow casting lights. Figure 9–13 shows an example with Highlights, Reflections, and Shadows all turned on.

Average Color will produce results similar to Single Color except it will calculate an average color for the object based on the shading values across its entire surface rather than the base color of the object. Average Gradient and Mesh Gradient use (as you might guess) vector gradients to shade the surface. Experiment with each to understand how it works.

figure | 9-13 |

Average Color with
Shadows, Highlights,
and Reflections
turned on.

Full Color and Mesh Gradient produce the most realistic results but
with long render times and with file sizes that are probably not suit-
able for most Web applications.

ANIMATION

Open the file "swordAnimation.mb" in the scenes folder for this
chapter on the enclosed CD (Figure 9–14).

figure | 9-14 |

The file "sword
Animation.mb"
opened in Maya.

Open the Render Settings window, and select Maya Software as the current render engine. In the Common tab (Figure 9–15), under the

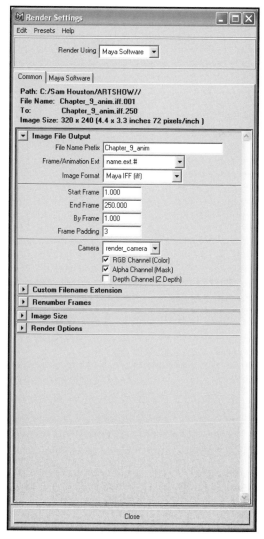

figure | 9-15 |

Render Settings
Common tab.

Image File Output options, Enter "Chapter_9_anim" in the File Name Prefix field. (If you do not give the render a name, it will default to using the scene name.)

To render more than a single frame, you need to select the correct Frame/Animation Ext setting. The default setting is "name.ext (single frame)." Selecting "name.#.ext" or "name#.ext" will activate the settings for multiframe output. Select "name.#.ext." (These settings are further explained later in this chapter.)

For now, leave the file format at the default [Maya IFF (iff)] setting. If you have a compositing or editing package that can import multi-frame bitmap sequences (most can), selecting any of the bitmap file formats should work fine. You also have the option of opening a numbered bitmap sequence and reviewing it in Maya's Fcheck utility. Otherwise, you can always render to AVI or QuickTime, if you like.

Leave the Start frame at 1.000, and set the end frame to 250.000.

Also, make sure RGB Channel (Color) is checked.

If you look at the top of the Common tab in the Render Settings window, you will see information about where your render will be saved and how it will be named.

The path shows where on your hard drive Maya will save the image files. By default, this location will be in the Images directory in either the default project directory in your users folder or the current project you have defined in the Project Settings window (File > Project).

Notice the File Name and To values. Those will be the names of the first and last frames of your animation. Change the Frame Padding value to 3 and see how the names change. (There are leading zeros before the frame number so that the file names will sort correctly when viewed and imported.) It is a good idea to set the frame padding number equal to or one greater than the number of text spaces needed to display your last frame's frame number (i.e., if your last frame is 100, then a value of 3 or 4 for frame padding is recommended).

Scroll down a little and confirm that the Resolution value is set to 32 × 3240. On the Maya Software tab, scroll down to the Motion Blur section, and make sure Motion Blur is off (not checked).

Leave all the other settings as they are.

To initiate the rendering, select the Rendering menu set and select the following (Figure 9–16):

figure | 9-16 |

Batch Render window.

Render > Batch Render (dialogue)

If you have a multiprocessor computer, check "Use all Available Processors."

Click Batch Render, and close the Batch Render window. If you open the Script Editor (Figure 9–17), you can monitor the progress of your animation by watching Maya report the current status.

You can also initiate renderings by using Maya's command-line render program. You will gain efficiency (sometimes quite a bit) because using the line render instead of rendering from within the Maya application itself eliminates the overhead of having the entire Maya application open, which is the advantage to using this program.

figure | 9-17 |

Script Editor window displaying progress.

Your first and simplest option is to simply right-click on the Maya scene file you want to render in the directory it resides in, and select Render from the pop-up menu. The command prompt window will open, and your scene will render based on the settings in the Render Settings. The second option is to activate the command-line render program directly from the command prompt. You simply type "render" a space, and the complete path and file name of your scene file, and then press Enter. If you are savvy enough to write system scripts (e.g., .bat files), you can use this method to queue up several scenes for rendering. There are also additional arguments that can be used to override the Render settings (e.g., to choose a different rendering camera). To see a complete list of the available options, just type "render" at the command prompt.

RENDER LAYERS

Maya has a method for breaking renderings up into pieces so that they can be composed and manipulated more easily in postproduction: Render Layers. Like Display Layers, Render Layers allow you to organize objects on different layers (e.g., foreground and background objects) so that they may be rendered in separate passes. To access the Render Layer window, make sure the Channel Box and Layers palette are visible, and then select Render from the Layer Palette menu (Figure 9–18).

You place objects on render layers in the same way you place them on display layers, by selecting the objects, and, in the Layer Editor, selecting the Create New Empty Layer button. Then click your right mouse button (RMB) on the layer name, and select Add Selected Objects from the pull-down menu. Also, in Maya 7 you can simply select an object and press the Create New Layer and Add Selected button (Figure 9–19).

You can then tell Maya to output objects on different Render Layers to separate files during rendering. You can also individually edit the different attributes of each layer's passes by selecting one of the three buttons that reside on that layer (Figure 9–20). The first button will bring up the hypershade and will allow you to edit shading groups for that render layer. The second button will bring up the Attribute Editor and allow you to further edit various attributes of that Render Layer. And finally, the third button will bring up the Render Settings and allow you to edit the render settings for that layer. You can also simultaneously adjust the settings for every layer by adjusting

figure | 9-18 |

Render Layer Palette menu.

figure | 9-19 |

Adding objects to a Render Layer.

figure | 9-20 |

Edit the Render
Layers attributes.

the master layer, which is created by default, once the first Render Layer is created (see Figure 9–21).

Using the Render Layers in Maya allows you to break down your rendering into multiple passes for each layer consisting of color, shadow, and highlight information for even greater control in post-production.

The remainder of this chapter will be dedicated to going over the Render Settings Common tab as well as features of the Maya Software and Maya Vector render engines in more detail. For additional Mental Ray information, consult the documentation that came with your software.

RENDER SETTINGS COMMON TAB

The first tab in the Render Settings window is called Common (Figure 9–22). These are settings that are shared no matter which rendering engine you choose. The following describes the settings with which you will be most concerned.

figure | 9-21 |

Master Layer.

Image File Output

The Image File Output area is where you make decisions about file format, naming convention, and what camera (or view) you want to render from.

File Name Prefix

The File Name Prefix will be the name of your file (or files). By default, Maya will use the name of the scene file if no name is entered here.

Frame/Animation Ext

By default, Frame/Animation Ext is set to "name.ext" and is used for single-frame renderings. This is simply the name of the rendering followed by the extension for the file format (e.g., "myFile.iff" or

figure | 9-22 |

Render Settings
Common tab.

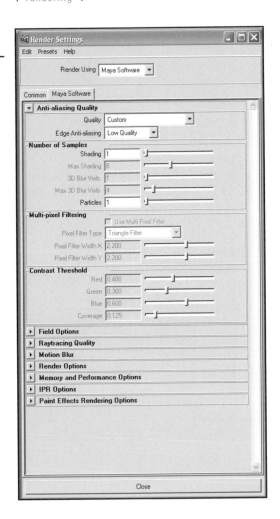

"myRender.tga"). The remaining options (name.#.ext, name.ext.#, name.#, and name#.ext) all deal with rendering animations using different methods of naming sequential bitmap files. When chosen, each will activate the Start Frame, End Frame, and By Frame settings. Which naming convention you choose will depend on the requirements of your editing or compositing software. Examples of each are as follows:

name.#.ext	**myFile.001.iff**
name.ext.#	**myFile.iff.001**
name.#	**myFile.001**
name#.ext	**myFile001.iff**

Start Frame

The Start Frame is the frame you want Maya to start rendering from (usually frame 1).

End Frame

The End Frame is the frame you want Maya to stop rendering at (the end frame of your animation).

By Frame

The By Frame is the number by which Maya will divide your total number of frames to determine which frames to render. The default (1.000) means Maya will render every frame. If you set the By Frame to 2.000, it would render every other frame. Setting it to 3.000 would render every third frame and so on. You could also set the number to decimal values to get a rendered frame at every frame and one-half (1.500) or every half frame (0.500). It is an easy way to resample your animation at a different frame rate or to only render some of your frames for test renderings.

Frame Padding

The Frame Padding specifies the number of character spaces Maya will use to number the frames of your animation.

A frame padding of 3 or 4 is generally desirable both to ensure no import issues into other packages as well as for visual organization (3 for under 1,000 frames, 4 for over).

Image Format

The Image Format is the file format you want the output images to be saved in. This choice will again depend on what software or video system you intend to use the rendering in after it is complete. In general, you may wish to stay away from GIF and JPEG, formats because they can negatively affect the quality of your final image because of compression or conversion to 8-bit color depth. Rendering to a high-quality lossless format such as IFF, TIFF, or TGA is generally recommended. Conversion to other formats for delivery (to the Web, for example) is generally better handled in another application after rendering.

Camera

The Camera option allows you to select which camera or view you want to render from. The default is the Perspective view, but you can select any camera you create or any of the Orthographic views.

Channels

RGB and Alpha Channel are turned on by default. RGB is the color image created by rendering. Alpha is a Matte Channel used for

compositing objects in your rendering, which allows you to, for example, composite images in your rendering onto a background. Depth Channel (Z Depth) is another channel that can be added to certain file formats that allow compositing packages to know how far away from the camera each pixel is. This enables effects like depth of field and fog to be added in postproduction packages.

Resolution

Under the Image Size tab in the Render Settings window, you can pick from several standard pixel dimensions and aspect ratios (several standards use nonsquare pixels). You can also enter your own. Generally, you should determine what your target delivery platform is, and select the preset for that standard. (Maya provides the most common and some not-so-common ones.) Otherwise, enter your pixel width and height in the corresponding fields. The Device Aspect Ratio values should be left alone unless you know that the values should be different from the default values.

MAYA SOFTWARE SETTINGS

Another tab in the Render Settings window is the Maya Software tab (Figure 9–23). It too has a number of adjustable settings as described in the following sections.

Anti-aliasing Quality

Working from the presets is a good starting point. Use the Preview and Intermediate qualities when doing a test rendering; use Production, Contrast Sensitive, and 3D Motion Blur settings as required (with each progressively adding more time to your rendering).

Edge Anti-aliasing

Edge Anti-aliasing controls how many samples Maya will take of each pixel that appears at the edge of objects to get a final result. The higher the setting, the more samples will be used and the more accurate the result will be.

The Number of Samples section settings will control how intensely Maya will calculate anti-aliasing raises for each pixel.

Max Shading

The Shading option becomes available when Highest is selected for Edge Anti-aliasing. This setting will help combat situations where

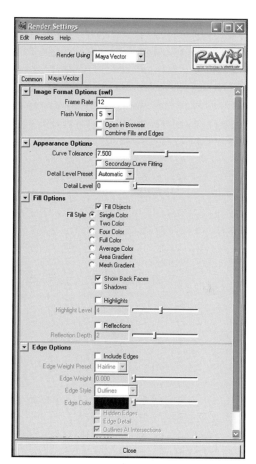

figure | 9-23 |

Maya Software tab.

the texture map applied to an object appears jagged and requires increased anti-aliasing. The default setting of 8 will generally suffice, but it can be increased slightly if needed. It is important to be sure that texture maps are of sufficient resolution so that they do not appear stretched. (Increasing Max Shading will not resolve that issue.)

If there are small, distant objects in your scene that appear to flicker in your rendering, there is an Anti-alias Override setting for each object that you can activate to improve rendering quality on an object basis. Select the object and then open the following:

Attribute Editor > Render Stats

Turn on Geometry Anti-aliasing Override, and gradually increase the level until the problem disappears. Similarly, you can activate the Shading Samples Override for individual objects as well.

Field Options

When outputting to video, you will often be required to deliver your animation in an interlaced format made up of fields. Maya provides several options for field rendering your animations. You should determine the requirements of your video system when setting these options. In general, unless you are told otherwise, 30 frames per second noninterlaced will work for most professional applications.

Raytracing Quality

Raytracing, as mentioned in previous chapters, is a method of tracing light rays in the scene to produce physically accurate reflections, refractions, and shadows. If you plan on using the Raytracing Quality feature, it needs to be activated in the Render Settings window. The numbers next to Reflections, Refractions, and Shadows determine how many surfaces the light rays will hit before the render engine stops calculating that effect. (In the case of shadows, raytraced shadows need to be activated in the light source for this to have any effect.) The defaults work well unless you run into a situation where you are not seeing something you expect. (For instance, several transparent objects with refracting materials clustered together may require a setting of higher than the default 6 for them all to appear in the refraction of the closest object.)

Motion Blur

Motion Blur will simulate the blurring effect created when fast-moving objects move past a camera. The amount of blur is controlled by the settings in the Render Settings window as well as the Camera's Shutter Angle setting (Attribute Editor > Special Effects > Shutter Angle). The 2-D setting is the faster of the two and should be used unless artifacts appear in your rendering. Spinning objects, transparent objects, objects moving over complex backgrounds, and objects entering and leaving the frame can cause problems for 2-D Motion Blur. Using 3D Motion Blur will produce superior results, but at the expense of increased render times. In general, use 2-D Motion Blur until you run into a situation where there is an issue.

Render Options

Selecting Environmental Fog will create an environmental fog material that can be edited to set up fog in your scene.

Environmental Fog has many settings associated with it and could easily have an entire chapter dedicated to its use. Results are influenced by many factors relating to lights, shadows, materials, camera, and render settings, making it a bit tricky for a beginner. Consult your Maya documentation and online user forums for more information.

MAYA VECTOR SETTINGS

The last tab in the Global Settings window is the Maya Vector tab (Figure 9–24). Its settings are described as follows.

Maya Vector produces images in vector format made up of curves, enclosed shapes, fills, and gradients. It will output to Macromedia Flash (.swf) format as well as .eps (encapsulated Post Script), .ai

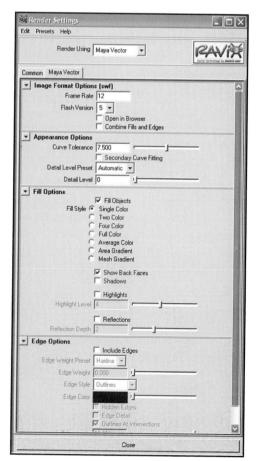

figure | 9-24 |

Maya Vector tab.

(Adobe Illustrator), and .svg (scalable vector graphics). It will output the vector "look" to bitmap format as well. It is important to note that the Vector render engine does not simply convert a bitmap image into a vector image, and as such, not all features available to you in the Software render engine will appear in a Vector render.

Image Format Options (.swf)

Frame Rate

The Frame Rate sets the number of frames per second at which the animation will play back.

Flash Version

The Flash Version gives the version of the resulting Flash player file.

Open in Browser

If Open in Browser is selected, a preview of your animation will appear in your default browser when completed.

Combine Fills and Edges

Combine Fills and Edges should generally be turned off. Activating this feature will result in smaller file sizes, but leaving this setting turned off and optimizing file size in Flash is preferred.

Appearance Options

Curve Tolerance

A Curve Tolerance setting of 0 will reproduce an outline that exactly matches your model (and will create a larger file size); a setting of 10 will approximate the outlines and may cause some distortion (but will create a smaller file). Use the setting that offers the best quality-to-size ratio.

Detail Level Preset

The presets will provide increasing levels of detail at the expense of render time and file size.

Fill Options

Fill Objects

When checked, Fill Objects will fill each object's shape with a color, colors, or gradient.

Show Back Faces

When Show Back Faces is turned on, both sides of a surface will be rendered. When it is turned off, only the side with the surface normal will render.

Shadows

The Shadows feature turns on shadows (works with point lights).

Highlights

Highlights will display specular highlights in your render. The number refers to the number of steps used to produce a transition between highlight and nonhighlight areas.

SUMMARY

Rendering is a broad topic and requires a great deal of experimentation and hands-on experience to gain a good understanding. The information presented in this chapter should remove some of the confusion often encountered in this area. The important thing is to gain enough understanding to make these tools work for you in terms of both aesthetics and efficiency.

in review

1. What is the simplest way to render an animation at 15 frames per second that you key-framed at 30 frames per second?

2. How do you ensure that your numbered bitmap files from a rendering will display and import into other packages in the correct order?

3. Which form of Motion Blur is better to use in most situations, and why?

4. How would you fix a texture map that jitters in your rendering?

5. How would you fix a small or distant object that jitters in your rendering?

6. Which render engine should you do your test renderings in?

7. How would you choose which camera you want Maya to render from?

8. Where does Maya save your rendered animation files?

9. What do you have to do to activate Maya's raytracing feature?

10. How would you render foreground and background objects in your scene to separate files?

▶ EXPLORING ON YOUR OWN

1. Using one of the scenes provided in this chapter, experiment with render engines and quality settings to see the effect that changing settings has on the look and the render times.

2. Create a scene with some of your own objects, render them out with an Alpha Channel, and experiment with reassembling them in Adobe Photoshop or a compositing package like Shake or Combustion.

3. Try breaking up the sword animation into separate layer passes and then reassemble it in your favorite compositing package. Experiment with changing the opacity and tint of your shadow passes as well as duplicating and blurring your specular passes.

4. Many visual effects are more easily achieved in postproduction than in a 3D package. Research some alternative methods for creating effects like bloom, glow, and depth of field on popular computer graphics Web sites, such as highend3d.com or cgtalk.com.

notes

ADVENTURES IN DESIGN

MODELING FOR ANIMATION
USING EDGE LOOPS

When creating a model that will be animated, it is important that the geometry of the model can deform properly. If a model does not deform properly, it is almost impossible to animate.

The Proper deformation in your model must be considered prior to the modeling process. The design of the geometry must allow for movement around the areas that are deformed when animating. The areas that are most effected in this deformation are usually around the joints, and on the character's face, specifically around the mouth and eyes.

When you model a character for animation, it is a good idea to know what parts of the character you are going to animate. This helps when you begin to model your character because the areas that are going to be deformed during animation usually require special attention. A lack of geometry around areas like a hip or shoulder joint will cause undesired results, making the model difficult to animate. The best technique for adding geometry around these areas is called edge looping.

Figure D-1 is an example of an edge loop.

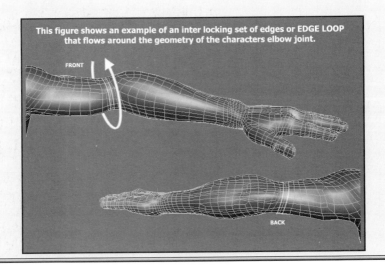

This figure shows an example of an inter locking set of edges or EDGE LOOP that flows around the geometry of the characters elbow joint.

FRONT

BACK

An edge loop, by definition, is an interlocking set of edges. Edge looping is a technique that is used by modelers to get the best possible deformation around joints and other areas that move. These areas are called points of articulation. Edge looping is used primarily on poly and subdivisional surfaces. Edge looping is a simple concept that is effective for generating geometry that needs to be deformed because of animation. In general, the more edge loops you have around the points of articulation, the smoother the deformation; however, too many loops may make the geometry hard to move and rig due to its intricacy. In most cases, you need a minimum of at least 3 edge loops to get decent deformation around joints. Another attribute of edge looping is the effort made by the modeler to keep all the faces that she/he is creating as 4-sided or quads. This helps produce the expected results when the geometry is deformed during animation.

Figure D-2 shows a surface made up of all quads.

When you begin to cut edge loops into a surface that is comprised of 4-sided faces, it is common to end up with 3- and 5-sided faces, as shown Figure D-3.

A quick way of getting rid of these 3- and 5-sided faces and returning to quads at the same time is to split the tri- or 3-sided face at the center of its edge to the corner of the 5-sided face as shown in Figure D-4. This is referred to as a 3- to 5-split.

This 3- to 5-split technique was used extensively to arrive at the edge loops that you see in the character's face in Figure D-5.

As you can see with Figure D-5, the edges around the eyes and mouth loop around in a circular fashion much like our own facial muscles do. Using the proper edge looping to model this face, will allow it to be much easier to deform the eyes and mouth to get dynamic expressions.

Figure D-6 is an example of an expression of a face that uses edge looping.

Project Guidelines

1. Create a model of a simple character using the poly tools. Refer to Chapter 3 for modeling with polygons.

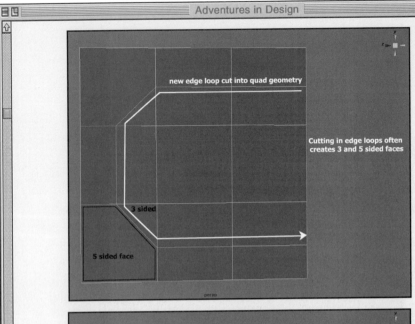

new edge loop cut into quad geometry

Cutting in edge loops often creates 3 and 5 sided faces

3 sided

5 sided face

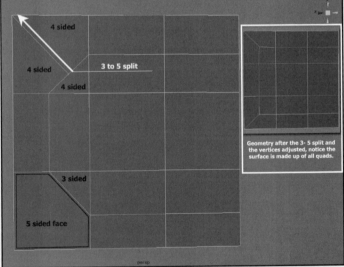

4 sided

4 sided 3 to 5 split

4 sided

Geometry after the 3- 5 split and the vertices adjusted, notice the surface is made up of all quads.

3 sided

5 sided face

2. Decide what part of the character needs edge looping.

3. Use the poly tools to cut in new edge loops. For best results, try to use only 4-sided faces or quads

and try to avoid 3-sided faces or "tris" as well as 5-sided faces.

4. Move the vertices on the mesh to test the deformation. Add or remove edge loops as necessary.

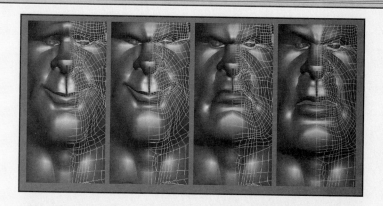

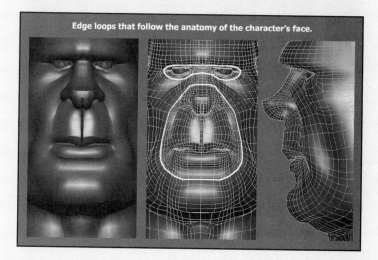

Edge loops that follow the anatomy of the character's face.

Things to Consider

1. Remember that edge looping is primarily used on things that deform when animating. If you are not going to animate the model, you do not need to put edge loops on it.

2. Plan your edge loops in advance. If you are working from a model sheet, draw the edge loops on the model sheet before you start.

3. Test your edge loops as you model by using the transform tools. Try not to add too many loops because the extra geometry will slow you down when you begin to set up and animate the character later.

an introduction to animation

10

 charting your course

The first assignment that a traditional animator typically receives is the "bouncing ball." Here the animator practices the first principles of animation. If you can add convincing appeal to a mundane object, you are ready to apply those skills to a more complex object. We will try bouncing a ball as our first computer animation.

 goals

- To animate the motion, scale, and rotation of a primitive object.
- To apply changes in the Graph Editor.
- To learn how to create a pose test.
- To practice timing, squash and stretch, and volume manipulations.

TOOLS WE ARE USING

- Graph Editor: The Graph Editor (Figure 10–1) charts all of the animation curves for every animated asset. It is a powerful tool capable of interactive editing. This tool allows you to change your ease in and ease out, fix problem movement, or change the timing of an entire series of key frames.

figure | **10-1**

Graph Editor.

- Key Selected: The Key Selected command (Figure 10–2) captures the placement information of your object in *x, y, z* space. This information is kept in a node.

figure | **10-2**

Key Selected.

- Node: A node (Figure 10–3) is like a file folder for keeping documents tidy. A node rests on top of an object in the Hierarchy window. It stores mathematical information relating to the object. Nodes are attached to an object in a hierarchy, and depending on where the math is placed, an object can move in different ways.

figure | 10-3 |

A node in the
Outliner window.

TUTORIAL: BOUNCING BALL

Figure 10–4 shows a bouncing ball drawn in traditional animation.

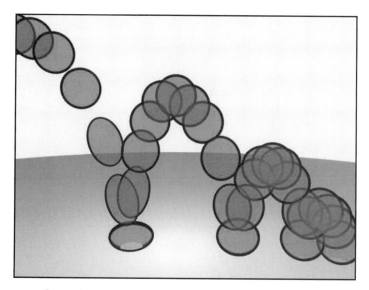

figure | 10-4 |

Animated bouncing ball.

There are three characteristics of bouncing balls that may be altered: timing, squash and stretch, and volume.

- Timing: Notice how the ball's movement is represented by multiple images clustered where it moves the slowest, and the images are far apart where movement is sped up. Spacing has a great deal to do with timing.

- Squash and stretch: Now look at how the ball is squashed when it hits the floor and stretched when it is moving quickly.

- Volume: Notice how the volume does not change. Imagine it is a water ball. One cup always holds one cup of water. Squeezing only alters its shape, not its volume.

We will create the animation in Figure 10–4 in Maya, emphasizing timing, squash and stretch, and volume. We will animate over 13 frames. Like traditional animators, we will set up key frames and then add images in between. We will learn the basics of the bounce and then apply it to different bounce situations.

figure | 10-5 |

Animation module.

First, make sure you are in the Animation module (Figure 10–5).

Enter 13 as your playback end time and final end time (Figure 10–6). Playback end time is the amount of time you will view while working. Final end time is the duration of the entire animation. Now, select the following:

Create > NURBS Primitives > Sphere

figure | 10-6 |

Playback end time and final end time. Mine here is set at 12.

Do not deselect the sphere. It appears in your Channel Box as "nurbs Sphere1."

Scale the sphere using your Channel Box with the following settings (Figure 10–7):

- Scale X: 3

- Scale Y: 3

- Scale Z: 3

figure | 10-7 |

The Channel Box with the sphere selected.

Notice how the sphere reacts when you change each scale option. It squashes and stretches as the values are changed. We will be using the scale option in the squash and stretch portion of our animation.

We now have a sphere of scale (3, 3, 3) at the origin. We will animate the scale options later. With the sphere selected, go to the Channel Box and rename "nurbsSphere1" to "ball" (Figure 10–8).

We will move the pivot to the bottom of the ball. This will allow all scale actions to refer to the pivot as the contact point. The contact point is where the ball hits the floor.

If you are having trouble understanding pivot, take a piece of paper and lay it on your desk. Place your finger on the middle of the sheet, and press against the table. Spin the sheet. The paper rotates around your finger. Move your finger to the bottom of the paper. Rotate again. In Maya, the pivot will have the same effect against the object as your finger against the paper.

figure | 10-8 |

Renaming the
default title "nurbs
Sphere1" to "ball."

Make sure you are in three-panel view as shown in Figure 10–9. You
get here by the following pull-down menu (Figure 10–10):

Panels > Layouts > Three Panes Split Top

figure | 10-9 |

Three-panel view.

figure | 10-10 |

How to get to the three-panel layout.

It is useful to have a Perspective and Front Camera view to keep an eye on the ball's movements. Change the default Top view to Front view. It is also handy to be able to watch the Graph Editor when animating. So, in the lower panel, go to the pull-down menu and select the following (Figure 10–11):

Panels > Panel > Graph Editor

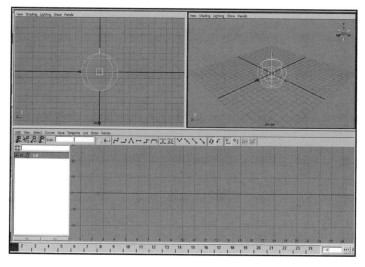

figure | 10-11 |

Three-panel view with Graph Editor.

Later, a shot camera to frame the work for final approvals will be created.

Select the Move tool. (The Manipulator icon will not show up if you have not selected the Move, Rotate, or Scale tool.)

With the ball selected, press the Insert key. The manipulator is now a pivot, and it looks like a yellow square with a circle inside (Figure 10–12).

figure | 10-12 |

The manipulator changes to a yellow box icon.

Move this square with your left mouse button (LMB), and center it on the bottommost contact point of the sphere (Figure 10–13). Press Insert again to turn off the Translate Pivot option. The translate manipulator returns.

figure | 10-13 |

Square moved to bottom of sphere.

Play with different Scale entries in the Channel Box to see how the sphere reacts to the new pivot. Changing the Y value in Scale will give you the most interesting reaction (Figure 10–14).

Select the green arrow of the translate manipulator. Move the ball along the Y axis so that it rests on top of the origin. If you want to

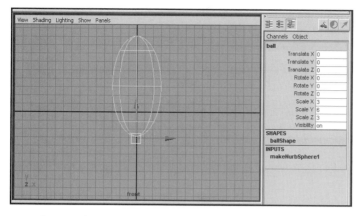

figure | 10-14 |

Changing the Y value in the Channel Box.

continue using the Channel Box, type "3" into Translate Y and keep Translate X and Z at 0.

Before we begin to key-frame, reset the default settings in Maya for your tangents. Go to your Preferences window as follows (Figure 10–15):

Windows > Settings/Preferences > Preferences...

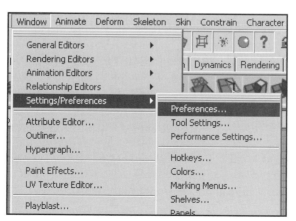

figure | 10-15 |

One way to get to your preferences.

Go to Animation in the Preferences window, and change Default in Tangent to Linear, Default Out Tangent to Stepped, and turn on Weighted Tangents (Figure 10–16). This will allow us to have static poses. Later, we will tweak the curves.

figure | 10-16 |

Changing the tangents in the Preferences under Keys.

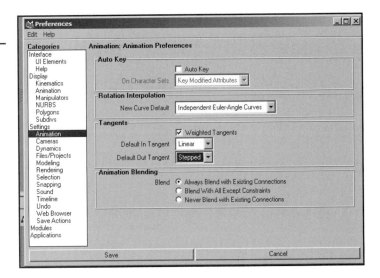

At this stage, we want to define our key poses. We change our tangents so that we are in control of the type of movement we achieve. Right now, we want static poses at certain points in time.

Set a key frame for the ball at frame 1:

Animate > Set Key

The shortcut for default key framing is *s*. Notice how all the Channel Boxes went from white to beige (Figure 10–17). This indicates that key-frame animation has been attached to every channel.

A red tick should now be on your timeline. The red tick will not be visible until you move off the frame. This tick indicates that a key frame has been set.

Pressing "s" is the default way of setting a key frame in Maya, but selecting the default is usually not advised. Do you see how the beige signifies a key frame in every channel in your Channel Box? We do not want a key frame in every channel. This makes our animation heavy, difficult to edit, and messy overall.

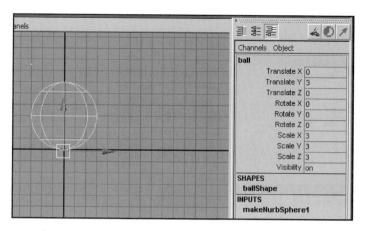

figure | 10-17 |

Area next to key-framed item should turn beige.

For this part of the tutorial, we will only concentrate on the Y translate. To give us a clean slate, choose the following (Figure 10–18):

Edit > Delete All by Type > Channels

All the beige should be removed from your Channel Box.

Set a key frame for the ball at frame 1. Do not use the shortcut "s" key. Instead, go to the Channel Box. Use your LMB to select the Y translate channel. Right-click over the Y translate channel to reveal the menu shown in Figure 10–19.

Select Key Selected. Now you will see that only the Y translate channel is beige (Figure 10–20).

Go to frame 13. Right-click over the Y translate, and select Key Selected again. The first and last frames of a loop must be the same or the animation will appear choppy.

Now, in your timeline, change the playback end time to 12 (Figure 10–21). The key frames 1 and 13 are the same now.

Go to frame 7. Type 20 into the Translate Y field. Set a key frame. The result is shown in Figure 10–22. This is the "float" position.

figure | 10-18 |

All animation is removed with this command.

figure | 10-19 |

A hidden menu.

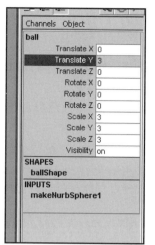

figure | 10-20 |

Animation module.

figure | 10-21 |

Resetting the playback end time to 12.

Select a window as your playback view. Perspective view or Front view are your best choices.

Play your animation using the controls (Figure 10–23), which look like those of a VCR.

This is a pose test. It is your first opportunity to view the timing. You will want to create a play blast to get an accurate view, but this is

figure | 10-22 |

The float position.

figure | 10-23 |

Controls used to play animation.

what you can use for now. The animation is supposed to be choppy. To capture the timing found when the ball loses upward momentum and gains downward momentum, we will now set two more key frames.

Go to key frames 5 and 9, and set a value of 17 in the Y translate. Your curve should look like that shown in Figure 10–24.

Play the animation. At this stage in production, you must get approval for the timing before you work on movement.

figure | 10-24 |

Graph Editor with stepped curve.

You have created the basic timing of the bouncing ball. Traditional animators call this "setting the key poses." *Key pose* is a term used in traditional animation. Key pose is the primary stance of the character. A character may have several key poses as he/she moves through a scene.

To see a representation similar to our traditional bouncing ball sketch, turn on ghosting. To do this, make sure the sphere is selected. Then turn on the following (Figure 10–25):

Animate > Ghost Selected

figure | 10-25 |

Turning on ghosting.

Play the animation. To turn off the animation, do the same command. Also, open the Options box and check out all the different ways you can ghost.

Create a shot camera by selecting the following (Figure 10–26):

Panels > Perspective > New

figure | 10-26 |

Creating a shot
camera.

Look for the new camera you just made by going to the Outliner as
follows (Figure 10–27):

Window > Outliner

figure | 10-27 |

Finding the new
camera in your
Outliner window.

The new camera is called "persp1." Rename it "shot."

Select the shot camera, and set the Camera view you wish to see
through.

Set your shot and lock the camera. You lock a camera by selecting it in the Outliner. Then, in the Channel Box, select all the channels. Right-click over the selected channels and choose Lock Selected. Locked channels will appear gray in the Channel Editor.

Adding Motion

Now you may add motion between key frames. In the Graph Editor, select each key frame and change it to a flat tangent. Select the key frame, and then right-mouse click to get a hidden menu. Select the following (Figure 10–28):

Tangents > Flat

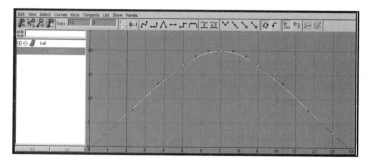

figure | 10-28

Selecting flat tangents.

Notice how curvy the curves are. We need to edit these curves. Play the animation to see what needs to be done.

Select the key frames at 5, 7, and 9, and shape them to look like the curve shown in Figure 10–29.

figure | 10-29

Shaping the curve.

Remember, to shape the tangents (and thus the curve), left-mouse click to select the key frame (only one at a time for this purpose). Then, left-mouse click to select the tangent, and using your MMB, you can move the tangent up or down.

Play the animation. The timing is decent. What we need next is squash and stretch.

Squash and Stretch

Go to your preferences. Although you know how to get there through the pull-down menus, now use the graphic shortcut. Click the icon next to your automatic key-frame button on the lower right of the interface (Figure 10–30). The Preferences window opens (Figure 10–31). Select Settings > Animation. In the Keys area, change the Default In and Default Out Tangents to Flat. Keep them weighted.

figure | 10-30 |

Preferences icon.

figure | 10-31 |

Key prefrences.

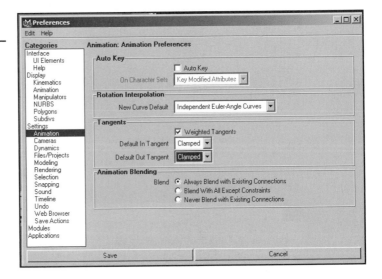

We are done with the pose test. Our tweaking from now on will contain movement.

Go to frame 7. Make sure the values for the *x*, *y*, and *z* scale are 3.

Set a key frame for three scale channels. Remember to use Key Selected so that only these channels are key-framed (Figure 10–32).

Make sure to set the same values for key frames 5 and 9.

figure | 10-32 |

Setting key frames for the *x*, *y*, and *z* scales.

Go to frame 12. Change the scale values to the following:

● Scale X: 2.5

● Scale Y: 4

● Scale Z: 2.5

Set a key frame for these channels. Do the same at frame 2. You now have stretch.

Now go to frame 13. Set the scale values as follows:

● Scale X: 3.4

● Scale Y: 2.2

● Scale Z: 3.4

Set another key frame. Do the same at frame 1. You now have squash.

Notice that we have shaved 0.8 off the Scale Y value and added 0.4 to the Scale X and Scale Z values. This was done to maintain a consistent volume with a value of 9.

The movement is a little like a bag of ooze. Tweak the in and out tangents of the scale values to give a crisper transition.

Edit your tangents in the Graph Editor, and move the in and out tangents to suit the movement you would like. In the Graph Editor, select all the scale curves. Then use the Graph Editor pull-down menu as follows (Figure 10–33):

View > Frame All

figure | 10-33 |

View pull-down menu.

You will now see only the scale curves close up (Figure 10–34). They are easier to work with this way since sometimes a shift of movement is hidden, so you need to look closely at your curves.

figure | 10-34 |

Close-up view of the scale curves.

Figure 10–35 shows edited scale curves for this bounce.

figure | 10-35 |

Scale curves.

Be very careful with curves. Look out for overshoots. If the curve extends beyond your key frame, it is hitting a key pose that you did not want. Break the tangent in these cases, and edit the curve. Here is how.

Choose a key frame and use the Break Tangents tool (Figure 10–36).

figure | 10-36 |

Break Tangents tool.

Left-mouse click on the tool after the key frame is selected. The tangent is now broken.

You will notice that the in and out tangents are now two different colors—red and blue (Figure 10–37). When you select one and move it, the other side does not respond.

figure | 10-37 |

Fixing the overshoot.

Let us apply some cartoon physics. When an object bounces, the volume of the object adjusts to the force of contact. Note that volume does not disappear; it displaces. You can observe this firsthand when you place a water balloon on a table top (Figure 10–38). A balloon that was skinny and tall while you carried it is now short and fat as it lies on a table. The weight and appeal of the object will determine the physics you apply.

figure | 10-38 |

A water balloon is elastic.

If you play the key frames now, you will notice that you have a very small amount of believable bounce. We will be using additional tools to create more believability.

We will add a few more keys. Save this version of your file before continuing. Name the file "ball_base_v1_101." Replace "0101" with today's date. If you save multiple versions of your file with dates attached, you will be able to access older versions of your files.

Interactive Editing

Highlight the ball in the Graph Editor by left-mouse clicking on it. This will allow us to see all four curves.

Make sure you are on frame 7 in the timeline. Activate the Front View window. In the Graph Editor, click on the Move Nearest Key

figure | 10-39 |

Move Nearest Key Picked tool.

Picked tool (Figure 10–39). Your Arrow icon should turn into an arrow pointing to a box. Select the uppermost key frame on the Y translate curve. If you have correctly done this, the key frame changes from black to yellow and the affected curves turn white.

Middle-mouse click and continue to hold down the MMB. Then move the mouse toward you. The key frame should follow. Watch the ball in the Front view: It should be moving in response to where you move the key frame. Move the key frame up and down. See that the ball moves up and down as well because you are changing the information in Translate Y. Watch Translate Y in the Channel Box; look at how the numbers are changing as you move the key frame.

When a typical ball bounces, it initially rises quickly after contact with the floor. It then slows down and loses speed as it rises. It continually gets pulled by gravity, floats for a bit at its peak height, and then gravity pulls it back to the ground. Notice how the curve

arches (Figure 10–40). The ball appears to float momentarily before succumbing to gravity.

figure | 10-40 |

A bouncing ball showing slow and fast portions.

Tweak your frames until you are happy with the movement. This time, save your file as version 2 with today's date.

Move the Ball across the Screen

Now we will bounce our ball across the screen. You can do this using two channels: the X translate and the Z translate. These represent movement forward and back or left to right. We will move forward and back using the Z translate.

Look at the ball in the Side view. Move to frame 1 on the timeline. Set the value of Z translate in the Channel Box to −15. Set a key frame for only the Z translate channel. Go to frame 13. Move the sphere to the right side of the screen, and set Z translate to 15. Set a key selected for the Z translate channel.

Play the animation. The ball now bounces toward you in the Perspective view.

To add the final beauty to your ball bounce, we will add one small rotation to the X axis. When your ball moves forward, it must lean forward. When your ball lands, it must land from the trajectory.

Go to frame 1. Set a key frame in X to rotate to 0. Go to frame 2. Set 2 and set X to rotate to 12. Set a key frame. Go to frame 7 and set X

rotate to 0. Go to frame 9. Set X 9 and set X to rotate to −12. Set a key frame. Go to frame 13 and set X to rotate to 0. Set a key frame.

The X rotate curve is shown in Figure 10–41. The curve has been edited it so that it would transition more quickly. You can figure out what was done by editing your curve to look like the figure.

figure | 10-41 |

X rotate curve.

Play the animation.

The final curves for this animation are shown in Figure 10–42. Your curves may look a little different. You only need to have mastered the buttons to achieve the motion you desire. Do this chapter over again until you can complete this animation unaided by the book.

figure | 10-42 |

Final curves.

You can certainly cycle this animation, but that would be impractical to do so after all the effort you put into achieving a believable bounce. Bouncing balls lose height and energy as they move forward, and cycling keeps all constant. It would take only a few key frames and a few tweaks to create a believable bouncing ball.

Look at this drawing and edit your ball to bounce forward a few more times. Move ahead one bounce at a time. Each time, shorten the movement in the Y and Z translates. Also, reduce the squash and stretch.

You have now reviewed all the necessary tools to edit this bouncing ball to look like any kind of ball you want to create. Look at the ping-pong ball and water balloon examples on the enclosed CD. Try your hand at editing the function curves to emulate the motions of these two distinctly different balls.

SUMMARY

This bouncing ball is the basis for most movement in animation. A frog jumping and landing will require similar arc, bounce, and stretch. The fleshy parts of a larger person jogging will require bounce and stretch, timing, and arcs. Knowing how to use your tools to create the basic principles will make your animation much more convincing.

The principles of animation are very important fundamentals to master. However, other types of animation are growing in importance and should be acknowledged as viable methods for achieving believable movement.

Expressions and constraints based on physics can attach a real-world movement to an object without the need for key-framing poses and interpolating.

Motion capture takes actual movement and attaches the data to an object. Game companies rely heavily on this to achieve realistic movement in a short production time.

Sometimes you want reality-based movement and will be happier experimenting with your own system of movement creation. Learn as much as you can about every movement process, and when the time comes, you can choose the tools you need.

Remember, it is the character of the object you are creating that dictates what type of movement is required. No system is better than any other. Intelligently choose each method for its purpose.

in review

1. What is the shortcut for setting a key frame?

2. What is a clean and efficient way to set a key frame?

3. Which translate curve represents the up- and down-motion of the ball in this chapter?

4. What command do you use to delete all of the animated channels?

5. How does volume change when a ball squashes and stretches?

6. When you first set the preferences for your tangents, what is your default "in tangent" when key framing for the pose test? What is your default "out tangent"? Are tangents weighted or free?

7. What are these values changed to when you are ready to edit the curves?

▶ EXPLORING ON YOUR OWN

1. Create a ping pong ball dropping from a high wall onto smooth concrete. How do you edit your curves to achieve this? Now make the ball bounce on carpet.

2. Do the same but now make a water balloon.

notes

notes

index